THE WATERCOLORIST'S A TO Z OF TREES & FOLIAGE

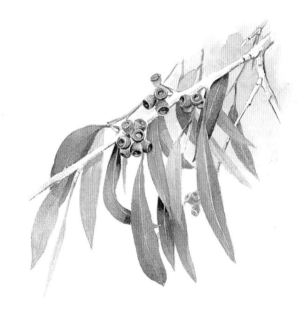

The Watercolorist's A to Z of Trees & Foliage

THE WATERCOLORIST'S A TO Z OF TREES & FOLIAGE

*An illustrated directory of techniques
for painting 24 popular trees and their foliage*

Adelene Fletcher

NORTH LIGHT BOOKS
Cincinnati, Ohio

Overview

HOW TO USE THIS BOOK

The core of *The Watercolorist's A to Z of Trees & Foliage* focuses on how to paint 24 different species of tree. The opening section looks at the main materials and techniques that every tree painter will need, while the final section explores aspects of painting trees in different ways and settings. This overview provides a breakdown of each of the three sections (Essentials, Directory of Trees, and Composition) to enable you to enjoy and benefit from this book to the utmost.

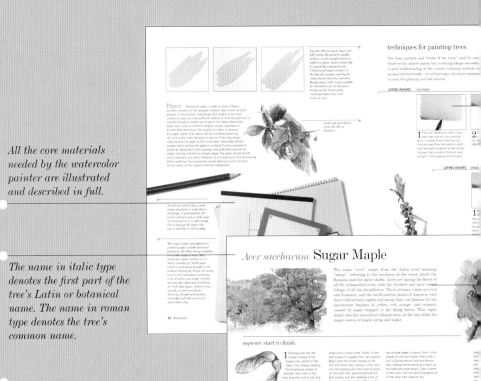

All the core materials needed by the watercolor painter are illustrated and described in full.

The name in italic type denotes the first part of the tree's Latin or botanical name. The name in roman type denotes the tree's common name.

Detailed step-by-step instructions showing the painter how to paint the tree. Cross references to watercolor painting techniques described in the Essentials section are printed in small capital letters (e.g., WET-IN-WET).

Special techniques are suggested to help the painter capture certain vital characteristics of each tree.

The Composition section shows the painter how to paint trees in context. Aspects of composition, such as leading the eye, and warm and cool colors are discussed. All cross references to this section are printed in small capital letters (e.g., COMPOSITION).

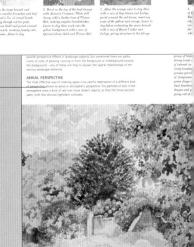

A QUARTO BOOK

First published in North America in 2003 by North Light Books, an Imprint of F&W Publications, Inc., 4700 East Galbraith Road Cincinnati, OH 45236

Copyright © 2003 Quarto Inc.

ISBN 1-58180-424-5

QUAR.WTF

Conceived, designed, and produced by Quarto Publishing plc
The Old Brewery
6 Blundell Street
London N7 9BH

Project Editor Jocelyn Guttery
Art Editor Anna Knight
Copy Editor Hazel Harrison
Designer Brian Flynn
Assistant Art Director Penny Cobb
Photographers Paul Forrester, Colin Bowling
Proofreaders Anne Plume, Kath Farrell
Indexer Rosemary Anderson

Art Director Moira Clinch
Publisher Piers Spence

Manufactured by PICA Digital (pte) Ltd, Singapore
Printed by Star Standard Industries (pte) Ltd, Singapore

Contents
CONTENTS

Each of the basic techniques of watercolor painting are demonstrated using step-by-step photography and explanatory text.

Botanical features of the tree are highlighted for the painter's interest. Tips are given on how the tree's smallest details can be enhanced.

A brief introduction outlining the tree's distinguishing characteristics.

The complete color palette needed to paint the tree.

Acer saccharum

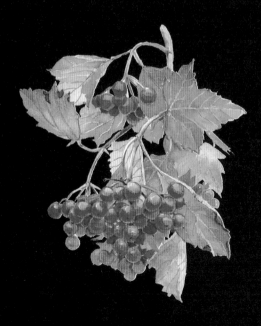

introduction

Trees provide a wonderfully varied painting subject, with each different species having its own distinctive look. In the case of deciduous trees, the changing seasons offer further variety, with the vivid yellow-greens of spring gradually changing to deeper, lusher greens, and then to the rich reds and yellows of fall. Winter trees can also make an exciting subject, as the absence of foliage gives you the opportunity to exploit the colors and textures of trunks and branches.

The aim of this book is to show you how to paint a wide variety of trees, using a range of different watercolor techniques and color mixes. Most of the paintings show foliage-clad trees, but to help you to understand the basic structures and individual characteristics, I have included in each demonstration a sketch of the tree in winter, together with close-up views of leaves, nuts, berries, and blossoms.

Each of the 24 demonstrations, accompanied by full step-by-step instructions, focuses on an individual species – some well-known and others rarer and more exotic. Each one is shown in a full landscape context, so that you will discover not only how to paint a portrait of a tree but also how to compose the painting and orchestrate the surrounding elements.

Summer trees obviously call for a predominantly green palette of colors, but it is important to choose the greens with care and to vary them as much as possible to avoid monotony. Although greens can be produced by mixing yellows and blues (primary colors), good-quality, ready-made greens are often brighter and more vibrant than primary mixes. In each demonstration, I list all of the colors used, with swatches so that you can see what they look like, and give instructions for specific mixes in the captions.

As well as dealing with the basic watercolor methods such as laying

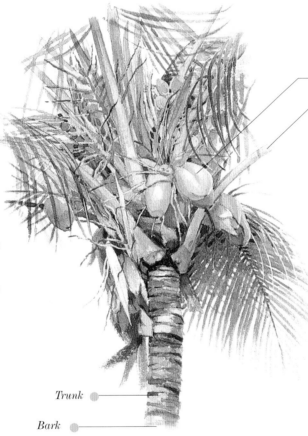

Seeds

Branch

Trunk

Bark

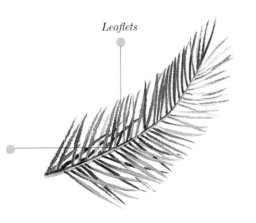

Leaflets

Stem

washes, building up layers of color, and reserving highlights, I have also suggested several more unusual techniques to help you to capture the special qualities of foliage, or the textures of bark. But the key to painting trees successfully is brushwork, so do practice making marks with different brushes until you gain confidence and find you can "let the brush do the work" of describing leaf shapes and foliage masses.

Watercolor is a lovely medium, but it can be unpredictable, and it takes a good deal of practice before you can achieve a result you are proud of. Don't be discouraged if your first attempts don't come out quite like the demonstrations – if you keep at it, you will soon see an improvement.

As well as practicing techniques, spend time observing trees so that you become familiar with the structures, shapes, and colors. Don't go straight into a painting until you have a good idea which colors you will need, and always start with a preliminary drawing. Good watercolors look almost effortless, but in fact they are almost always the result of careful advance planning. Once you become familiar with both the medium and your chosen subject, you will begin to paint with confidence and enjoyment.

materials and techniques

materials for tree painting

You don't need a vast quantity of materials and equipment to paint stunning trees in watercolor. If you are painting trees and landscapes for the first time, it is useful to restrict yourself to just a few basic materials to begin with until you have evolved the colors, brushes, paper, and other equipment suited to your favorite techniques and particular style of working. This section gives you information on all the basic materials and equipment you will need for watercolor tree painting.

Paints: The choice of colors available to the watercolor painter can be bewildering, especially as color perception varies from person to person. Although the palette below looks huge, and all the colors are used throughout the book, each painting uses on average eight colors. However you should never feel restricted in the colors you use, and you will be amazed at the range of colors that can be produced by mixing. Transparent watercolors come in two qualities—artist's colors and student's colors. The latter are not always labeled as such, but the former always are, so look for the label "Artist's watercolor" on the tubes or pans, and don't be tempted by the cheaper versions.

Paintboxes made for pans have central recesses to hold the pans, and fold-out outer "wings" for mixing colors. If you are using tube paint you will need a separate palette. There are many different versions on the market today.

You won't need all of these colors for every painting, for example a picture of acers in the autumn will call for the reds, oranges, and yellows rather than the greens of a summer tree, so you can build your collection of paints up gradually, buying new colors to suit the subject.

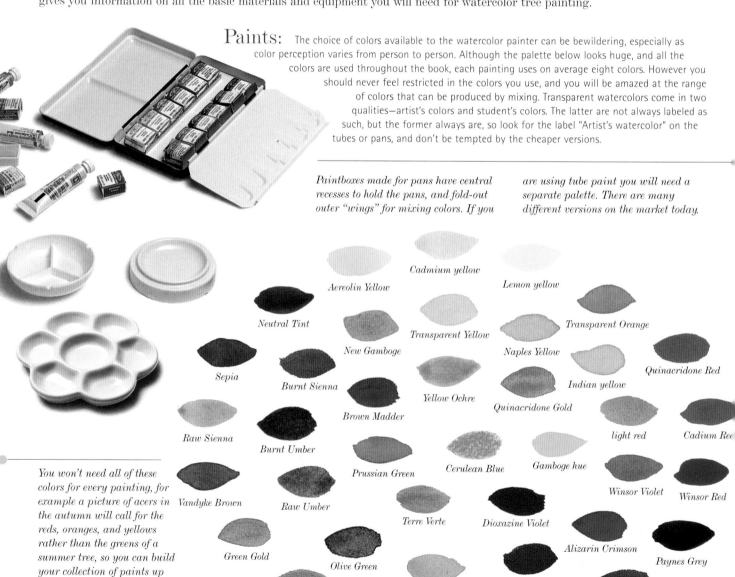

Cadmium yellow
Aereolin Yellow
Lemon yellow
Neutral Tint
Transparent Orange
Transparent Yellow
New Gamboge
Naples Yellow
Sepia
Quinacridone Red
Burnt Sienna
Yellow Ochre
Indian yellow
Brown Madder
Quinacridone Gold
Raw Sienna
light red
Cadmium Re[d]
Burnt Umber
Cerulean Blue
Gamboge hue
Prussian Green
Winsor Violet
Winsor Red
Vandyke Brown
Raw Umber
Terre Verte
Dioxazine Violet
Green Gold
Olive Green
Alizarin Crimson
Paynes Grey
French Ultramarine
Phthalo Green
Viridian
Phthalo Blue
Sap Green
Cobalt Blue
Indigo

Brushes and Equipment:

Brushes are every bit as important as paints, but you don't need a large range, and depending on the subject, you can often complete an entire painting, from first washes to final details, with just one brush. The best brushes are Kolinsky sable, but there are many less expensive alternatives, either sable and synthetic mixtures or wholly synthetic. Apart from paints, brushes, and paper (see following page), you will only require a few additional bits and pieces, many of which you will probably have around the house already, such as jars for water.

Round brushes are extremely versatile, enabling you both to make a great variety of different brushmarks and to paint linear detail. When buying, make sure that the brush comes to a fine point without the hairs splaying out. The rigger brush (bottom, below) is used for very fine detail such as fine twigs and branches, while the Chinese brushes (second from top, below) produce the calligraphic brush effects seen in Oriental flower paintings.

Paper towel is useful for general cleaning up, and can also be used for various lifting out techniques.

Waterpots can cost virtually nothing, as the most commonly used receptacle is a recycled jam jar or yogurt pot, but for clumsy people, or those working outdoors, a non-spill pot (below) is especially useful.

Masking fluid (left) is painted on to reserve highlights (see reserving whites), and cotton buds (above) and small sponges (below right) are both useful for lifting out paint and softening edges.

You will also need a drawing board, but this can be simply a piece of plywood or other board cut to a size that suits you.

Gumstrip (left) is used for stretching paper to prevent it buckling when wet paint is applied. Thicker paper can be attached to the board with masking tape (below left).

Smooth (Hot-pressed) paper (far left) causes the paint to puddle, as there is not enough texture to hold it in place. Some artists like to exploit this characteristic. Cold-pressed paper (center) is the best all-rounder, used by the majority of watercolor painters. Rough paper (left) is less suitable for detailed work, as the grain breaks up the brushmarks, creating broken lines and areas of color.

Paper:

Watercolor paper is made in three different surfaces: smooth (or Hot-pressed), medium (also known as Cold-pressed, or Not surface), and Rough. Not surface is the most commonly used, as it has sufficient texture to hold the paint but is smooth enough to enable you to paint fine detail. Watercolor paper also comes in different weights, usually expressed in pounds (lbs) referring to the weight of a ream. In general, any paper lighter than about 140 lbs will need stretching, or it will buckle when wet paint is laid on. To do this, simply soak the sheet of paper briefly in the bath, then shake off the surplus water, and lay the paper on a board. Cut four lengths of gumstrip, damp them with a sponge, and stick them around the edges, starting with the two longer edges. The paper should be left to dry naturally, not with a hairdryer, so it is wise to do this the evening before painting. The process may sound laborious, but it can be a money-saver, as thin paper is relatively inexpensive.

Leaf and seed detail from the horse chestnut painted on Rough paper. Note how the grain of the paper contributes to the texture of the leaves.

You do not need to buy a wide range of pencils to make tree drawings. A good-quality 2B pencil will give you a wide scope of expression as it is soft enough not to damage the paper but not so soft that it will smudge.

The major paper manufacturers produce paper in both sheet and pad form, the latter being available in a wide range of sizes. Most watercolor pads contain 10-12 sheets, usually of 140-lb paper, which is just heavy enough to use without stretching.

techniques for painting trees

The basic methods and "tricks of the trade" used by watercolor painters are more or less the same whatever the subject matter, but rendering foliage successfully requires sure and accurate brushwork. A good understanding of the various texturing methods is also useful when dealing with foliage masses and tree trunks – as well serving a descriptive purpose, these can also help to enliven an area of a painting and add interest.

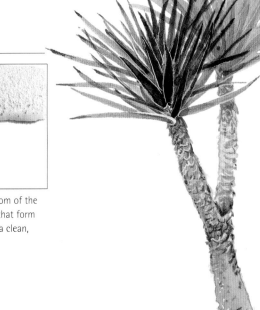

LAYING WASHES FLAT WASH

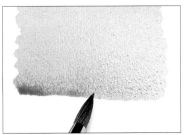
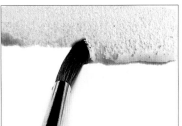

1 If you are intending to cover a large area, make sure you mix up enough paint – it is wise to mix more than you think you need. Prop the board at a slight angle and paint successive "stripes" across the paper. Use a round or flat brush large enough to hold a good quantity of paint.

2 Continue down to the bottom of the area. Any unwanted pools that form can be removed with the tip of a clean, slightly damp brush.

LAYING WASHES GRADED WASH

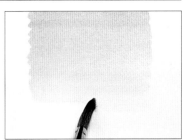

1 Graded washes are more commonly used than flat ones in landscape painting, as they are ideal for skies and backgrounds. Start with a band of full-strength color and then, for each subsequent band, dip the brush first into clean water and then into the paint, thus diluting it by a precise amount each time.

2 The color at the bottom of the wash is dictated by the first band, so you can make it much stronger if desired. For a reverse graded wash, becoming lighter at the top, turn the board upside down.

LAYING WASHES VARIEGATED WASH ON DRY PAPER

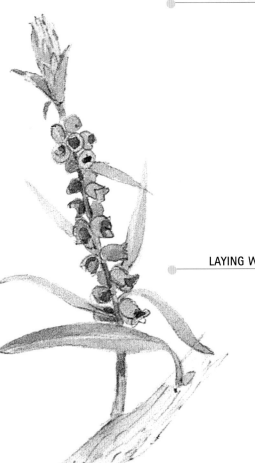

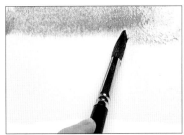
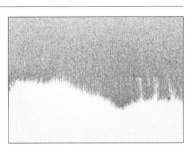

1 In this type of wash, two or more colors are laid on at the same time and allowed to blend. Here Phthalo Blue merges with Transparent Yellow.

2 By tilting the board in whichever direction you choose, you can encourage the flow of paint. Angling it upward, for example, will make more color collect at the top.

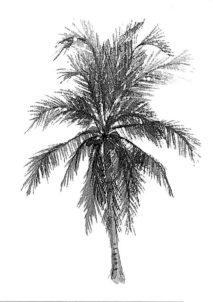

1 Wetting the paper first helps the colors to merge rapidly. It creates a softer effect, but is slightly less easy to control.

2 More colors can be dropped in before the paper has dried, but they should not be more watery than the first colors, or blotches will form.

BRUSHWORK ROUND BRUSH

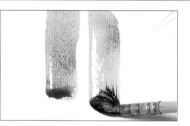

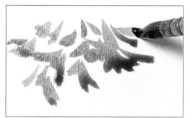

Graceful and supple linear marks can be made with a rigger brush, using a stroking motion and keeping the brush vertical to the surface.

A No. 10 round round brush can achieve a number of different finishes. Here the side of the brush is used to drag wide strokes almost parallel with the paper surface.

Short stabbing strokes with the brush angled sideways give a good indication of leaves.

BRUSHWORK TWO COLOR BRUSHSTROKES

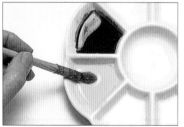

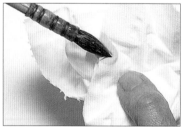

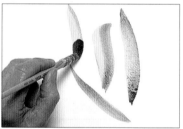

1 This is a very useful technique for painting foliage. Mix up an equal quantity of blue and yellow, and dip the brush into the yellow.

2 Hold the brush level and dry the tip with a tissue before dipping it into the blue.

3 Holding the brush slightly sideways and at a flattish angle to the paper so that both colors come into contact, press down from the tip, pulling the stroke downward.

WET-IN-WET CREATING SOFT BLENDS

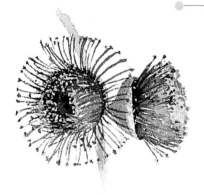

1 Most watercolors are begun by blending colors wet-in-wet, here paint a leaf shape with a Sap Green.

2 Before the paper has lost its sheen, drop along the center a pale yellow to push the green to the outside edges creating this soft blend.

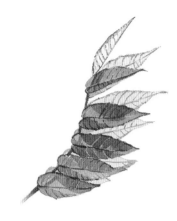

1 If you drop water, or watery paint, into a dark wash, the blotches known as backruns will occur. These can be a good way of creating highlights on foliage masses. Lay a dark wash, and leave until almost dry.

2 Spatter on drops of water by knocking the brush against the handle of another one. The dark paint will run away from the water to leave lighter areas, which form hard edges as they dry.

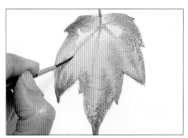

1 You can create surprisingly crisp edges around wet-in-wet work as long as you take care with wetting the paper. Make a guide drawing, and then "paint" clean water over the whole leaf inside the drawn lines. Lay on watery Raw Sienna, and you will see that the paint stays within the boundaries and does not flow over onto the dry paper.

2 Let the paper dry slightly before adding Burnt Sienna around the edges, followed by Alizarin Crimson around the tips.

3 Leave to dry for a few more minutes, and paint the veins with a rigger brush and Burnt Sienna.

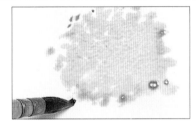

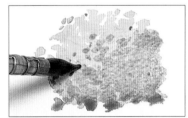

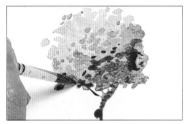

1 Wet-on-dry methods are often used for the foreground or focal point of a painting, where sharp focus is needed. Lay a base wash of yellow, and allow to dry.

2 Paint a second color, making small brushstrokes and letting the paint pool at the bottom of the area. These pools will form hard edges as they dry.

3 Now paint on the third color, again making small strokes and leaving some of the second color showing.

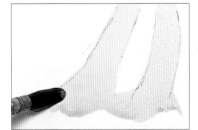

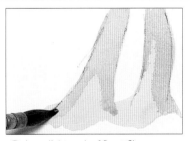

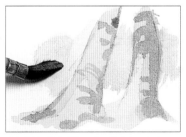

1 Glazing is a method of building up one or more layers of color. You can either work over a whole area to amend an existing color, or glaze selectively, leaving some of the first color showing. Lay a yellow wash and allow to dry.

2 Lay a light wash of Burnt Sienna, leaving areas of yellow. Work lightly to avoid disturbing the first wash.

3 Add a little Dioxazine Violet and glaze on shadow shapes. When dry, paint a background wash with very pale Dioxazine Violet.

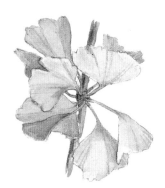

WET-ON-DRY SOFTENING WITH TISSUE

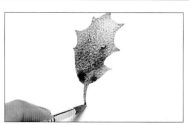

1 Watercolor washes and brushstrokes form hard edges as they dry. You will sometimes want to soften these to achieve a contrast. Lay a dark green wash all over the leaf.

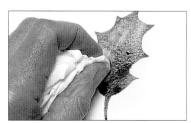

2 While still wet, use a paper tissue to gently lift some of the color from the left-hand edge.

WET-ON-DRY SOFTENING WITH A SPONGE

1 Paint the leaves with a pale green, using the tip of the brush to make spiky strokes. Let the first color dry, and then paint a darker layer of foreground leaves.

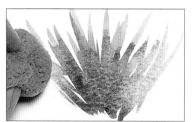

2 To create a sense of recession, soften the edges on farther-away leaves with a damp sponge. This is more effective than tissue for removing dry paint.

TEXTURING METHODS DRY/ROUGH BRUSHING

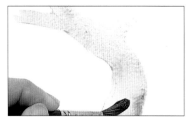

1 This is a very commonly used watercolor technique that can be widely varied. Lay a base wash on the tree trunk and allow to dry.

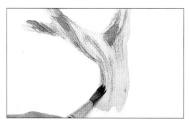

2 Make a darker gray-brown mixture, dip the tip of the brush into it, and dry it slightly, splaying out the hairs as you do so. Drag the brush over the paper to create a series of tiny fine lines. You could also use a flat brush dragged lightly over the paper, or for a more subtle effect, dry-brush into a slightly damp wash.

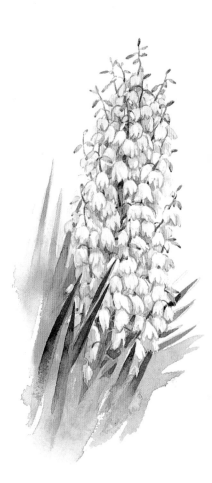

TEXTURING METHODS SPATTERING

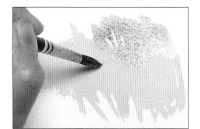

1 This is a useful method for suggesting either texture or detail, such as flowers on a tree. It can also add interest in certain areas of a painting without being over-specific. Lay on the first two washes and allow to dry.

2 Mix some fairly strong red, dip the brush into it, and tap it against your finger or the handle of another brush to release droplets of paint. Softer effects can be gained by spattering onto damp paper.

1 Some pigments are described as sedimentary: They tend to precipitate – or separate from the water to produce a grainy appearance. Begin with French Ultramarine, which is one of the sedimentary pigments.

2 Before the paint dries, drop in Burnt Umber to blend, concentrating most of the color on the shadowed side.

3 The attractive mottled effect is ideal for tree trunks or foliage masses. Most of the so-called "earth colors" will granulate, as does Cerulean Blue.

1 A small natural sponge can render foliage texture more effectively than a brush. Dab on a light yellow-green and allow to dry.

2 Lay on a second tone, using the sponge lightly so that it does not fully cover the first color.

3 The soft, fluffy effect usually needs crisping up with brushwork in the later stages, so details can be added with the tip of a round brush.

1 This method is frequently used for bark textures, or simply to add surface interest in certain areas of a painting. Make an outline drawing, and scribble lightly with a candle or wax crayon.

2 When washes are laid on top, the paint slides off the waxed areas. The more pressure you apply with the wax, the more pronounced the effect will be.

Dragging the brush lightly across the paper in different directions is ideal for suggesting the small leaves at the edges of foliage clumps.

To paint clumps of small, delicate leaves, load the brush well and make a series of separate dabbing strokes with the tip. To achieve a range of tones, continue to paint as the brush becomes progressively starved of paint, and then reload it.

1 The classic way of creating white or pale shapes in watercolor is to paint around them. Decide where the highlights are to be, make a drawing, and lay on the first wash.

2 Continue to build up the colors of the leaves, working wet-in-wet. The darker the surrounding colors, the stronger the whites will appear.

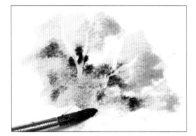

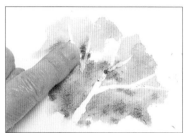

1 Protecting areas that are to remain white or light-colored allows you to work freely without worrying about paint spilling over edges. Paint on masking fluid and wash the brush immediately, or it will be ruined. It is wise to keep an inexpensive brush for masking fluid.

2 Lay washes over the whole area, allow to dry, and then remove the masking fluid. The reserved white areas can be tinted as desired in the final stages.

LIFTING OUT SMALL HIGHLIGHTS

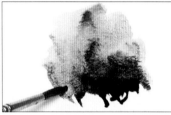

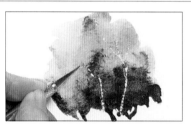

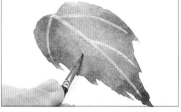

1 This method of scratching into dry paint, also known as sgraffito, is used for small linear highlights such as twigs, or highlights on leaves or grasses. Complete the whole area and allow to dry.

2 Use the point of a knife to scratch back to white paper. You can also use the side of the knife to partially remove larger areas of paint. Scratching or scraping should always be the final stage in a painting, as it scuffs the paper, making it impossible to lay washes on top.

1 This is another method of creating small highlights, or reclaiming ones that have become lost. Paint the leaf with a mix of Dioxazine Violet and Alizarin Crimson, and allow to dry. With the point of small damp brush, go over the leaf veins, until you have removed sufficient paint.

PULLING OUT

1 For soft effects and larger highlighted areas, a tissue or small sponge can be used to lift out wet paint. This method is commonly used for skies and light-catching areas of foliage.

2 Lay on a roughly-applied wash, and immediately dab into it with a piece of tissue.

1 To achieve this texture lay in a wash of mid-yellow with a band of darker green above it. When the paint is still damp use the end of the brush or a palette knife to drag the yellow color into the green.

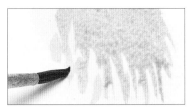

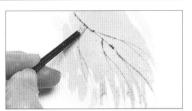

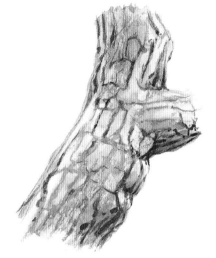

1 Pressing into wet paint with a sharpened stick indents the paper so that the paint flows into it, making dark lines. This is a useful method for leaf veins and small twigs.

2 Lay a wash of Phthalo Green and Alizarin Crimson, and with the paint still wet, draw into it with the stick. The effect is rather like pencil marks, but more subtle.

NEGATIVE PAINTING DEFINING LIGHTER SHAPES

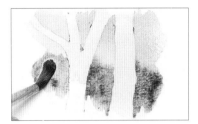

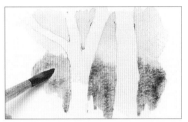

1 Painting the spaces between objects, known as negative shapes, can be an important way of defining the positive ones, such as tree trunks, branches, and leaves. Make a drawing, and lay in a wash of Raw Sienna.

2 Continue to build up the colors until the shapes stand out clearly.

USING BODY COLOR DEFINING LIGHTER SHAPES

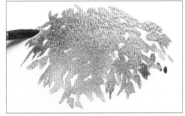

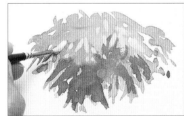

1 White Gouache, an opaque version of watercolor, can be used to paint highlights, either on its own or tinted with watercolor (an alternative is White Acrylic). Here tinted gouache is used for small branches. Paint the tree with a strong mix of Dioxazine Violet, Alizarin Crimson, and Raw Umber.

2 Mix just a little of this color into White Gouache and paint in the lighter leaves on the top section..

USING BODY COLOR HIGHLIGHTS

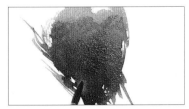

1 Body color is useful for giving extra emphasis in certain areas of a painting, as on this red maple tree, where a few leaves are picked out in opaque paint. Paint on brushstrokes of Burnt Sienna and Dioxazone Violet, leaving small white shapes around the edges.

2 Tint White Gouache with a little Burnt Sienna and make individual twig-shaped marks, pressing the brush onto the paper and then lifting it to taper the strokes.

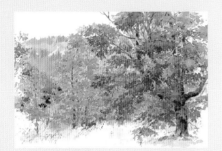

20 Acer saccharum
(Sugar Maple)

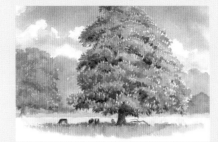

24 Aesculus hippocastanum
(Horse Chestnut)

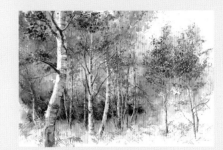

28 Betula pendula
(Silver Birch)

32 Callistemon subulatus
(Dwarf Bottlebrush)

36 Cocus nucifera
(Coconut Palm)

40 Cupressus sempervirens
(Italian Cypress)

44 Cedrus libani
(Cedar of Lebanon)

48 Eucalyptus perriniana
(Spinning Gum)

52 Fagus sylvatica
(Common Beech)

56 Gingko biloba
(Maidenhair Tree)

60 Ilex aquifolium
(Common Holly)

64 Juglans nigra
(Black Walnut)

directory

68 *Malus domestica*
(Apple)

72 *Nerium oleander*
(Oleander)

76 *Olea europaea*
(Olive)

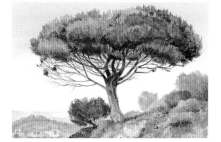

80 *Pinus pinea*
(Umbrella Pine)

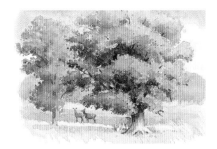

84 *Quercus robur*
(Common Oak)

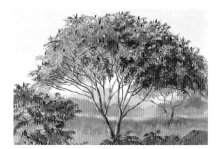

88 *Rhus typhina*
(Staghorn Sumac)

of Trees

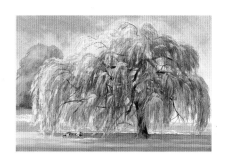

92 *Salix chrysocoma*
(Golden Weeping Willow)

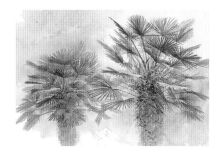

96 *Trachycarpus fortunei*
(Windmill Palm)

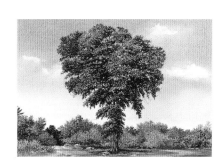

100 *Ulmus Americana*
(American Elm)

104 *Viburnum opulus*
(Guelder Rose)

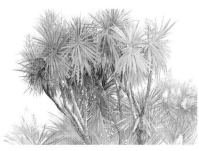

108 *Yucca aloifolia*
(Spanish Bayonet)

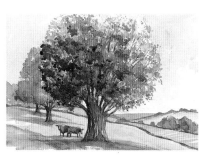

112 *Zelkova carpinifolia*
(Caucasian Zelkova)

Acer saccharum Sugar Maple

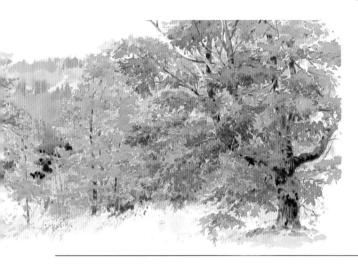

The name "acer" comes from the Latin word meaning "sharp," referring to the hardness of the wood, which the Romans used for spear shafts. Acers are among the finest of all the ornamental trees, with the loveliest and most varied foliage of all the broadleaves. Their autumn colors are rich and dramatic, and the north-eastern states of America, with their cold autumn nights and sunny days, are famous for the spectacular displays of yellow, red, orange, and crimson, caused by sugar trapped in the dying leaves. This sugar maple also has important culinary uses, as the sap yields the major source of maple syrup and sugar.

sequence start to finish

1 Starting with the red foliage clumps of the largest tree, sketch in the basic color shapes, keeping the drawing as simple as possible. Also mark in the main branches and trunk, and lightly indicate the outlines of the two smaller trees. These are to be offset against the dark green of the background conifers to give a sense of depth, and to break up the orange and red shapes.

2 Lay down the yellow areas first, as the lightest tone, using Quinacridone Gold. Use a large round brush to help keep the strokes bold and loose, and make sure to leave some "holes" in the leaf masses to suggest their lacy quality. Begin with the broken shapes of the two left-hand trees, taking a little color into the background, then start to work on the main tree, painting behind the leaf masses, and also dabbing some of the color into the clumps. Allow to dry before adding the next colors.

3 Now paint the leaf masses on the largest tree, starting with watery Alizarin Crimson. Load the brush well, and work across the shapes with the tip of the brush. Then paint with a stronger mix of Winsor Red, using short, sharp, angular strokes to suggest the pointed leaves, and stippling (see BRUSHMARKS)

the outside edges in places. Paint in the shapes of the two smaller trees with a mix of Quinacridone Gold and Winsor Red, making the brushmarks smaller, as the trees are more distant. Dab in some of this color into the yellow background of the main tree. Leave to dry.

4 Green and red are complementary colors (see COLOR MIXING), so the reds and oranges of the acers will glow out against the dull green of the background conifers. Using a fairly pale mix of Sap Green and a touch of Indigo, paint in the shape behind the two small trees, leaving some of the first yellow wash. Dab some of this same green between clumps of foliage, then lightly

special detail delicate effects with strong color

1 *Draw in the large branch and indicate the smaller branches and leaf masses. Load a No. 12 round brush with watery, though not too pale, Quinacridone Gold and paint around the large branch, working loosely into the leaf masses. Allow to dry.*

2 *Paint in the top of the leaf clumps with Alizarin Crimson. While still damp, add a darker tone of Winsor Red, making angular brushstrokes. Leave to dry, then work into the yellow background with a mix of Quinacridone Gold and Winsor Red.*

3 *Allow the orange color to dry, then with a mix of Sap Green and Indigo paint around the red leaves, reserving some of the yellow and orange. Leave to dry before indicating the main branch with a mix of Burnt Umber and Indigo, giving structure to the foliage.*

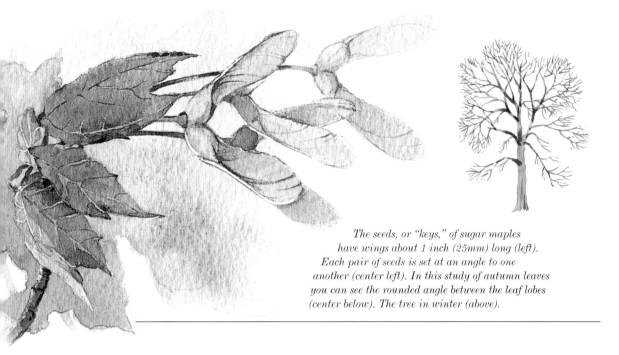

The seeds, or "keys," of sugar maples
have wings about 1 inch (25mm) long (left).
Each pair of seeds is set at an angle to one
another (center left). In this study of autumn leaves
you can see the rounded angle between the leaf lobes
(center below). The tree in winter (above).

Quinacridone Gold

Alizarin Crimson

Winsor Red

Sap Green

Indigo

Burnt Umber

Brown Madder

suggest the conifers with upright strokes of darker green while the first wash is still damp. Using the paler green mix and the tip of the brush, paint in negative shapes (see NEGATIVE PAINTING) behind the main acer, and begin to indicate the branches and trunks of all the trees with a mid-toned mix of Burnt Umber and Indigo, using delicate broken lines for those of the smaller trees.

5 Continue to add tones to the leaves of the main tree, using mixes of Brown Madder and Winsor Red. Don't be afraid of dark tones, as these will give form and structure, but take care over the shape and direction of the brushmarks; aim to give the impression

of lots of little leaves. The profusion of twigs and branches is also important. Paint the smallest twigs with a small pointed brush and mixes of Burnt Umber and Indigo, using a larger brush and a darker mix of the same colors to add texture to the trunk and main branches.

6 To suggest some very pale twigs coming forward on the main tree, use a small brush and a fairly dry mix of White Gouache tinted with Burnt Umber and Indigo. These may seem a minor detail, but they play an important part in giving the tree a three dimensional feel.

4 There are considerable variations of tone and color in the leaf masses. Build up the darkest tone on the lower edges with a mix of Brown Madder and Winsor Red, and then add further accents of Winsor Red alone where needed.

Acer saccharum

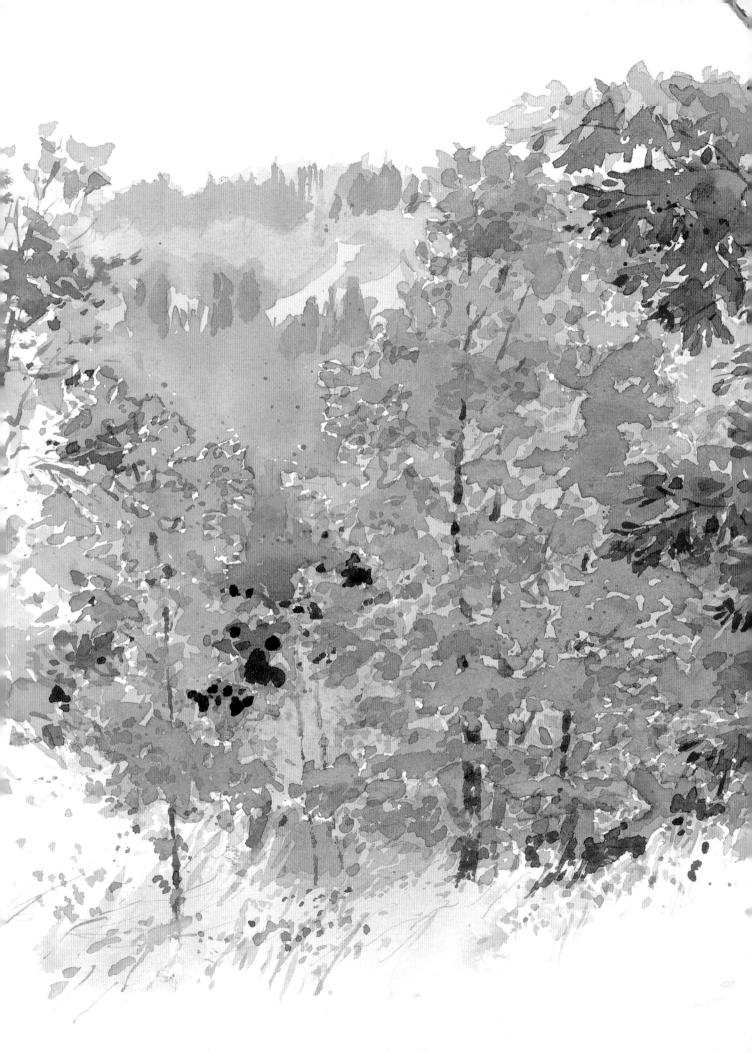

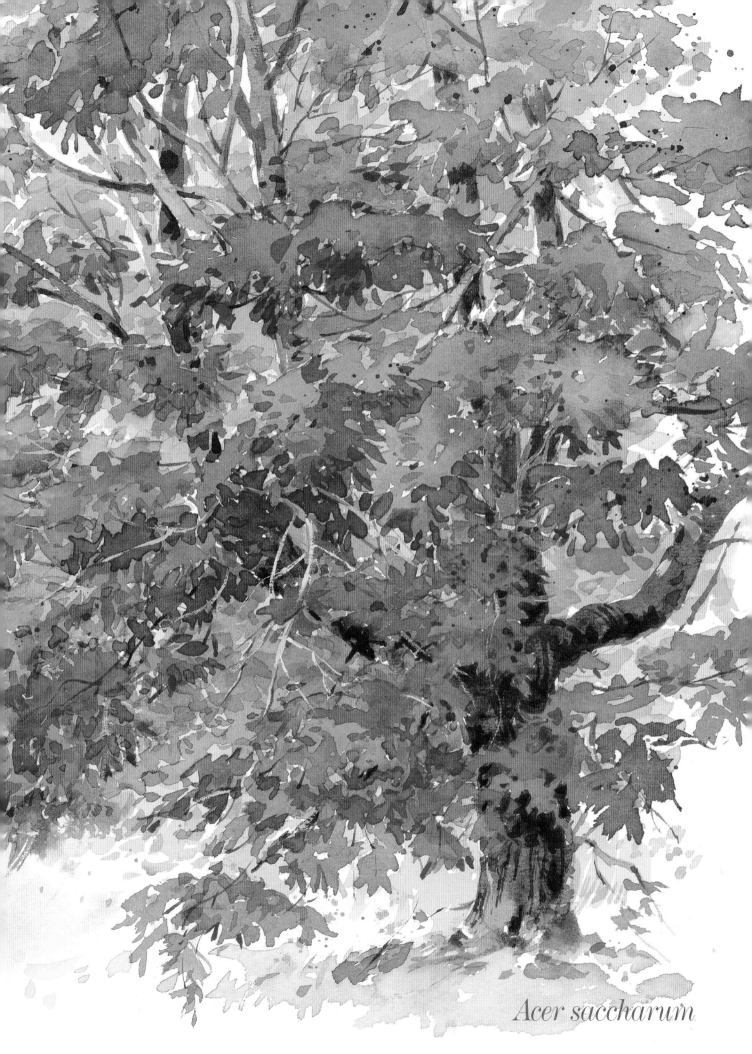

Acer saccharum

Aesculus hippocastanum Horse Chestnut

These magnificent trees were brought to the West from Turkey and northern Greece in the sixteenth century. The billowing form of the mature tree is impressive throughout the summer, but its true glory is seen in the springtime, when it produces a wonderful display of candelabra-like, snowy white – or sometimes pink – blossoms on its arching branches. It is also admired for its foliage; the large, sticky brown buds open into huge-fingered, dark green leaves, which turn yellow and gold in autumn. It is then that the fruit ripens from pale green spiky husks, into dark brown spheres holding one or more glossy, chestnut-colored seeds.

sequence start to finish

1 Sketch in the basic shapes and then mask out the conical blossoms. Notice how they follow the leaf masses, and also how they appear larger toward the bottom of the tree, and smaller and closer together at the top and sides where they recede. Spatter some masking fluid onto the lower grass strip, and then begin to paint the sky, first wetting the area with clear water. Paint a graded wash of Cobalt Blue, and then lift out (see LIFTING OUT) cloud shapes with a tissue. With the paper still damp, paint in cloud shadows with a mix of Dioxazine Violet, Burnt Sienna,

and French Ultramarine. While the sky is drying, wash in parts of the foreground with a Raw Sienna and Green Gold mix, adding Cobalt Blue as the land recedes toward the trees. Paint these trees very simply, working wet-in-wet as follows. Damp the whole area, allow to dry a little, and then drop in Raw Sienna, Hooker's Green, Transparent Yellow, and French Ultramarine. Tip the board to make the paint flow downward, then leave tilted to blend and dry.

2 Now begin to paint the tree, starting with the lightest areas, and keeping the masses simple. Look for the leaf clumps and analyze how they are affected by the light, coming from top right. Mix Hooker's Green and Green Gold, softened with a touch of Raw Sienna, and work from the right side to the center, using a stronger mix as you reach the left side. Stipple (see BRUSHWORK) the edges of the tree, and before it has fully dried, drop in a mid-toned mix of Hooker's Green and a little Burnt Umber. Allow to dry a little more, then paint in a darker tone above the

special detail clump forming

1 *Sketch the top of each leaf mass, noting the direction of the light, and masking out the blossoms. Lay a watery mid-toned mix of Hooker's Green, Green Gold, and a little Raw Sienna and make simple leaf strokes.*

2 *When the paper has only just lost its shine, apply a slightly darker tone than previously of Hooker's Green with touch of Burnt Umber on the underside of each clump, allowing the colors to blend a little.*

3 *Let the previous color dry slightly, but not completely, before working into it with a third tone – a stronger, darker mix of the same colors. Allow to dry completely before rubbing off the masking.*

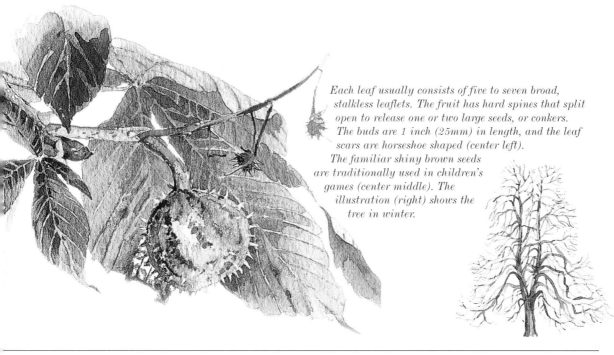

Each leaf usually consists of five to seven broad, stalkless leaflets. The fruit has hard spines that split open to release one or two large seeds, or conkers. The buds are 1 inch (25mm) in length, and the leaf scars are horseshoe shaped (center left). The familiar shiny brown seeds are traditionally used in children's games (center middle). The illustration (right) shows the tree in winter.

Cobalt Blue

Transparent Yellow

Raw Sienna

Green Gold

Raw Umber

Burnt Sienna

French Ultramarine

Hooker's Green

Burnt Umber

Dioxazine Violet

curves of the foliage clumps, reserving some of the previous washes for the light-struck tops, and concentrating on the shaded left side. Allow to dry.

3 Rub off the masking on the tree blossoms. On the right side, where the light strikes, they largely retain their white, but they are slightly darker at the base, so dab in a little Raw Umber to give them form. Tint those in deepest shadow – in the clump recesses and on the far left – with mid-toned leaf colors, and when dry, wash over them with mid-toned Raw Umber, leaving some of the green tones showing here and there, and using paler tones at the top.

4 Paint in distant horse chestnut on the left, keeping it cooler in color and less detailed and hard-edged. Use the same greens as for the main tree, but with Cobalt Blue and more water added, and tilt the board to encourage the colors to flow into one another. Add the trunk with a mix of Burnt Umber and the foliage colors.

5 Now return to the main tree to complete it, but avoid too much fussy detail. Dab in the darkest leaves with strong Hooker's Green and Burnt Umber, then paint the trunk with Burnt Umber added to the leaf greens, strengthening the tone at the top.

6 Finally, touch in the smaller blossoms on the distant left tree, using White Gouache tinted with Hooker's Green and Raw Umber, and paint the cows with two or three tones of Burnt Umber mixed with French Ultramarine. Add the cast shadow from the tree, and darken the foreground grass with the foliage greens. When dry, rub off the spots of masking on the grass, and tint with Transparent Yellow and a touch of Burnt Sienna to suggest buttercups.

4 *Using a fine brush, tint the white blossoms with mixes of the leaf colors plus Raw Umber, using mid-tones for those in shadow. To preserve the form of the tree, concentrate the darkest shadows on the left side of the tree.*

Aesculus hippocastanum

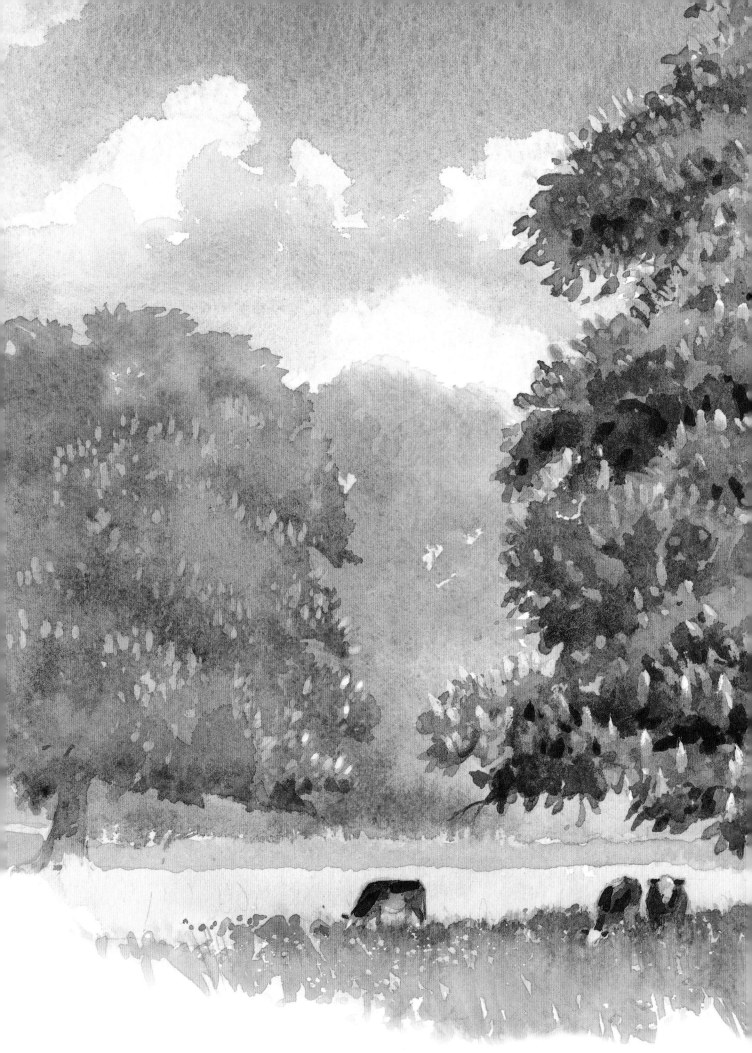

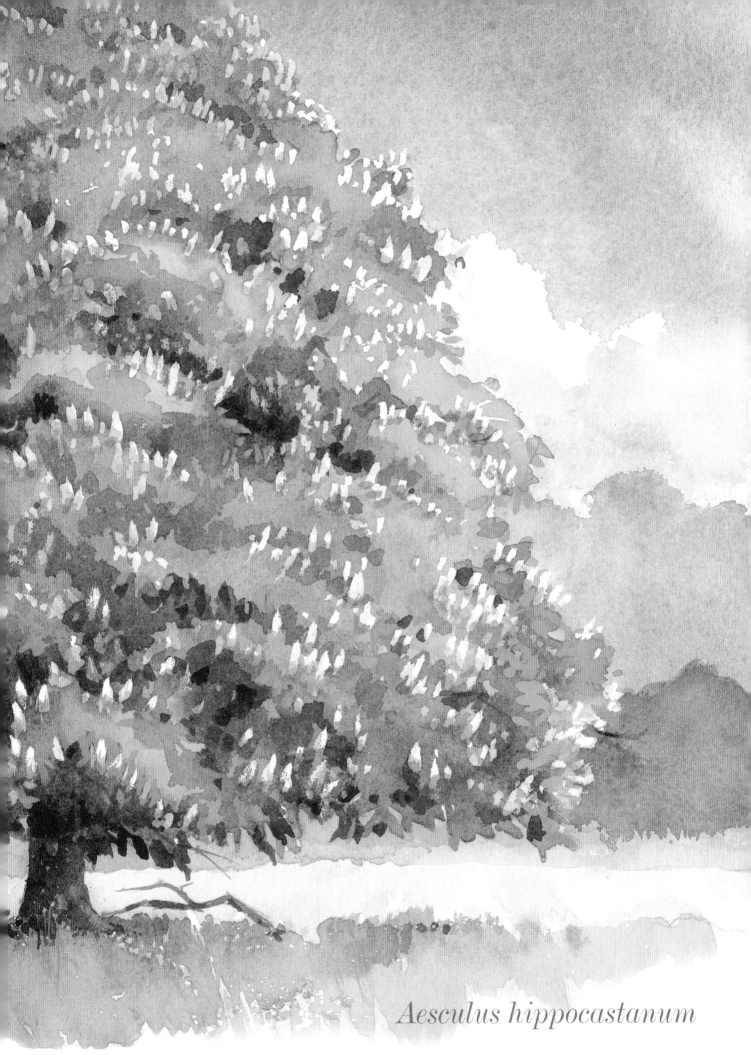

Aesculus hippocastanum

Betula pendula Silver Birch

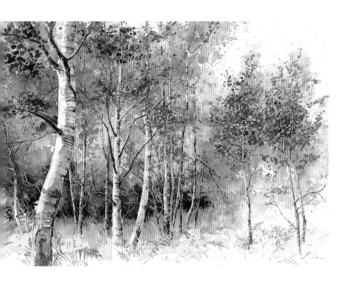

The European silver birch is a slender, lightly branched, thin-twigged tree, which colonizes open land, often at the edges of woods or forests. The trunk has silvery-white bark with thin, dark, horizontal markings, and some older trees also have black diamond-shaped ridges placed low down on the trunk. It is this distinctive patterning that makes these trees such an exciting subject, and they offer attractions in all seasons. In winter the trunks and branches are seen to advantage; in spring the long catkins appear on bare branches; in early summer the canopy of pale green leaves appears; and in the autumn the leaves turn the purest gold of any tree. Unlike larger trees, such as horse chestnuts or oaks, these delicate trees usually need to be treated as a mass rather than as individuals, so be aware of the abstract patterns formed by the interplay of negative and positive shapes.

sequence start to finish

1 When massed together, trees in full foliage seem to merge, so analyze the structure of the subject when making the initial drawing. Before putting on color, mask out the smaller trunks and the main branches, breaking up the shapes where leaves appear in front of them. Make a pale yellow-green mix of Raw Sienna and Green Gold, and lay a wash over all of the foliage with a large, well-loaded round brush. Stipple (see BRUSHWORK) the outside edges of the trees on the top right edge, and take the color down into the lower foreground where ferns are growing. While still wet, add texture by spattering (see TEXTURING METHODS) with slightly darker colors made up from Sap Green, Burnt Sienna, and Green Gold. Allow the colors to merge a little, and allow to dry.

2 Paint the strip of dark woodland above the grass and ferns next. Partially wet the area, and then drop in mixes of Phthalo Green and Burnt Umber. As these colors begin to dry, drop in still darker spots of the same mix and allow to blend a little. Lightly indicate a few foreground ferns with the same colors, using a small brush or a rigger (see BRUSHWORK), then dot in some foliage on the three young trees to the right. Allow to dry.

3 Rub off all the masking, and then start to paint the largest trunk. Use a pale mix of Raw Umber, Burnt Sienna, and a touch of Indigo to begin to describe the curved linear markings, most prominent on the shadowed right side. When dry, take a wash of watery Indigo and Dioxazine Violet down the right-hand side, and before this has fully dried, reinforce the bark pattern by stroking in the lines with a small brush, and a very dark mix of Burnt Umber and Indigo. Paint the other trunks in a similar way, but first knock back the white on those farthest away with a pale wash of Raw Umber and Burnt Sienna to make them recede.

special detail light against dark

1 *After drawing in the four trunks and some twigs, use masking fluid to mask off the three smaller ones, together with the wispy twigs and the light left side of the main trunk. Lay in a pale wash of Raw Sienna and Green Gold over everything except the shaded right side of the main trunk.*

2 *Analyze carefully the contrast and the patterns made by the middle and dark tones that are in the background. When you are absolutely sure of where to place the darks, add Sap Green to the previous mixture and drop a stronger mix into the still-damp wash. Allow to dry.*

3 *Next wet the area and add some mid-toned shapes behind the trunks. Drop in different mixes of Phthalo Green and Burnt Umber. When dry, rub off all the masking. Paint the main trunk by showing the textured bands with pale mixes of Raw Umber, Burnt Sienna, and touches of Indigo.*

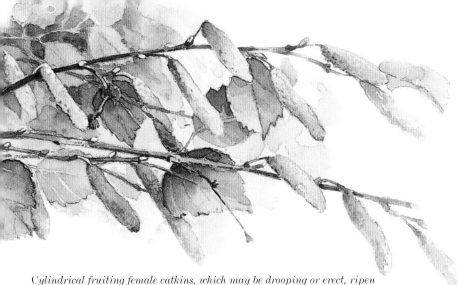

Cylindrical fruiting female catkins, which may be drooping or erect, ripen brown. The leaves are toothed and diamond shaped (above). The white bark, which shreds off in papery flakes, has thin horizontal markings and large diamond-shaped cracks on mature trees (center left). The pendulous male catkin droops from the tip of the shoot (center below). The tree in winter (right).

Raw Sienna

Green Gold

Sap Green

Burnt Sienna

Phthalo Green

Burnt Umber

Raw Umber

Indigo

Dioxazine Violet

4 Before painting in the dark branches, stipple in some darker leaves, starting with those in the background, and using mid-toned mixes of Raw Sienna, Sap Green, and Burnt Sienna. Then paint in the darkest leaves on the main tree with a strong mix of Phthalo Green and Burnt Umber to bring the tree forward in space. Tint any small branches on background trees that were previously masked out with various shades of mid-toned greens.

5 Now work on the branches and twigs, using a very dark mix of Burnt Umber and Indigo for the nearest ones, and a paler one for those that are in the background. Take care to reserve some of the white paper, especially on the three foreground trees, which need to stand out well.

6 The painting now needs only a couple of finishing touches. To give the three foreground trees more emphasis, use a sharp blade to scratch out (see SCRATCHING OUT) any white details lost in the painting, such as curved linear lines and odd spots of white down either side of the trunks. Finally, use White Gouache tinted with Green Gold to stipple a few leaves on areas that appear a little too dense or flat.

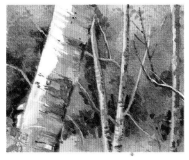

4 Before the paint has dried, put in the dark markings round the trunk with a strong mix of Burnt Umber and Indigo, with accents of dark Indigo. Paint a few dark greens in the background with Phthalo Green and Burnt Umber. Finish off the three small trunks with Burnt Umber.

Betula pendula

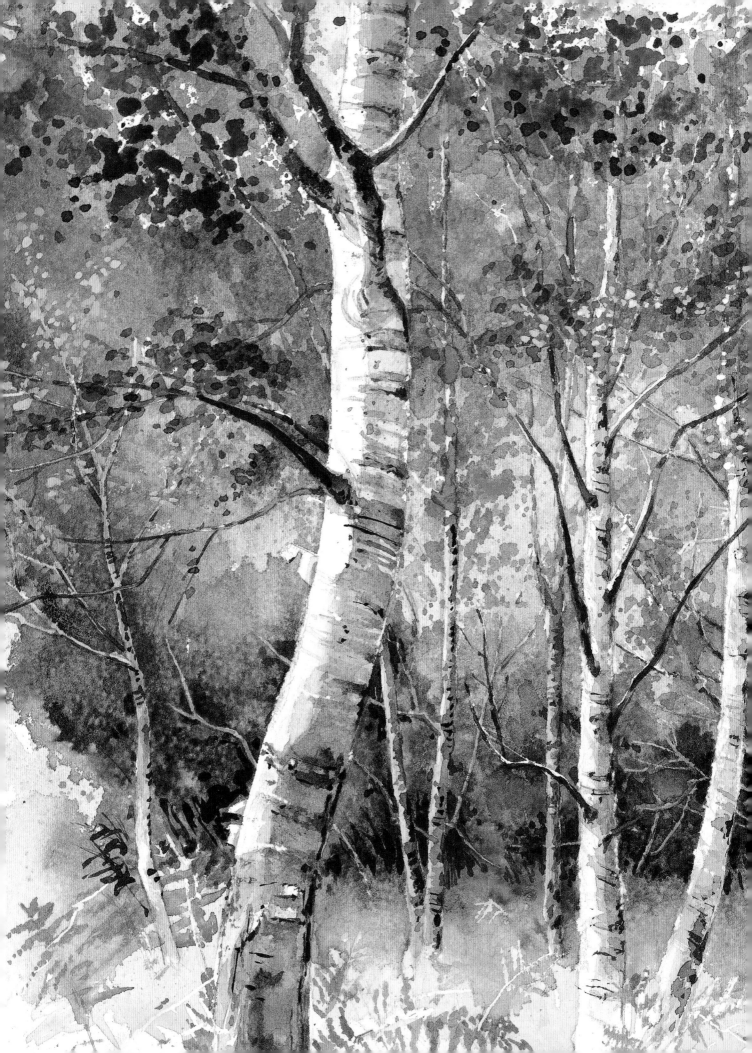

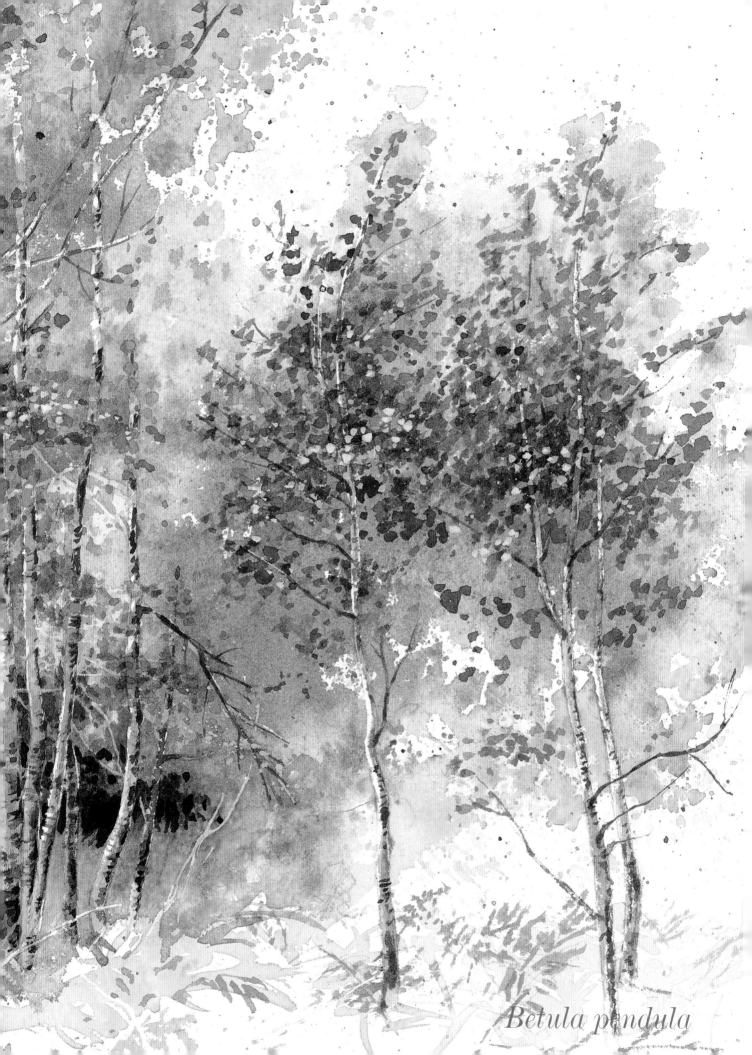

Betula pendula

Callistemon subulatus Dwarf Bottlebrush

This tree is a native of south-east Australia, and usually grows in moist habitats. It is a small evergreen with long, slender, rather arching stems clothed in hard, narrow, dark green, pointed leaves, which are often bronze colored when young. It looks very exotic in the summer, with its masses of heavy-looking crimson flower-heads set against the delicate, spiky foliage. Close inspection reveals that each of the flower clusters consists of several small-petaled flowers with numerous long stamens. These radiate around the stem, giving it the unusual appearance from which it takes its name of "bottlebrush." Study the varying textures and foliage patterns carefully so that you can emphasize its special characteristics.

sequence start to finish

1 Sketch in the two trees, and some of the spiky leaves in the near foreground to give yourself a guide for the shapes, then mask out (see MASKING) a few thin branches and leaves on the left main tree to keep their edges crisp and clear. Next, lay on a variegated background wash (see VARIEGATED WASH). Wet the whole of the paper with clear water, and then, starting at top left, flood in a wash of quite strong Phthalo Blue, gradually grading to Transparent Yellow on the left, and watering the colors down toward the lower edge of the composition. With the wash still damp, use a tissue to lift out some of the main flower shapes on

both trees, and then immediately dab some Quinacridone Red into these white shapes, letting the color soften a little into the wash. Allow to dry.

2 Begin painting some leaves on the left-hand tree, starting with the palest ones. Use a fine pointed brush and various warm and cool mixes (see COLOR MIXING) of Transparent Yellow, Hooker's Green, and Phthalo Blue. Mass the brushstrokes closer together at the top of the tree, but indicate individual leaves at the outer edges. Allow to dry, and then paint in the main trunk with a mix of Dioxazine Violet and Hooker's Green with a touch of Quinacridone Red, weaving the strokes between the

leaves. Paint the thin twigs in the same way, and allow to dry again before painting in more leaves and small negative shapes (see NEGATIVE PAINTING) with a mid-toned blue-green mix.

3 Now start on the smaller right-hand tree, working in the same way but avoiding too much tonal contrast. As you build up the leaves, consider whether you need a warm or a cool green, and vary the mixes accordingly, using a basic palette of Quinacridone Gold, Hooker's Green, and Phthalo Blue (the more blue that you add, the cooler the color will be). Again, keep the brushstrokes simple and in some areas mass them together. Now return to the

special detail varying the greens and reds

 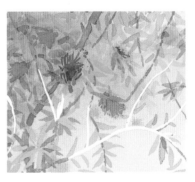

1 *Sketch in the trunk and branches, masking the areas you wish to keep light. Wet the whole area, then lay in a variegated wash of Phthalo Blue and Transparent Yellow and allow the colors to merge. These base colors will affect the leaf greens laid on top.*

2 *With the wash still damp, lift out the blossom with tissue, and brush in Quinacridone Red. Dot in smaller spots of the red for the more distant flowers, allow to dry, and then start painting the leaves, using just one brushstroke for each leaf.*

3 *Continue building up the leaf masses, varying the colors from mid-toned blue-greens to more yellow-green shades. Paint in some small negative shapes behind the leaves in places, mostly at top left. Add more detail with strong Quinacridone Red.*

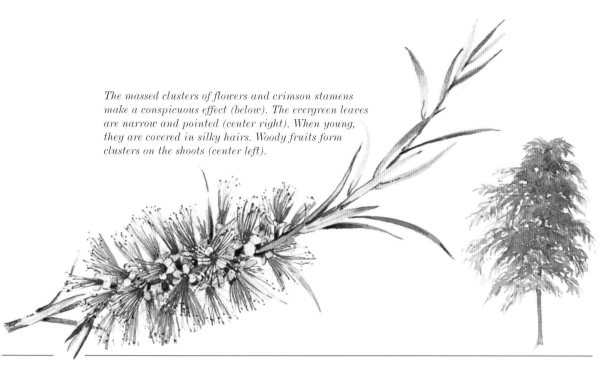

The massed clusters of flowers and crimson stamens make a conspicuous effect (below). The evergreen leaves are narrow and pointed (center right). When young, they are covered in silky hairs. Woody fruits form clusters on the shoots (center left).

Phthalo Blue

Transparent Yellow

Hooker's Green

Quinacridone Gold

Quinacridone Red

Dioxazine Violet

Indigo

left-hand tree and add some definition to the flowers, using short, feathery strokes and Quinacridone Red, darkened in places by the addition of Dioxazine Violet. Don't give all the flowers equal emphasis; leave some of them rather vague so that they recede. Allow to dry fully, and then rub off the masking.

4 Finish this main tree by adjusting the leaf tones and adding small dark accents here and there with Indigo. Then use a small brush to tint parts of the thin white branches with pale Quinacridone Gold, and add the final darks to the trunk and twigs with mixes of Dioxazine Violet and Quinacridone Gold. With the same

colors, dot in a series of small spots for the fruit (the remains of the flowers) seen periodically along some of the twigs.

5 Complete the right-hand tree. Strengthen the trunk in places with mixes of Indigo and Hooker's Green, warming the color toward the top by adding Quinacridone Gold. Paint in accent leaves, concentrating the darks around the center of the tree and on the forward-thrusting branch. Finish the flowers with a more orangey mix than on the left tree, using Quinacridone Red and Transparent Yellow, then dot in small negative shapes amongst the leaves to suggest partly hidden flowers.

6 Finally, paint in the sword-like leaves in the immediate foreground. It is important not to give these too much emphasis, so paint wet-in-wet (see WET-IN-WET) with watery mixes of Phthalo Blue and Quinacridone Gold, letting the colors merge gently.

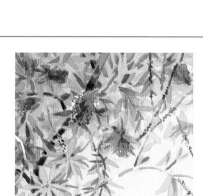

4 Finally, add some dark accents, and tint the white branches with Quinacridone Gold. Paint in the darkest markings on the trunk, and then on the dried flower remains with mixes of Dioxazine Violet and Quinacridone Gold.

Callistemon subulatus

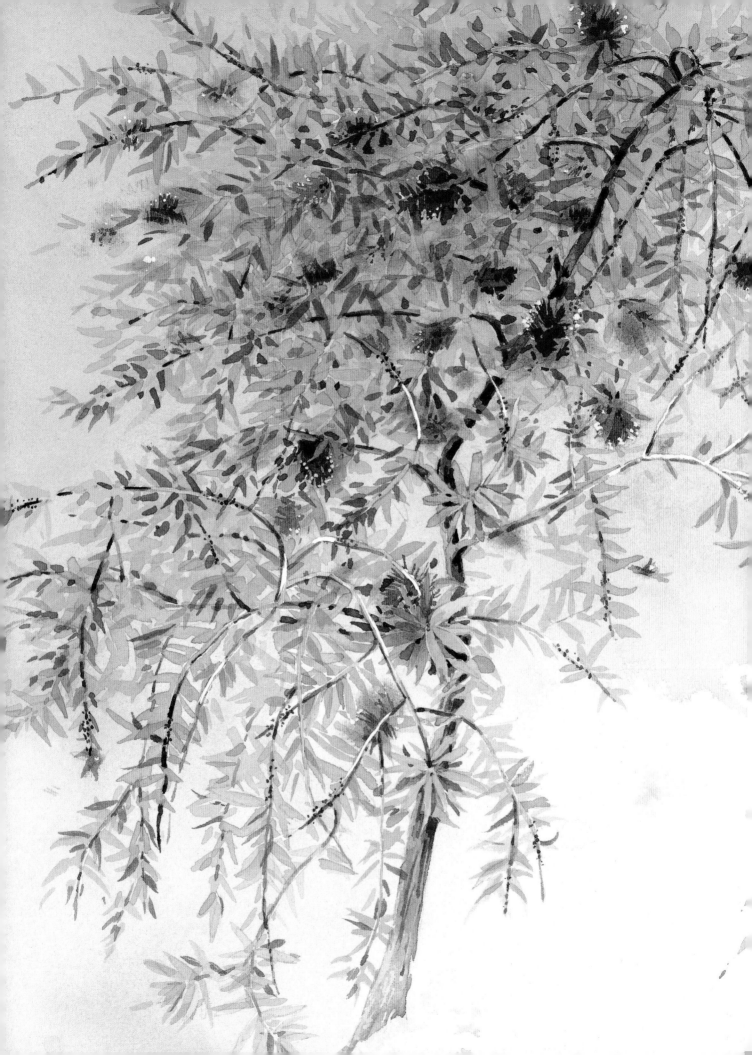

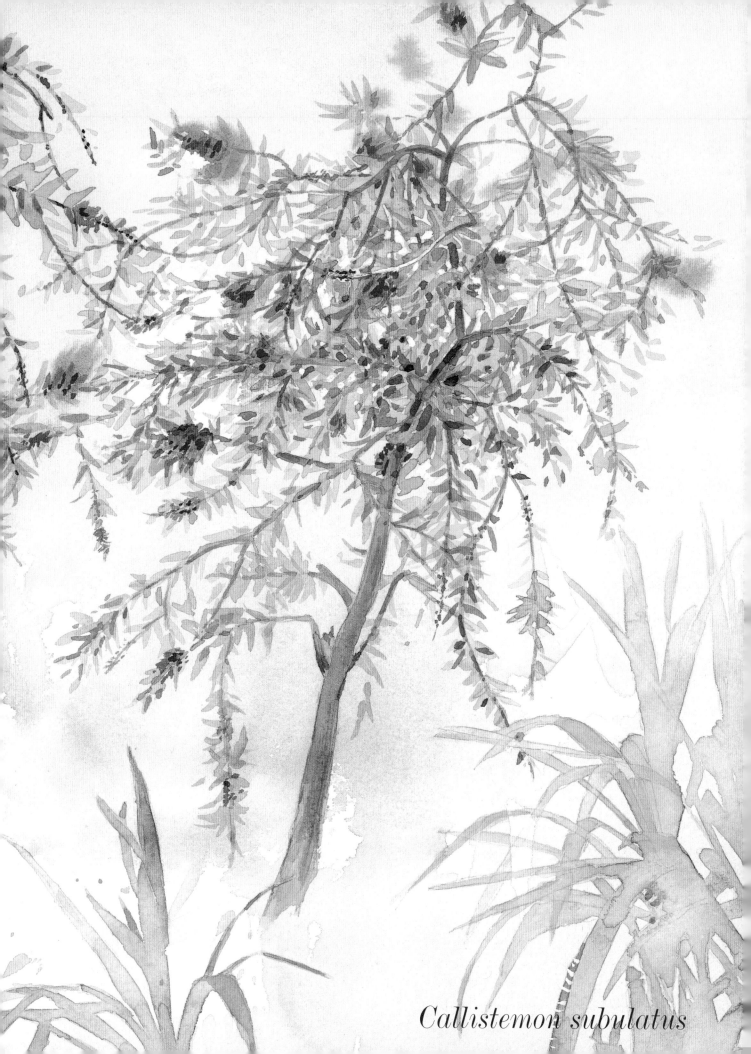

Callistemon subulatus

Cocos nucifera Coconut Palm

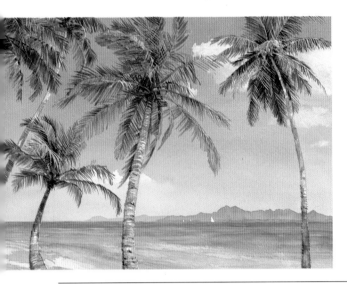

The coconut palm needs heat and moisture to survive, and thus grows only in frost-free regions. It is a wonderfully stately tree, typically seen on beaches, with its curving trunk inclined toward the surf over a dazzling expanse of white sand. It has no real branches or annual growth rings, and grows taller without increasing in girth. All the pinnate leaves are produced from the top of the stem from a single growing point in the center of the crown, or palm heart, and they encircle the trunk, adding to the tree's height. The thick husk of the fruit is used in coir rope production, and the nut itself has an important role in the cuisines of the regions in which it grows.

These palms make an enticing painting subject, although the feather-shaped leaves, typically seen gently swaying in the breeze, demand sure brushwork.

sequence start to finish

1 Sketch in the palm trunks, tapering their width at the top to give a hint of their height and the perspective effect created by their outward-leaning habit. The sky is painted first, so indicate the positions of the palm fronds, and mask out (see MASKING) any that will appear light against dark. Also mask out the sails and the trunks. Wet the paper with a clean brush, then tilt the board away from you, and use a large flat brush to lay a graded wash (see GRADED WASH), starting at the horizon with watery Phthalo Blue, and increasing the strength of the color as you paint toward the top edge. Add a touch of Dioxazine Violet to make a warmer, mid-toned shade at the top. Keep the paper slightly tipped up, and immediately lift out the fluffy white clouds with dry tissue. Allow to dry.

2 Using the sky colors with a touch of Naples Yellow, paint the sea by dry-brushing (see BRUSHWORK) long, horizontal strokes across the area. Still using the flat brush, brush in the sandy foreground with pale Naples Yellow, allowing it to overlap, and merge with the edge of the sea. When this is dry, paint in the darker horizontal line at the horizon with the sky colors, then leave to dry again.

3 The feather-shaped leaves are painted next, with mixes of Phthalo Blue and Green Gold, Phthalo Blue and Quinacridone Gold, and Indigo and Green Gold for the darkest. Use a No. 8 round brush with a good point, and taper the brushstrokes, working outward to the ends of the leaflets. Try to vary the strokes in order to give the impression of the different angles of the leaves, and weave the colors in and out of each other. When these first

special detail one-stroke brushmarks

1 *Each delicate leaflet must be painted with a single stroke. The brush is held almost vertically, and loaded with a precise quantity of pigment. Mask off the light-catching leaflets and the central trunk, and paint the sky with a graded wash of watery Phthalo Blue.*

2 *The pressure of the brush can be varied to make each stroke describe the shape. Starting at the central rib, place the tip of brush firmly on the paper and pull it down toward the edge, lifting it gently to finish. Let some strokes cross over others, and paint some leaflets in reverse.*

3 *When dry, paint in the darker leaflets with Dioxazine Violet to build up a range of tones and create a feeling of depth. Continue to regulate the pressure as you work. When dry rub off the masking and tint the leaflets with various mixes of Green Gold and Indigo.*

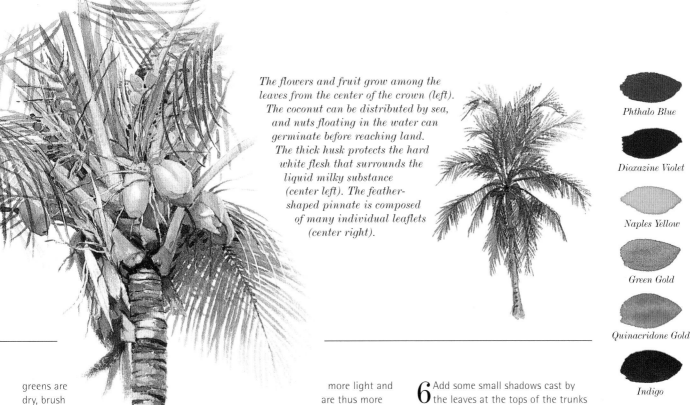

The flowers and fruit grow among the leaves from the center of the crown (left). The coconut can be distributed by sea, and nuts floating in the water can germinate before reaching land. The thick husk protects the hard white flesh that surrounds the liquid milky substance (center left). The feather-shaped pinnate is composed of many individual leaflets (center right).

Phthalo Blue

Dioxazine Violet

Naples Yellow

Green Gold

Quinacridone Gold

Indigo

greens are dry, brush Dioxazine Violet into the shadow areas, especially toward the centers of the palms. Leave to dry again before rubbing off all the masking.

4 Tint the white leaves (those that were masked) with Green Gold, and various mixes of Quinacridone Gold, Green Gold, and Indigo. Note that the light is coming from the right and behind the viewer, so that in general the fronds at fronts of the trees catch more light and are thus more yellow in color. Hint at the coconuts by tinting with Quinacridone Gold.

5 Now work on the trunks, laying on both warm and cool mixes of Quinacridone Gold, Dioxazine Violet, and/or Indigo, darkening those on the left in places. When dry, stroke in faint curved lines on the trunks with darker mixes of the previous colors. Take care to follow the curvature of the trunks and also to observe the effects of perspective – the lines are closer together toward the tops. Allow to dry.

6 Add some small shadows cast by the leaves at the tops of the trunks with a mix of Dioxazine Violet and Indigo, using the same color to build up the details and texture of the bark in places. When dry, paint dabs and curving lines of highlight on the trunks with White Gouache tinted with Naples Yellow. Add a few linear highlights to the leaves and finally, paint the shadows on the sand and the distant land on the horizon with a pale Dioxazine Violet and Indigo mix.

4 Paint the trunks with mixes of Quinacridone Gold, Dioxazine Violet, and Indigo. Allow to dry and add the linear curved markings on the trunks with stronger mixes of the same colors, varying the thickness of the strokes by continuing to regulate the brush pressure.

Cocos nucifera

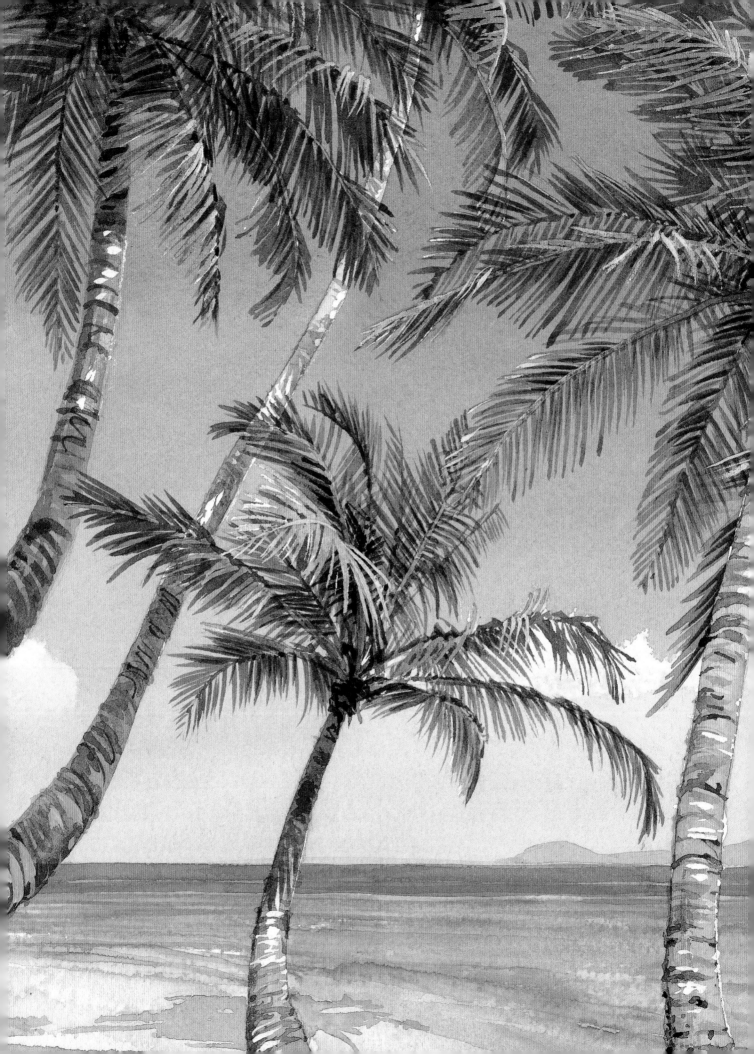

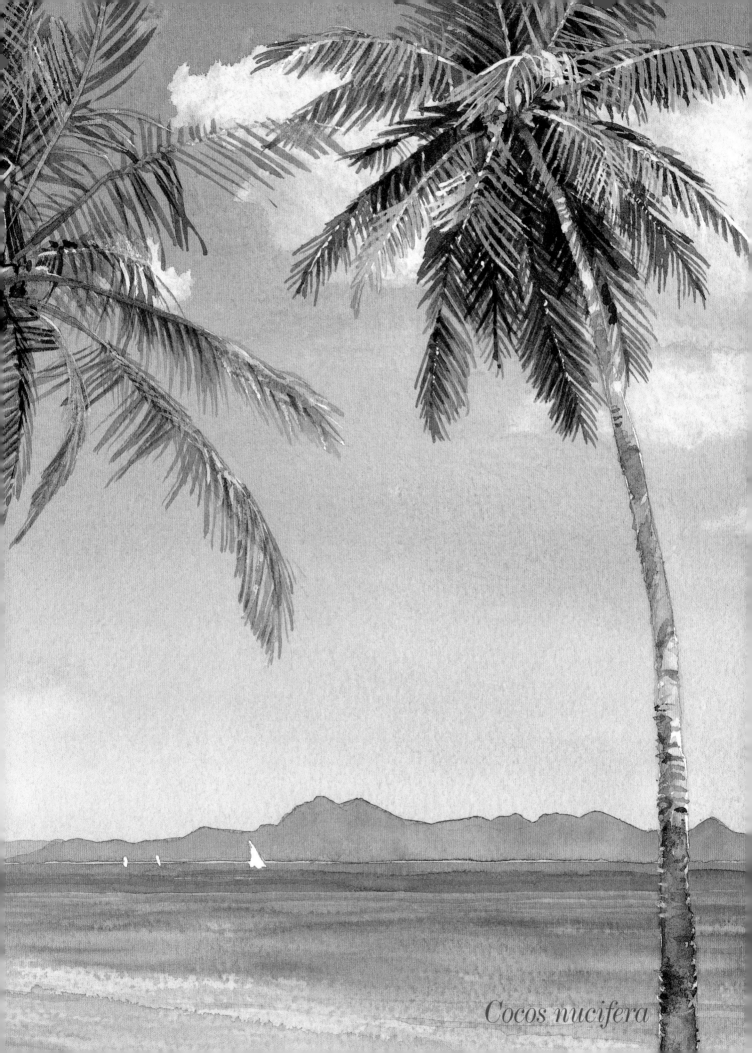

Cocos nucifera

Cupressus sempervirens Italian Cypress

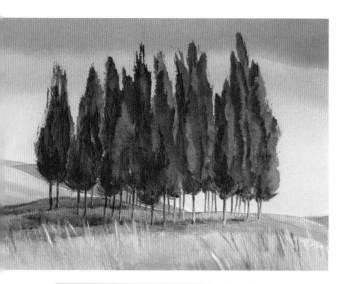

These glossy, dark, candle-like trees, whose natural habitat is the rocky places in the mountains of the Eastern Mediterranean, are a familiar sight in the Italian landscape, which has changed little since the time of Leonardo da Vinci and Michelangelo. They are also much seen in Italian-style gardens, where their unique formality sets off Classical architecture to perfection. There is no columnar tree more imposing; sometimes towering up to 165 feet (50 meters) high, a group of these splendid trees seen alone against a skyline or appearing as exclamation marks in a wide landscape can make exciting painting subjects. You will need to emphasize the bold, simple silhouettes, but at the same time find ways of creating interest in their repetition by observing the subtle differences of shape, size, and color.

sequence start to finish

1 After making the drawing, wet all of the paper with clean water and lay a variegated wash. Cold-pressed (Not surface) paper is used here, but you could try a Rough paper (see PAPER). Start at the top edge with a large flat brush and mid-toned Phthalo Blue, and paint down to the horizon line. Immediately go in with a stronger mix of Phthalo Blue and Dioxazine Violet at the top edge, making broad strokes, and then add a darker mix of the same colors to paint a band at the top of the sky, so that it now has three tones of blue. Then lay a wash of fairly strong Quinacridone Gold from the bottom of paper over the land area. Let the two colors blend at the skyline on the left, but try to keep them separate from the center to the right. Stroke in strong Burnt Sienna over the land at the lower edge and let it merge. Allow to dry.

2 Before painting the trees, brush in the distant hills with a mix of Phthalo Blue and Dioxazine Violet. Allow to dry again. The light is coming from the right, so the trees on this side show more modeling, with three distinct tones, than those on the left, which are more in the shade. This adds variety, and the tree textures can also be exaggerated. Start painting the tree on the right, using the dry-brush technique (see BRUSHWORK, and below), and a mix of Phthalo Green and Burnt Sienna, feathering the strokes lightly upward from the base of the foliage to give a lively and irregular edge.

3 Now indicate some of the mid-toned greens, working into the still-damp first colors with a stronger mix of Phthalo Green and Burnt Sienna. Brush in the darkest tone with a strong mix of Phthalo Green and Burnt Umber, and lightly feather in some wispy marks at the bottom of the foliage shapes where they meet the trunks. Allow to dry.

special detail adding interest to simple forms

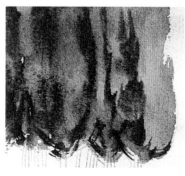

1 *A composition of very simple shapes can become monotonous and dull. Here the conical trees need variety to break up the stark lines, so look for variations in the outlines and the different negative shapes made by the spaces between the trees.*

2 *Emphasizing texture also adds interest. The foliage textures here are created with a dry-brush technique (see BRUSHWORK). Load a large round brush, and drag the side over the paper. Use short, light strokes so the color catches the grain of the paper.*

3 *Add the mid-tones next with a stronger mix of the same colors and a well-loaded brush. Gently stroke the color onto the damp (but not too damp) first layer. Try for an uneven, broken line to suggest shading, and to give a different sort of texture.*

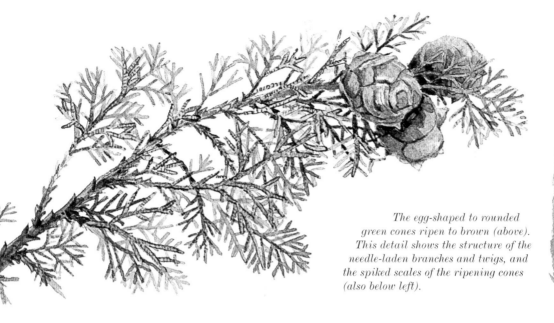

The egg-shaped to rounded green cones ripen to brown (above). This detail shows the structure of the needle-laden branches and twigs, and the spiked scales of the ripening cones (also below left).

Phthalo Blue

Phthalo Green

Quinacridone Gold

Dioxazine Violet

Burnt Sienna

Burnt Umber

New Gamboge

4 The shadows are important, as they form a horizontal counter-balance to the verticals of the trees. Mask out the tree trunks (see MASKING) and, using a ¾ inch flat brush and a mix of New Gamboge and Phthalo Green, start at the right side of the tree group and loosely paint a horizontal band across the paper, following the top of the hill on which the trees stand. Work in Phthalo Blue and Phthalo Green wet-in-wet (see WET-IN-WET) for the shading, and lastly add strong Dioxazine Violet for the deepest shadows.

5 The foreground textures also need to be painted wet-in-wet, so before the colors of the shadows are dry, use the same brush to stroke in a broad strip of New Gamboge and Burnt Sienna into the lower section. Allow to dry a little, until the surface has lost its shine, and then draw some of the cast shadow color into this foreground color. To do this, wash the brush, squeeze out the excess water with your fingers, and use the edge of the brush to move the color. Using the same method, make brushmarks for the grasses from the bottom edge of the foreground up into the cast shadows, cleaning and slightly drying the brush between strokes. Add a few darker accent strokes of dark green with a rigger brush (see BRUSHWORK) and allow to dry.

6 Rub off the masking on the trunk, and use the tree colors (Phthalo Green, Burnt Sienna, and Burnt Umber) to tint and accent the trunks, keeping those on the right lighter. Finally add a very few touches of White Gouache tinted with New Gamboge to add some small highlights to the tree trunks, and dot in a few tiny flowers at the right, under the trees. If needed, use the same mix to emphasize the rough foreground grasses.

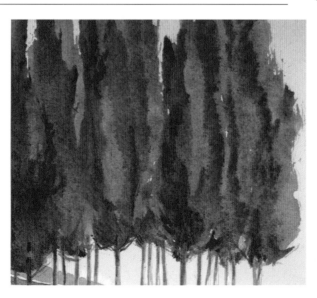

4 To achieve the darkest green, Phthalo Green is enriched with Burnt Umber. Paint in the darkest tones, adding accents where needed. Tint the trunks with Burnt Sienna and Burnt Umber, taking the trunks into the tree a little to reinforce the effect of foliage.

Cupressus sempervirens

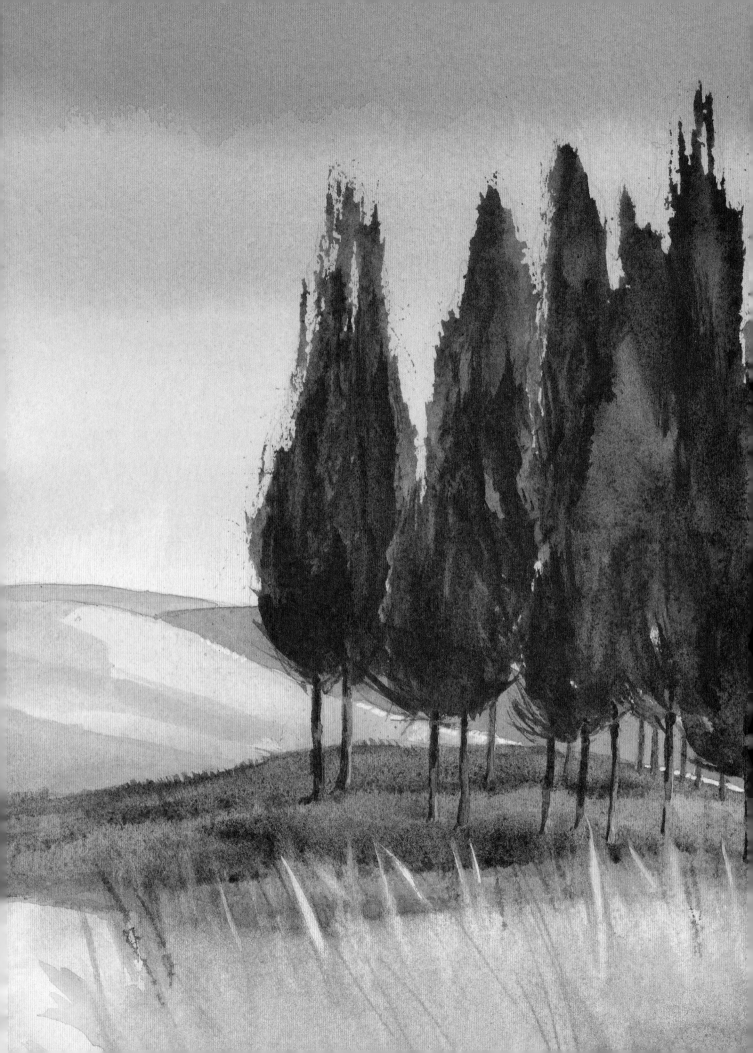

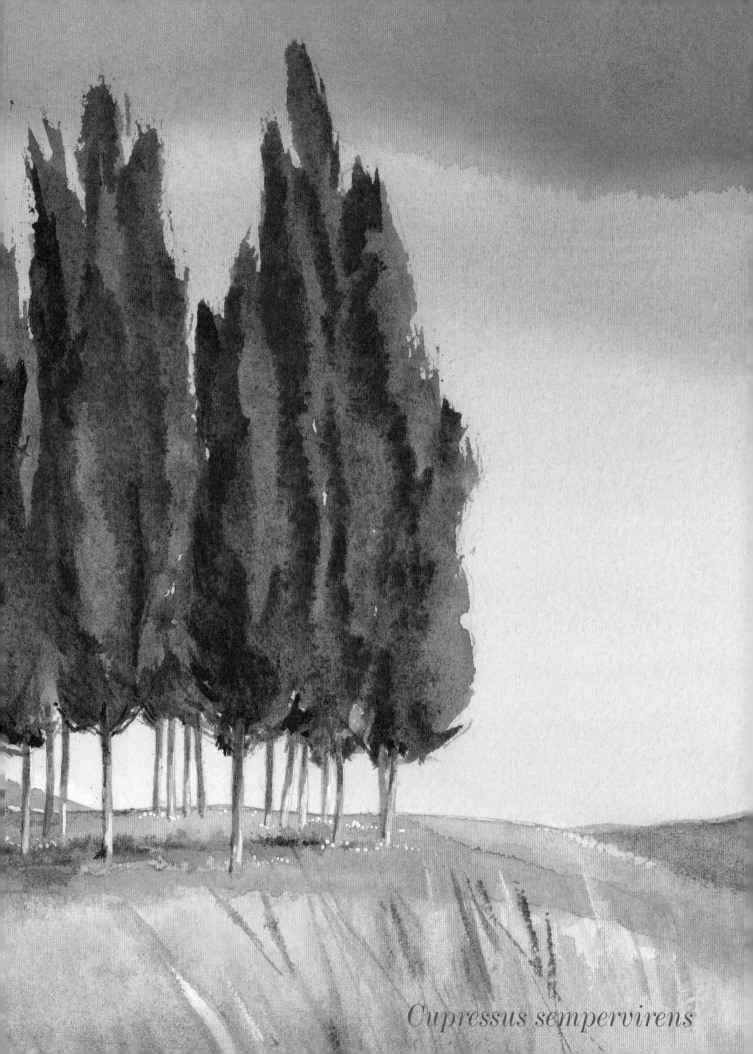

Cupressus sempervirens

Cedrus libani Cedar of Lebanon

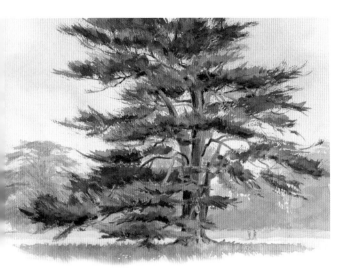

The origins of this noble and dignified evergreen are mysterious. King Solomon is said to have built his temple from the great groves of cedars that still stand on the slopes of Mount Lebanon. Cedars were much prized in England during the eighteenth century, and the famous landscape gardener Lancelot "Capability" Brown used them in many country-house park and garden schemes. The tree is most impressive when fully mature, when the branches leave the trunk almost at right angles, with the lower ones, heavy with needles, sometimes bending downward from their weight. This is a characteristic that needs to be observed when drawing the tree, together with the large horizontal layers of dense foliage, some of which go across the front of the trunk.

sequence start to finish

1 Make a simple drawing, taking particular care over the silhouette and the pattern of the branches, and adding a couple of tiny figures in the middle distance to indicate the scale. Before painting, analyze the varied tones of green, and then begin by applying a very pale sky wash with Alizarin Crimson, grading it down to a bluish shade at the horizon by adding a touch of Cobalt Blue. This hint of red will enhance the greens of the foliage.

Then wash in the land from the horizon with a mix of Green Gold and Raw Sienna, adding some Burnt Sienna wet-in-wet (see WET-IN-WET) at the lower edge. Allow to dry.

2 Paint the distant foliage on the right and behind the distant cedar on the left by rough-brushing (see BRUSHWORK, and below) with a mix of Phthalo Green, Raw Sienna, and Dioxazine Violet. To create distance on the left, omit the Raw Sienna to make the mix bluer. Add the branches while the first brushstrokes are still wet so that they blend in. Allow to dry.

3 The compact needles of the large cedar tree form flattish planes, with colors varying from blue-greens where the sections catch the light, to dark, warm greens for shadows on the undersides of the laden branches, especially those extending out over the ground. To block in the feathery shapes, use mixes of Phthalo Green and Raw Umber, working quickly with short, "whisking" strokes. Before this color has dried, go back into the shapes with a relatively dry brush fully loaded with Phthalo Green and Sepia and carefully dry brush (see DRY BRUSH, and below) the bottoms of the foliage areas. Add a few

special detail dry- and rough-brushing

1 Sketch the simple oval shapes of the foliage clumps – working on slightly textured paper. A Cold-pressed (Not surface) paper (see PAPER) is used here, but you could try a Rough paper to try out the effect of dry-brushing. Wash over the sky with a pale Alizarin Crimson, and allow

2 When painting a strong dark shape like these massed needles, the brushstrokes must be forceful so you need to work quickly and surely. Rough-, dragged-, or dry-brushing is affected by the angle of the brush, the speed of the stroke, and the amount of paint in the brush.

3 Lay in the darker tones on the undersides of the foliage clumps in the same way using a mix of Phthalo Green and Sepia. while still damp put in a few twigs and small branches with a rigger brush (see BRUSHWORK) letting their ends blend into the undersides of the foliage clumps.

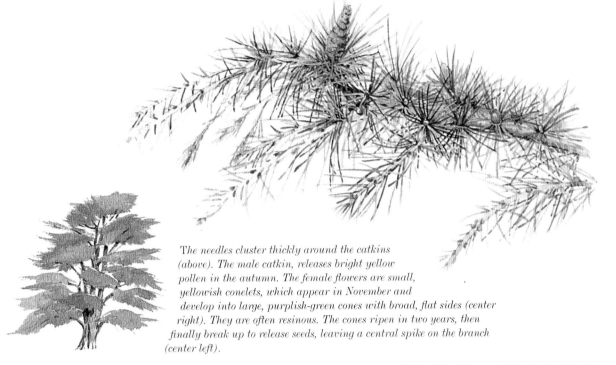

The needles cluster thickly around the catkins (above). The male catkin, releases bright yellow pollen in the autumn. The female flowers are small, yellowish conelets, which appear in November and develop into large, purplish-green cones with broad, flat sides (center right). They are often resinous. The cones ripen in two years, then finally break up to release seeds, leaving a central spike on the branch (center left).

Alizarin Crimson

Cobalt Blue

Green Gold

Burnt Sienna

Raw Sienna

Raw Umber

Phthalo Green

Dioxazine Violet

Sepia

strokes of warm Alizarin Crimson to the darks. To prevent the first brushstrokes drying before you have worked into them, you may need to work on just a few areas of foliage at a time.

4 When everything is dry, paint a wash of Raw Sienna with just a touch of Alizarin Crimson at the base over the trunk. Take this color over the main branches as well. Paint in the smaller branches with the Raw Sienna. Then start to model the trunk and branches with the previous foliage colors plus Dioxazine Violet, noting how some of the branches come forward

and others recede. Some areas of the bark are warm and others cool (see COLOR MIXING), so vary the proportions of the colors in the mixes accordingly.

5 Add the very fine twigs, which are mainly darker on the left side than the right. Use the foliage colors again for these, to unify the whole tree by making color links (see UNITY). When you have completed the main tree, paint the distant cedar on the left by dry-brushing with paler versions of the same colors. Finally, paint in the two figures and the foreground grasses. These are in shade on the left, so here

use a mix of Raw Sienna and Phthalo Green, changing to a mix of Raw Sienna and Burnt Sienna for the area on the right. Keep the edges soft below the trunk to give the impression of it disappearing into the grass. While still damp, dot in shadows with a mix of Dioxazine Violet and Phthalo Green.

4 The abstract foliage masses only begin to make sense when the branches and twigs have been put in place. Paint in the warmer-colored branches, lifting out (see LIFTING OUT) the area where it feeds into the foliage mass. Finally, add a few dark accents to the foliage and branches.

Cedrus libani

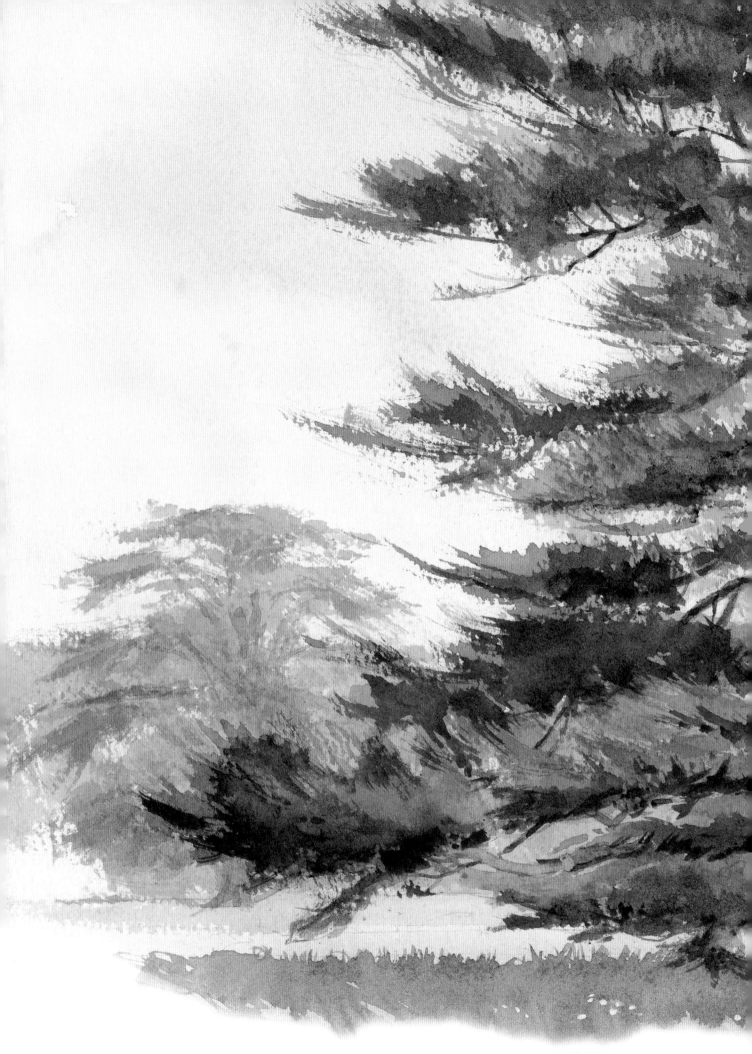

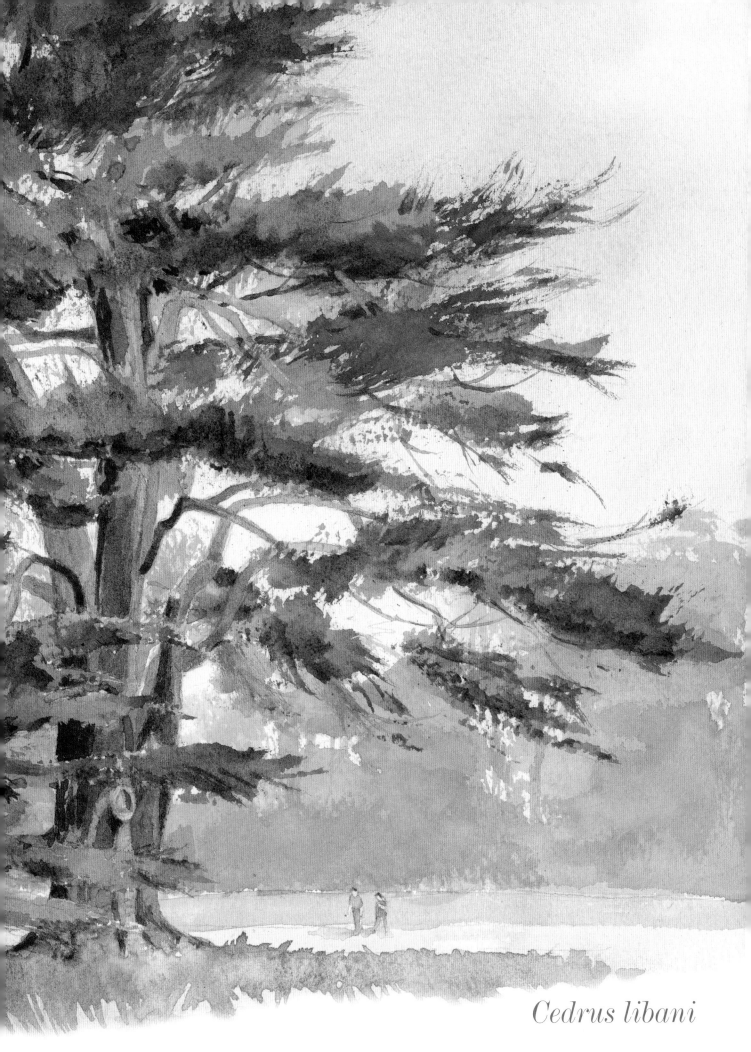

Cedrus libani

Eucalyptus perriniana Spinning Gum

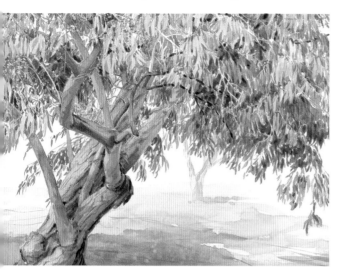

The huge eucalyptus trees that dominate the humid forests of Australia develop into giants up to 325 feet (100 meters) tall. The Australian eucalyptus trees are the main source of food for koala bears as well as providing timber and gum for dyes. They were of special importance to the Aboriginal peoples who pulled up long sections of the woody, underground roots, which provided sap to drink on long journeys across the desert. There are over five hundred varieties of eucalyptus, but all are easily identified by the rough bark, which often peels or flakes away in thin layers to make lovely patterns. The narrow, scimitar-shaped leaves, hanging down vertically and ranging in color from gray-green to blue-green, contribute to the distinctive appearance. They are full of wonderful contrasts, both of color and texture, and make an appealing painting subject.

sequence start to finish

1 The large tree trunk dominates the composition, dividing it diagonally, and it needs to be drawn precisely, with care taken to get the shape and textural details exactly right. Indicate where the lightest leaves are – mostly at the top of the page, with the background leaves in the shade. Then mask out the very fine twigs, and dot in the tiny "gum nuts" that are carried along them.

2 Instead of the traditional method of layering washes from light to dark, paint this tree in a more direct way, starting with the leaves. It can be hard to read the forms of the foliage clumps and achieve the correct subtle colors. Begin by stroking in the shapes of the palest leaves at the top edge, using a large, well-pointed round brush and mixes of Phthalo Green, Quinacridone Magenta, and Raw Sienna. Allow to dry before painting the mid-toned leaves behind the light ones using the previous colors plus French Ultramarine, and Burnt Umber, mixed in various proportions. Mass the leaves together leaving small white specks of paper showing, and then drop in darker tones wet-in-wet (see WET-IN-WET). Allow to dry.

3 The trunk is painted wet-in-wet initially. Use color mixes of Raw Sienna and Quinacridone Magenta for the warmest sections, dropping in Phthalo Green and Phthalo Blue, sometimes while very wet and sometimes when the colors have dried a little so they do not merge as much. Paint all the main branches in the same way; the darkest textures and tones will be applied later.

4 Before taking the trunk and branches to completion, paint in some wet-in-wet foreground. There is not much color in the sandy ground, so use artistic license to add some extra

special detail special effects for texture

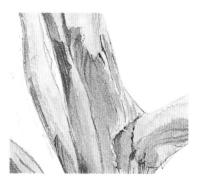

1 *Wet-in-wet is a great technique to use on the color, and textural qualities of the eucalyptus bark. But it is hard to control – if the paper is too wet, the exciting color interactions you see when you lay the paint on may be lost when it has dried.*

2 *Applying a second color to the damp wash and allowing the forms to blur should give a hazy effect. When working on large sections, it is best to paint one area at a time in order to prevent the first colors from drying out too much.*

3 *When the paper has just lost its sheen go in with a strong mix of Phthalo Blue and Burnt Umber; stroking the color to the edges of the pattern elements, and working in the direction of the bark grain. Be ready to capitalize on happy accidents.*

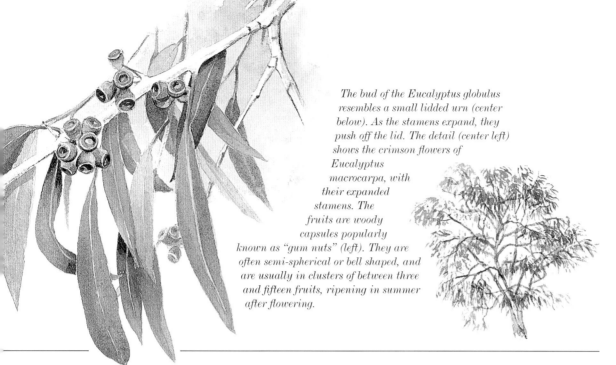

The bud of the Eucalyptus globulus resembles a small lidded urn (center below). As the stamens expand, they push off the lid. The detail (center left) shows the crimson flowers of Eucalyptus macrocarpa, with their expanded stamens. The fruits are woody capsules popularly known as "gum nuts" (left). They are often semi-spherical or bell shaped, and are usually in clusters of between three and fifteen fruits, ripening in summer after flowering.

Raw Sienna

Quinacridone Gold

Burnt Umber

French Ultramarine

Phthalo Green

Phthalo Blue

Sepia

interest in this large area. Lay a pale graded wash mixed from Raw Sienna and Quinacridone Magenta, darkening the mix at the lower edge, and also dropping in darker Quinacridone Magenta, Phthalo Green, and Raw Sienna to blend. Before the wash has fully dried, make some dark, wandering strokes across the whole area with a rigger brush (see BRUSHWORK) to suggest irregularities on the surface.

5 Continue to build up the leaves with mostly vertical brushstrokes and dark-toned mixes of Phthalo Green, Burnt Umber, and French Ultramarine. Keep some areas of leaves light, concentrating the darker accents mainly in the mid-toned masses. Half-close your eyes as you work to help simplify the forms of the foliage clumps.

6 The fine detail on the trunks and branches can now be completed. Mix Phthalo Green, Phthalo Blue, and Sepia, and suggest the flaking bark with a rigger brush and

touches of dry-brush work (see DRY BRUSH), making sure to follow the grain. Paint the branches up into the foliage, weaving the color between the leaves. Allow to dry, rub off the masking, and tint some of the thin twigs with pale Raw Sienna and Burnt Umber, leaving some white. Tint others with pale Phthalo Blue or a dull warm gray mixed from the bark colors. The small "gum nuts" can also be colored with this gray. Finally, paint in the far eucalyptus with very pale versions of the previous colors.

4 Using the rigger brush (see BRUSHMARKS), dot in the knots and fissures with strong Burnt Umber. Allow to dry, and then dry brush some mid-toned dull green-gray, and carefully stroke this same color down the shadow sides.

Eucalyptus perriniana

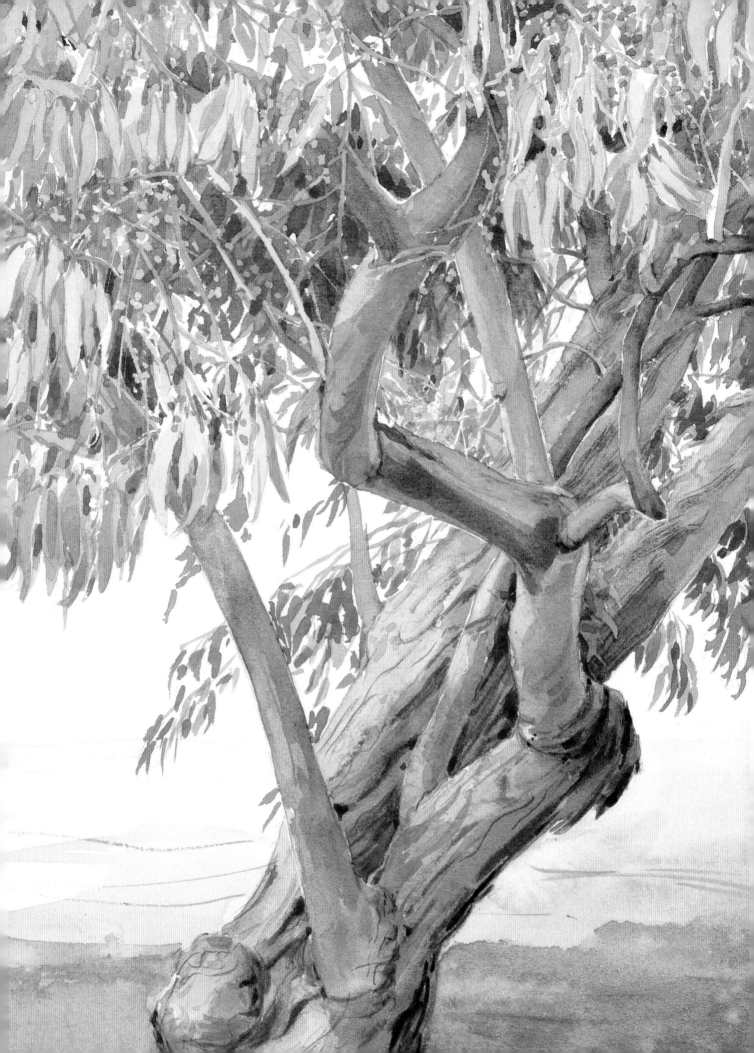

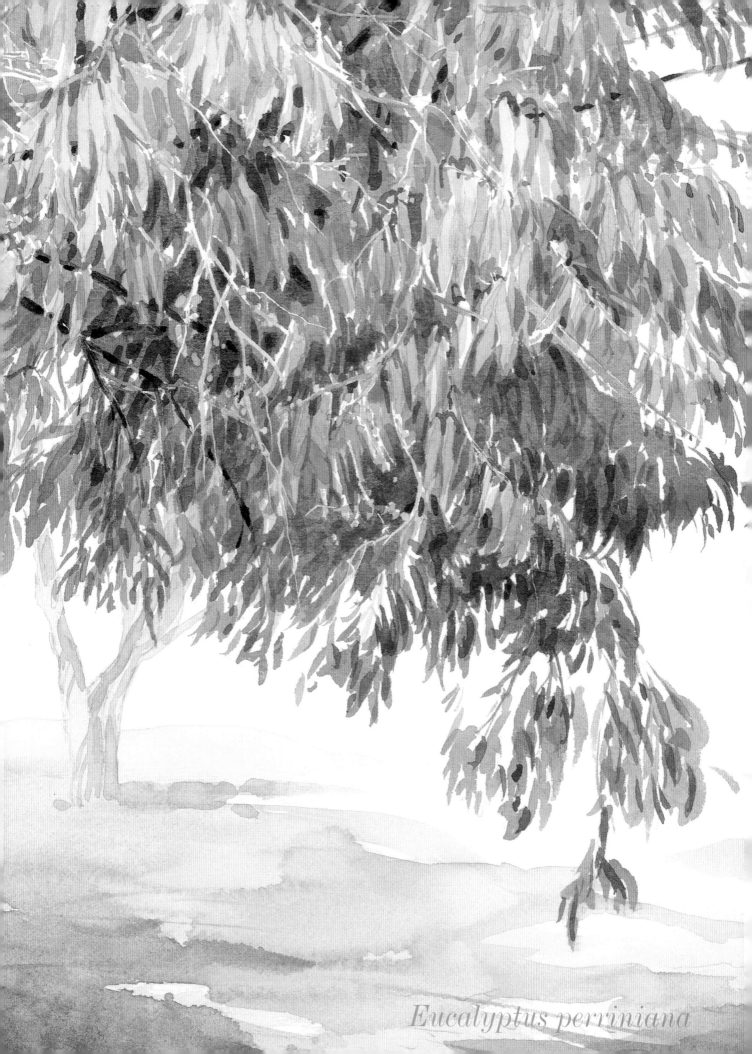

Eucalyptus perriniana

Fagus sylvatica Common Beech

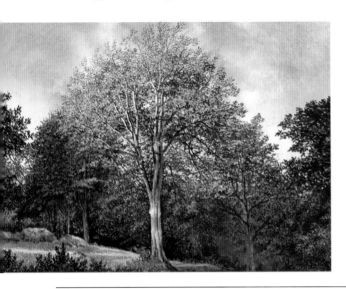

This tall deciduous tree is especially notable for its spreading canopy, and its smooth, silvery-gray bark, which makes it as attractive in winter as in summer and autumn. It grows mainly in woods and on well-drained soils, especially chalk, and is widespread all over Central and Western Europe. The branches are numerous, mainly upright but sometimes arching, and the elliptical oviate leaves, with their characteristic wavy margins, are about 4 inches (10cm) long, and covered with silky hairs when young.

This tree has been painted in early autumn, when the leaves begin to turn to yellow-gold, but still retain a few hints of green. To do justice to the brilliant hues, body color (in this case acrylic) has been used in combination with watercolor to add light to the tree.

sequence start to finish

1 Working on HP (Not surface) paper, draw the composition lightly with a 2B pencil, Try not to erase more than necessary, as this can affect the surface tension of the paper and may show when washes are applied. Paint the sky first, dampening the whole area down to about the halfway mark, and using a large round brush to drop in a mix of Cerulean Blue and French Ultramarine. Immediately lift out (see LIFTING OUT) the clouds with a small sponge or piece of tissue paper.

2 Reinforce the pencil lines on the branches by working over them with a fine, pointed brush and a mix of Vandyke Brown, Neutral Tint, and Burnt Sienna. Start to paint the leaves from the top down, working very carefully and making small strokes with Cadmium Red and Alizarin Crimson, gradually mixing in some Burnt Sienna for the shadows. To build up the form of the tree, paint the branches with the previous brown mix, starting at the outer edges and working inward. There are strong tonal contrasts on the trunk and branches, so leave highlighted areas where the light strikes.

3 Continue to build up the foliage, working from left to right, and using combinations of Lemon and Cadmium Yellow, Indian Yellow, and Yellow Ocher. Make short, stippled strokes, thinking of each brushmark as a single leaf. Paint the right-hand tree with the same colors, adding darks on the main tree with a strong mix of Raw Sienna and a touch of French Ultramarine to separate the two. The main tree is brightly toplit, but stands in shade, so the surrounding foliage needs to be very dark to bring out the vivid orange-yellows. Start to paint this next using strong mixes of Payne's Gray and Cadmium Yellow for the dark greens, and Raw Sienna mixed with Vandyke Brown for the dark greenish-browns. The two trees at the extreme left and right are almost black, so use pure Neutral Tint for these.

special detail light and dark with watercolor and acrylic

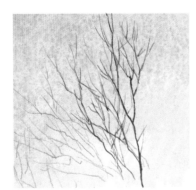

1 The hardest part of watercolor is ensuring that the brilliant highlights are not overworked. This can be done by mixing watercolor with white acrylic. First lay the sky wash, then draw the branches with a fine brush.

2 Begin to paint the leaves, using a slightly larger brush and mixes of Cadmium Red, Alizarin Crimson, and Burnt Sienna. With individual brushstrokes you will be able to weave the lighter yellow around these reds.

3 Continue using similar brushstrokes and mixes of Lemon Yellow, Cadmium Yellow, Indian Yellow, and Yellow Ocher. As you work inwards away from the outer edges, look for the shapes of the foliage.

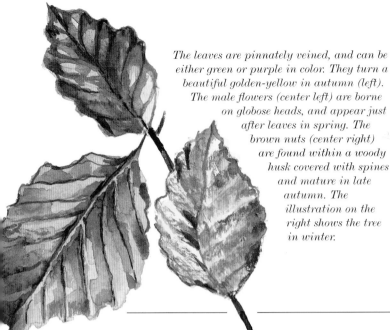

The leaves are pinnately veined, and can be either green or purple in color. They turn a beautiful golden-yellow in autumn (left). The male flowers (center left) are borne on globose heads, and appear just after leaves in spring. The brown nuts (center right) are found within a woody husk covered with spines and mature in late autumn. The illustration on the right shows the tree in winter.

Winsor Violet

Vandyke Brown

Neutral Tint

Payne's Gray

French Ultramarine

Cerulean Blue

Burnt Sienna

Raw Sienna

Yellow Ocher

Indian Yellow

Lemon Yellow

Alizarin Crimson

Cadmium Red

Cadmium Yellow

4 Paint the foreground grass with the larger brush and a strong mix of Lemon Yellow and Payne's Gray, varying the tones slightly, and grading to a brownish mix of Burnt Sienna and Yellow Ocher to the right of the main tree. When dry, return to the small brush and paint darker areas of grass at top and bottom, using the Payne's Gray and Cadmium Yellow mix with the addition of Burnt Sienna, and making upright and diagonal strokes in different directions.

5 Now paint the rocks and the trunk of the main tree, taking care to leave highlights. Use mixes of Raw Sienna, Vandyke Brown, and Payne's Gray for both, dabbing into the paint with a finger for the diffused highlights on the rocks. When the paint has dried, you can accentuate these light areas, especially those on the tree trunk, by gently scraping with a sharp blade, which gives an attractive rough texture. When dry, paint in the dark foliage in the left foreground, using strong Neutral Tint, and taking the top leaves over the rocks in the middle distance to link the two areas.

6 The final stage is to accentuate the lights and darks. Paint rich, dark accents on the beech trees, making small strokes of strong Cadmium Red, Alizarin Crimson and Burnt Sienna, plus one or two touches of Winsor Violet. The highlights can then be added with mixes of White Acrylic and the watercolor yellows used previously, but take care to use the acrylic sparingly, as opaque highlights can show in certain lights and stand out as a different texture. More darks can also be added if needed, with watercolor alone – don't be afraid to darken and lighten as appropriate.

4 To work the shadows, use Vandyke Brown, Burnt Sienna, Neutral Tint and Winsor Violet. These provide a key to judging the highlights which are painted last, with White Acrylic mixed with the light foliage colors.

Fagus sylvatica

Common Beech

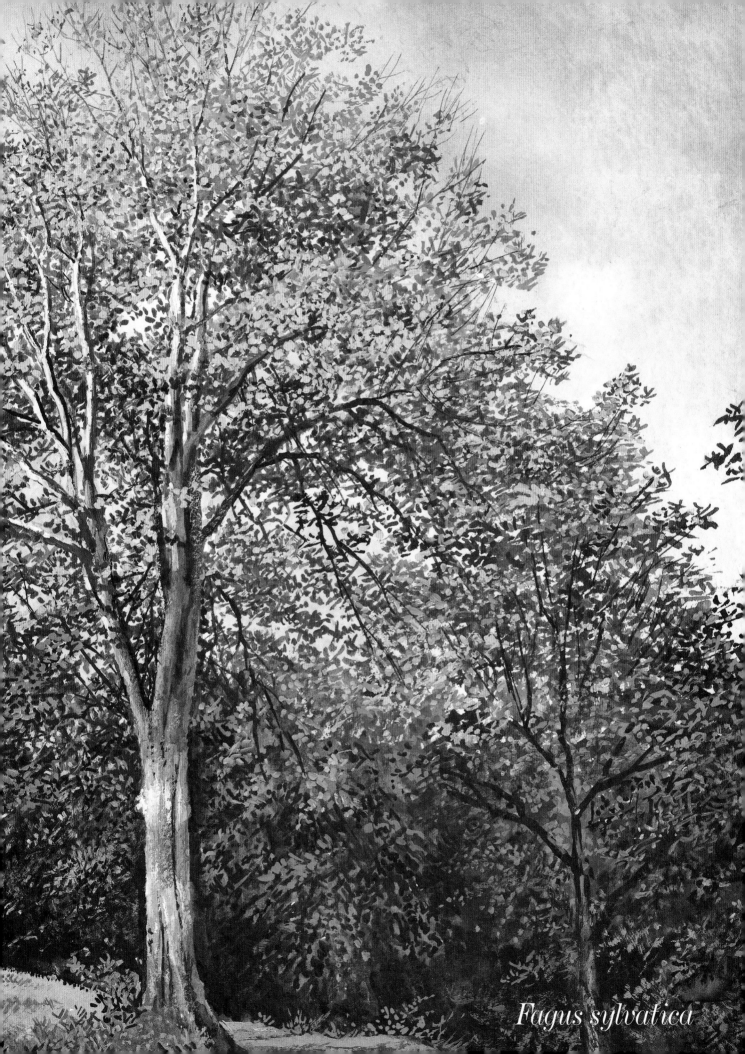

Fagus sylvatica

Ginkgo biloba Maidenhair Tree

This tree, the sole survivor of a group of trees that grew worldwide 200 million years ago, when the only other form of arboreal growth was ferns, has not changed its shape in all this time. It became a revered tree in Chinese and Japanese monastery gardens, and was brought to Europe by travelers in the 18th century. It has unmistakable butterfly-shaped leaves, referred to in the 16th century as a "duck's foot." It was christened the maidenhair tree by the Europeans, from the maidenhair fern, the only plant with leaves of a similar shape.

These trees look best in late autumn, when the leaves are turning from green to a clear butter-yellow with no hint of orange. The small leaves soften the tree shapes without disguising their basic structure, so as in all tree paintings, concentrate first on the main shapes and colors and on giving a sense of space through the use of aerial and linear perspective (see PERSPECTIVE).

sequence start to finish

1 This is a relatively complex composition requiring an accurate preliminary drawing. Mark in the horizon, the shapes of the three main trees, and the diagonal line of the river. Lay in the misty sky, wetting the paper down to the foreground bank and then dropping in Phthalo Blue, Alizarin Crimson, and New Gamboge. While still wet, use a large brush and sweeping strokes to pull these spots of color together. Before the surface has lost its sheen, drop in a darker mix of Phthalo Blue and Alizarin Crimson for the distant trees, lifting out color for the sunlit clumps of foliage on the left-hand trees. Allow to dry.

2 Lay in a foreground wash of New Gamboge, making it paler on the right and adding a little Alizarin Crimson toward the right side to warm the yellow. When dry, start on the foliage, using a small, just-damp sponge (see SPONGING and below) to lay on a strong wash of New Gamboge. Take the color right across the tree, but make it stronger and denser on the right side. Then sponge in the light-catching foliage on the left-hand tree with a mix of New Gamboge and Raw Umber, and apply a mix of Raw Umber and a little Quinacridone Gold to the central, more distant tree.

3 In this case, sponging should not be isolated to one part of the picture, so continue to build up the textures on the large right tree with mixes of New Gamboge and Raw Umber – the trees are backlit, so there will be very little of the lighter foliage showing at the end. Allow to dry before painting the group of trees on the right, taking the color around the trunk of the main tree.

4 Add the darkest tones to the shaded side of the large right-hand tree, with the sponge and a mix of Quinacridone Gold and Raw Umber with a touch of Phthalo Blue. To add variety, spatter (see SPATTERING) in some of this

special detail applying paint with a sponge

1 *Painting on dry paper with a sea sponge provides an excellent way of describing the feathery textures of these autumn leaves. Sketch in the trunk and a few branches, also indicating the leaf masses, then lay on a pale wash of New Gamboge.*

2 *Allow to dry, then making sure the sponge is clean, wet it well and squeeze it almost dry. Dip the sponge into a strong solution of New Gamboge and dab it over the leaf masses, then allow to dry before adding more color.*

3 *Wash the sponge and paint the second tone with a mix of New Gamboge and Raw Umber, leaving some of the first color showing at the edges. To suggest the small leaves, use a stippling technique, tapping the sponge lightly onto the paper.*

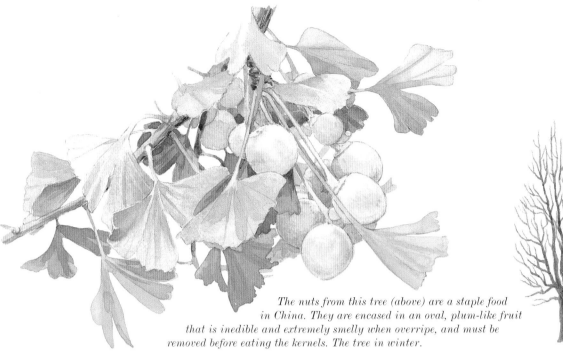

Phthalo Blue

New Gamboge

Raw Umber

Sepia

Alizarin Crimson

Quinacridone Gold

Dioxazine Violet

The nuts from this tree (above) are a staple food in China. They are encased in an oval, plum-like fruit that is inedible and extremely smelly when overripe, and must be removed before eating the kernels. The tree in winter.

color, and then use the No. 8 brush to stroke in the downward-trailing leaves at the clump edges. Sponge in the left-hand side with a mix of Raw Umber, Phthalo Blue, and Quinacridone Gold, and add some tiny leaf strokes with a small brush. The central tree needs less texture, so paint over the first sponged wash with the No. 8 brush and a mix of Raw Umber and Dioxazine Violet.

5 The strongest tonal contrast is at the foot of the right tree (the foreground is entirely in shadow), so sponge mixes of Quinacridone Gold, Alizarin Crimson, and Phthalo Blue onto this area, emphasizing the top

silhouetted edge. Allow to dry, and then sponge on some dark Sepia to give added detail and link with the leaf masses. Darken the left corner of the foreground with the foliage colors to prevent the viewer's eye from going out of the picture, and then paint in the trunks and branches, noting their structure. Vary the tones a little, and give a hint of the branches behind the foliage. Use mixes of Sepia, Quinacridone Gold, and Alizarin Crimson for the main tree, tones of Sepia alone for the left tree, and a fairly pale mix of Sepia and Dioxazine Violet for the smallest tree. Paint the finest twigs with a rigger (see BRUSHWORK).

6 Add the final details using White Gouache (see BODY COLOR) tinted with Quinacridone Gold or New Gamboge. Be sparing with the opaque paint, just dabbing on a few small spots, especially at outer sunlit edges. Scumble some of this color over the distant central tree to soften it a little, allowing the layer of color underneath to show through, then spatter some of the tinted body color into the dark foreground.

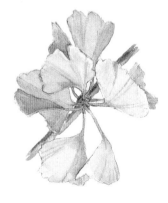

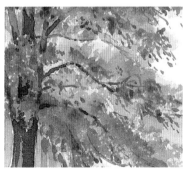

4 Dab on the darkest tone with the sponge and a mix of Quinacridone Gold, Raw Umber, and touch of Phthalo Blue, concentrating these on the undersides of the clumps. Then paint small brushmarks for the trailing leaves with the No. 8 brush.

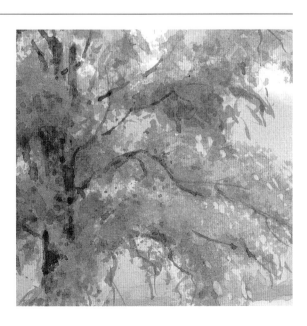

Ginkgo biloba

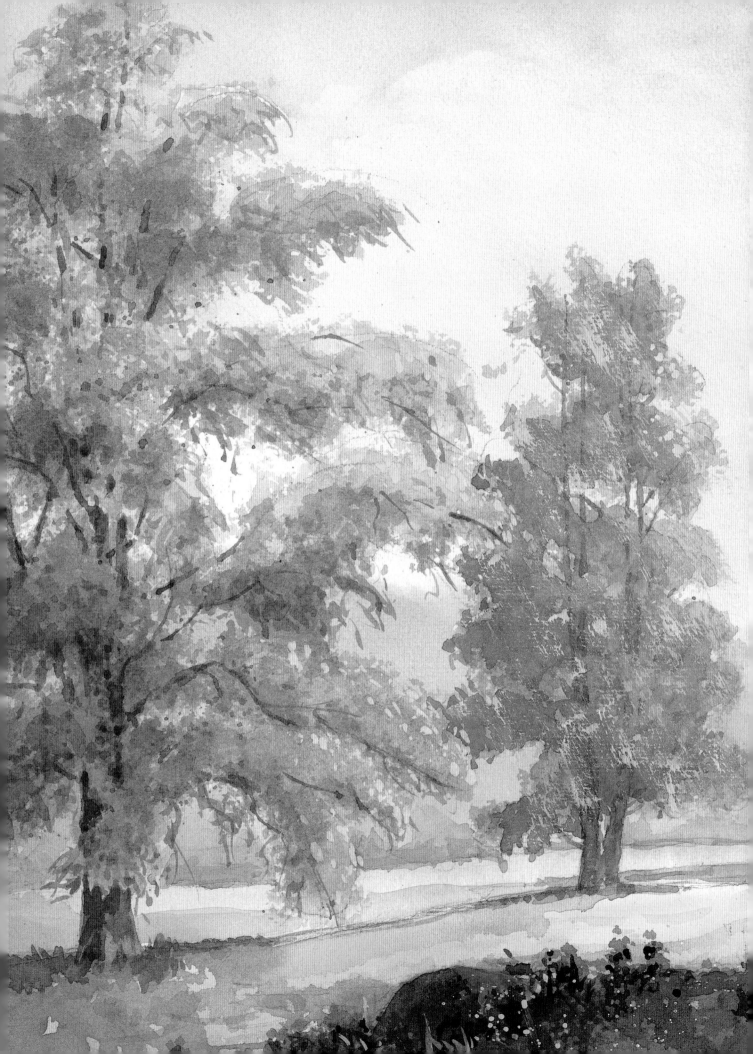

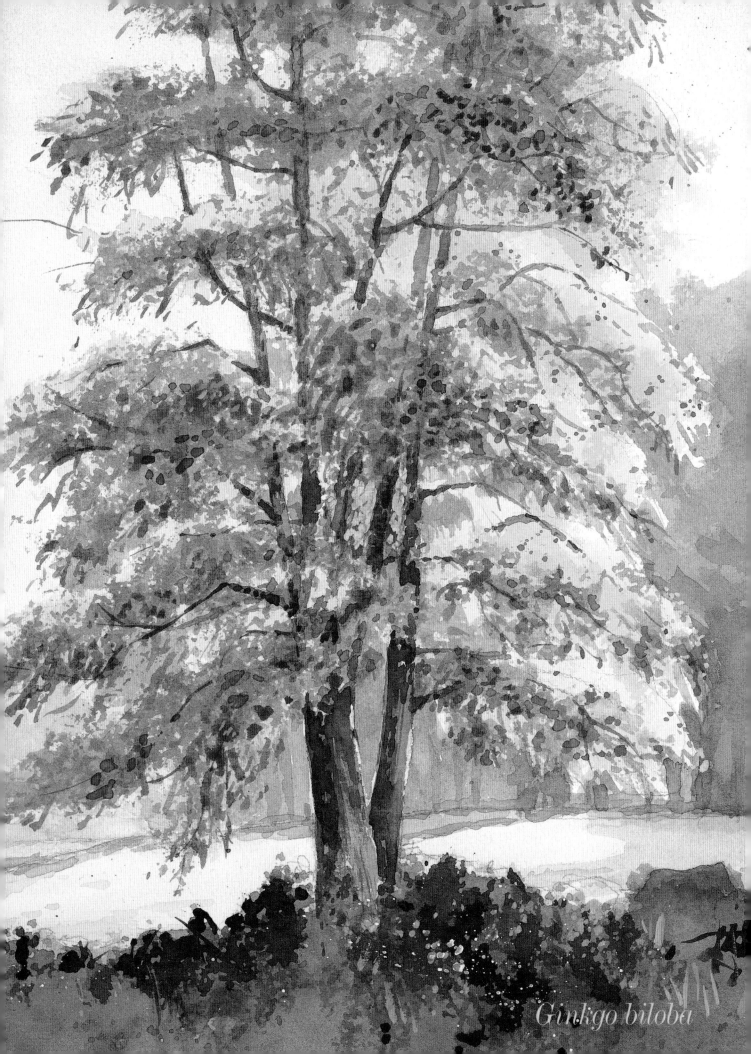

Ginkgo biloba

Ilex aquifolium Common Holly

Holly is always associated with Christmas, and folklore credits it with magical powers. Its berry-laden branches, which were brought into the house at the start of the Christmas festival, were thought to ward off evil. The holly is one of a few evergreen broad-leaved trees that is native to Northern Europe. It is found mainly in hedgerows or scattered throughout older traditional forests. Its dense conical shape, with branches of shiny, dark, wet-looking leaves, makes it a striking specimen tree. It is sometimes used for topiary work, as it stands clipping well, and looks striking when trimmed into simple shapes, such as lollipops, pyramids, or "cake stands," when it creates dramatic blocks of dark color. Pay careful attention to the direction of the light when painting these trees, as they need tonal modeling in order to appear solid and three dimensional.

sequence start to finish

1 Sketch in the main outlines of the three trees, then use a sharpened stick to mask out (see MASKING) a few of the branches that show up light against the foliage. Also mask out the dried grasses at the base of the trees. Dampen the whole sheet, and with a mix of Transparent Yellow and Cobalt Blue, wash this color into the central, variegated holly, using a No. 14 round brush, and taking the color across the lower grassy strip and into the right-hand tree. Immediately, while the wash is still very wet, dab watery Prussian Green on either side of the central tree to cover the foliage masses, tipping the board to direct the flow of paint and

help the colors to mix slightly. Add a Dioxazine Violet and Cobalt Blue mix to the area at top left, and splash some Quinacridone Gold into the lower grassy area. Allow to dry.

2 Paint in a second tone of pale Prussian Green on the central tree, using the tip of a No. 10 round brush held vertically to make tiny dancing leaf strokes across the surface. Paint into the shadow areas, leaving the first wash for the light-struck leaves in the light. Spatter (see TEXTURING METHODS, and below) some of this color into the foliage to add texture, and continue in the same way across the right-hand tree, using a mix of Olive Green and Prussian Green for the shading. On the

left-hand tree, use a pale mix of Indigo and Olive Green for the shading, dropping in a stronger mix while still wet. At top left, brush in this same color to go behind the foreground tree, watering it down if it appears too harsh. Allow to dry.

3 To introduce some warmth among the dominant greens, use a rigger brush (see BRUSHWORK) to randomly stroke in tones of Burnt Sienna plus Dioxazine Violet into the lower edge of dried grass. Then add final darks to the light central tree, but take care not to make them too dark, as this must still "read" as a light tree. Dab a mid-toned mix of Olive Green with touches of pale Dioxazine Violet into the shadow area,

special detail spattering

1 *Spattering can easily be overdone, but should be understated, giving the impression of glossy leaves and tiny berries. First lay a variegated wash of Prussian Green, Transparent Yellow, and Cobalt Blue so the spattering blends in with the existing colors.*

2 *Spattering can be applied in various different ways, here, a No. 8 round brush, loaded with pigment, has been knocked at right angles against the handle of another brush, flicking different-sized spots of color onto the paper.*

3 *Continue to build up shading on the light left-hand tree before adding darker accents. When dry, suggest light, glossy leaves with tiny stabbing brushmarks of White Gouache tinted with foliage colors. Concentrate on the outer edges of the leaf masses.*

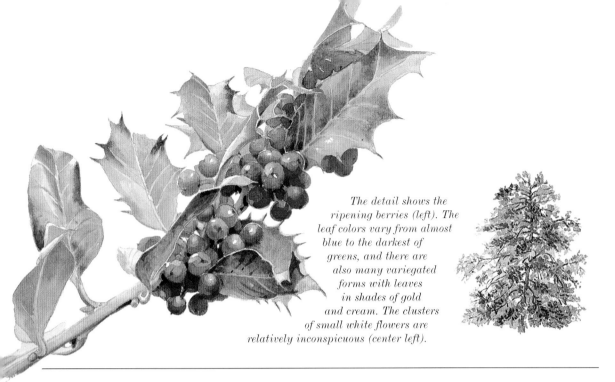

The detail shows the ripening berries (left). The leaf colors vary from almost blue to the darkest of greens, and there are also many variegated forms with leaves in shades of gold and cream. The clusters of small white flowers are relatively inconspicuous (center left).

Transparent Yellow

Quinacridone Gold

Cobalt Blue

Prussian Green

Burnt Sienna

Olive Green

Dioxazine Violet

Indigo

Winsor Red

and then finish the darker tree on the right with a stronger mix of Prussian Green and Olive Green. Soften edges where needed as you paint, and add a little spattered color. Drop in dark Indigo and a few marks of dark Dioxazine Violet wet-in-wet (see WET-IN-WET), but vary the tones, as you don't want to silhouette the central tree by placing darks all around its edges. To paint the left-hand tree, use Indigo and Olive Green in varying shades, making the marks crisper than on the right-hand tree to give some contrast. When dry, rub off all the masking.

4 Holly branches leave the main trunk at a near-horizontal angle, with some of the lower ones tending to bend downward, even appearing in front of the foliage. This is very noticeable on the central holly. Tint these white branches and twigs with a pale, neutral mix of the foliage colors plus Dioxazine Violet. By contrast, the left holly shows a few branches growing sideways, curving upwards at the tip and also in silhouette. The main trunk is tucked away amongst the foliage, going behind the central tree. The right holly, being very dense, shows hardly any branches.

5 Conveying the shiny light on holly leaves without making the painting look spotty can be tricky, so avoid trying to describe the leaves too literally. Instead, give a suggestion of the shine and create extra textural interest by adding some White Gouache (see BODY COLOR) slightly tinted with the foliage colors. Make small brushstrokes, especially on the edges of the light foliage masses, and spatter some white onto the central tree.

6 The most enjoyable bit, adding the berries, is left until last (the best time to paint hollies is in early autumn, before the birds have eaten all the berries). Employ the spattering method again, using Winsor Red, darkened in places with Dioxazine Violet, and lightened on the left tree with the addition of Transparent Yellow. Don't overdo it, as the painting will become dull if red is spattered evenly all over.

4 *Stroke in some small twigs with a fairly pale mix of Dioxazine Violet and Olive Green, and add just a little spattering to the light leaf shapes of the left-hand tree with White Gouache. When dry, spatter in the berries with Winsor Red.*

Ilex aquifolium

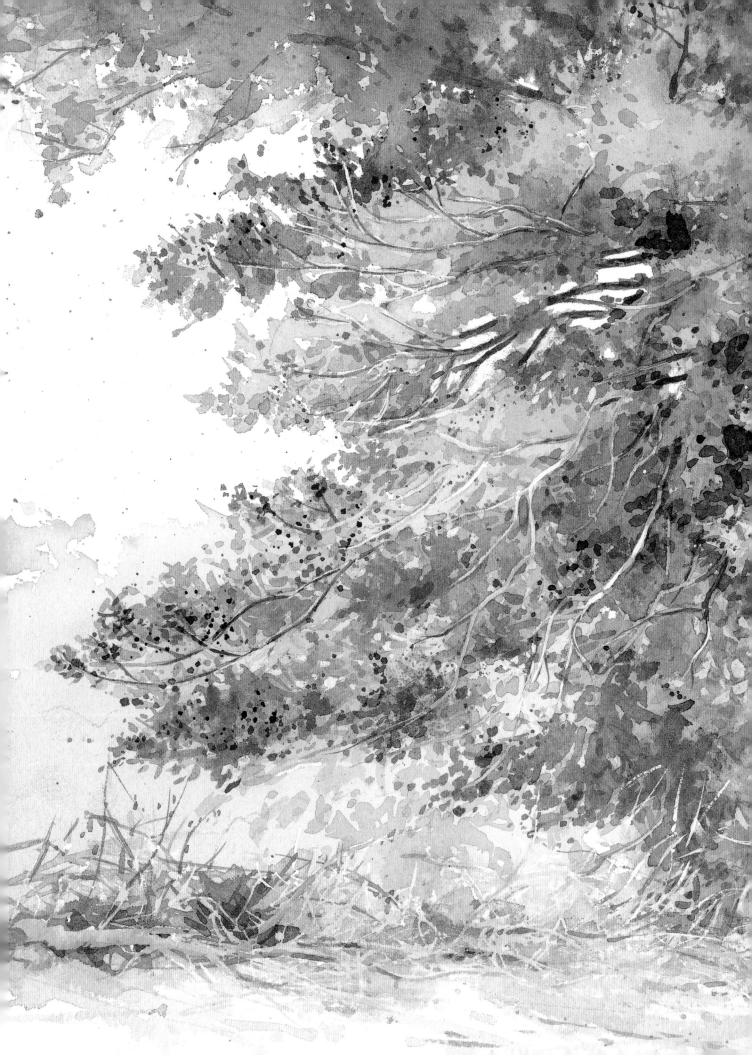

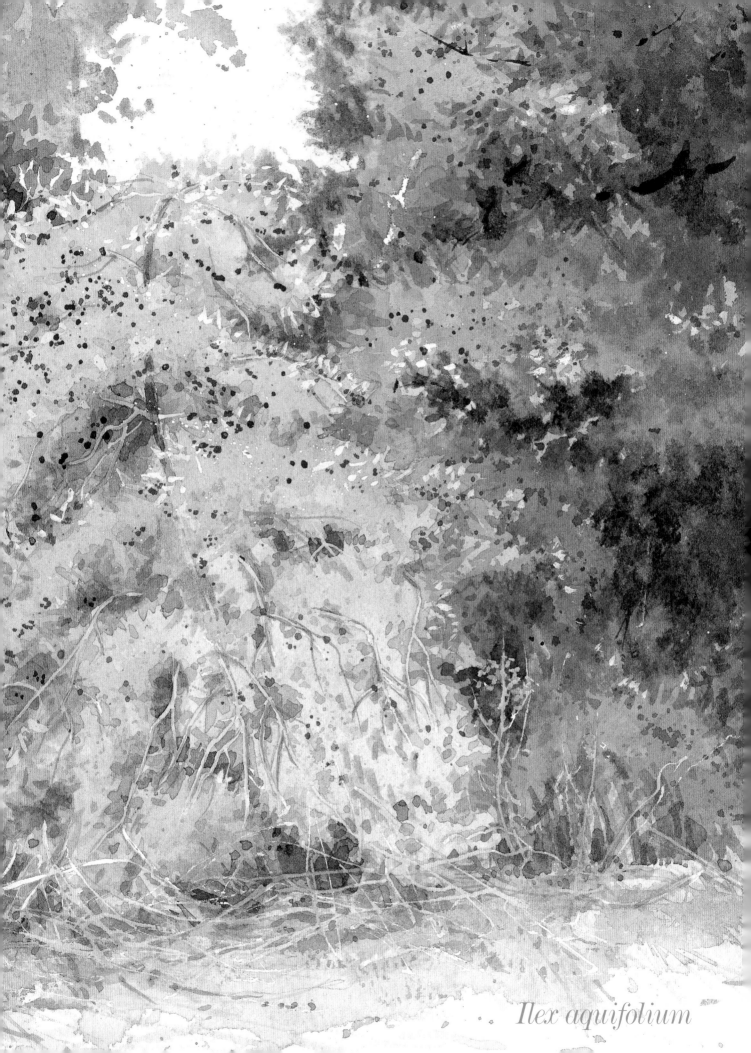

Ilex aquifolium

Juglans nigra Black Walnut

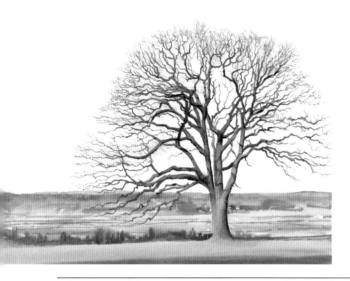

The walnut is a native of the Balkans, but has been planted and become naturalized in most of Europe and North America. It is a deciduous tree, growing up to 97 feet (30m) high, with a tall, domed crown. The wood, hard and with a beautiful, patterned grain, has for centuries been much prized by furniture makers and wood carvers, while the edible nuts are widely enjoyed in winter. They are also ground to make walnut oil, while the husks yield walnut juice, used for staining. The leaflets, growing in opposing pairs from a central stalk, are 2 to 4 inches (6-12 cm) long, and dark green in color.

The main challenges when painting winter trees, especially this one, are to capture the sinuous quality of the branches, and to give the impression of the overall rounded shape by making some branches and twigs recede and others advance.

sequence start to finish

1 Make a careful drawing of the trunk and main branches, but do not attempt to put in every tiny twig. Because this tree is painted in winter, the sky is left white, adding to the atmosphere, so start on the tree immediately. Using a No. 10 round brush, wet the tree trunk and the largest branches, but do not take the water to the ends. Using a mix of Raw Umber and French Ultramarine, drop color onto the tree trunk, tilting the board slightly so that it spreads down toward the base to produce a soft edge.

2 Now paint the light-colored mass of twigs and buds at the top of the tree with pale Raw Umber, using the dry-brush technique (see BRUSHWORK and below) and the side of the No.10 brush. Re-wet the trunk if it has dried, and add a mix of French Ultramarine and Burnt Umber to the shadowed edge, letting the color spread inward a little. On the left side, drop in just a touch of a very pale mix of Cerulean Blue and Burnt Umber. Allow to dry.

3 Begin to paint the main branches, using the point of the No.10 brush. Start with a mix of Raw Umber and Ultramarine for the paler ones,

changing to a stronger mix of Burnt Umber and French Ultramarine for the nearer, darker ones. For the smaller branches and twigs, use a No. 2 round brush with a good point, making fine, squiggling marks to describe the delicate tracery. As you work, keep checking one area against another to make sure that you maintain the overall shape of the tree.

4 To paint the meadow, mix a yellowish-green from Terre Verte and Gamboge Hue, and lay a wet wash on the dry paper, taking the color around the tree trunk. Brush a little of this color onto the base of the trunk to

special detail branches and twigs in winter

1 *The haze of green that appears at the ends of the small twigs in late winter to early spring presents a challenge to the artist, as the delicate effect can easily be spoiled by putting on too much color. Dry-brushing is a useful method in this context.*

2 *When dry, paint the branches with Raw Umber, Burnt Umber, and a little French Ultramarine, starting with a No. 10 brush and changing to a No. 2 for the tiny twigs. These can be reinforced with fine pen lines, but use these sparingly.*

3 *Wet the area at lower right, allow to dry slightly, and paint more branches, letting some of the color run downward (don't use the paint too wet). Allow to dry, and add darker tones on the branches that come forward in space.*

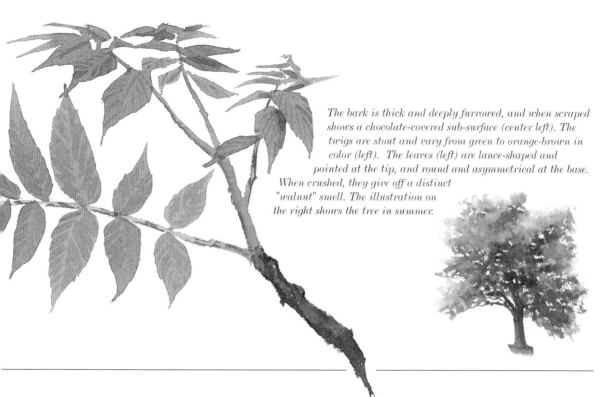

The bark is thick and deeply furrowed, and when scraped shows a chocolate-covered sub-surface (center left). The twigs are stout and vary from green to orange-brown in color (left). The leaves (left) are lance-shaped and pointed at the tip, and round and asymmetrical at the base. When crushed, they give off a distinct "walnut" smell. The illustration on the right shows the tree in summer.

give it a slight green caste of reflected light from the grass, and before the wash for the meadow has dried, drop in a mix of Terre Verte, and French Ultramarine, and Burnt Umber to suggest small clumps of foliage in the immediate foreground. Allow to dry, and brush in some horizontal lines on either side of the tree to break up the area.

5 Wet the area above the meadow, leaving the sky and tree trunk dry, and brush in the distant view, working wet-in-wet with loose, pale, horizontal passages of color. Start at the bottom of the area, using Terre Verte and a

little French Ultramarine with plenty of water, then move upward to the hills, painting with mixes of French Ultramarine, a little Burnt Sienna, and some Alizarin Crimson for a slightly grayed mauve-blue. Allow to dry, then add just a very few touches of detail with the small brush.

6 Lift out (see LIFTING OUT) some of the color on the trunk with a clean, wet brush, and add a touch of Burnt Sienna in the middle for warmth. Paint dark accents and shadows on the branches with the French Ultramarine and Burnt Sienna mix, damping the paper first in some places so that the color spreads –

aim for a balance of hard and soft edges. Concentrate the main darks on the branches that come forward in space. Finally, use a strong mix of the same colors to paint shadows on the small lower branches to the left of the trunk.

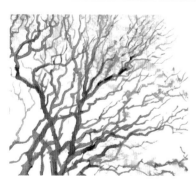

4 Trees in winter clothing can be a very dramatic painting subject. But it is very useful to paint and sketch branches and twigs in winter so that you can build up your overall knowledge of the shape and structure of the tree.

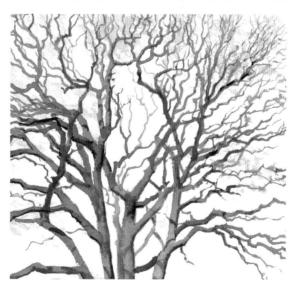

Juglans nigra

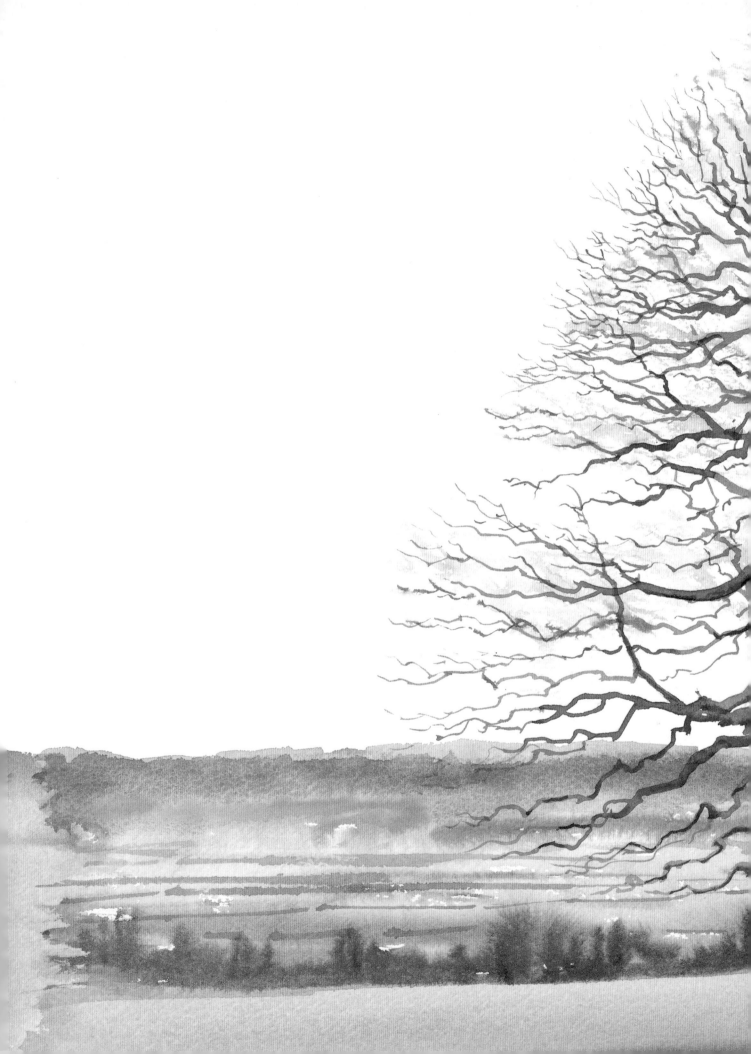

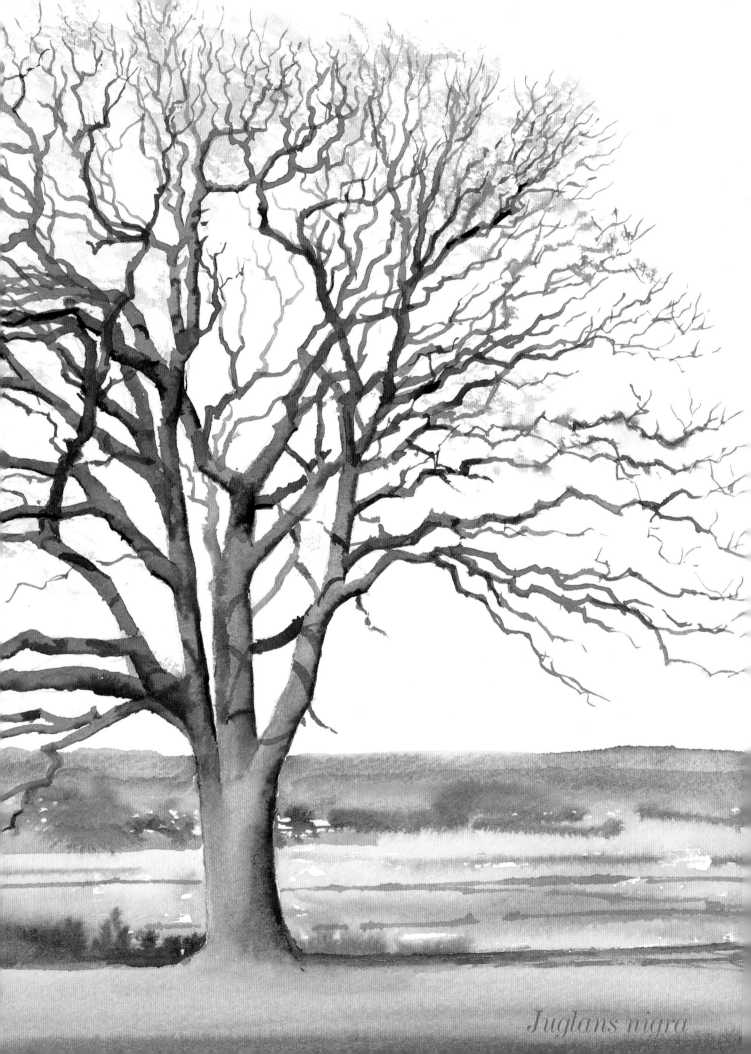

Juglans nigra

Malus domestica Apple Tree

The orchard apple tree differs from the crab-apple tree in that the fruit is larger and sweeter. There are also many – perhaps even hundreds – of different varieties. The apple is a bushy, dense, much-branched tree with interlacing branches bearing long shoots. These carry the red buds that in late spring open into the delicate, graceful pink and white blossom that provides one of the loveliest sights of the season. The bright green leaves are oval-shaped and about 2 inches (50mm) long, and the bark is grayish brown, becoming furrowed in old age and peeling off in thin flakes. When painting, look for the overall silhouette, which is a slightly erratic sickle shape, and note how the twigs link up to the branches and the latter to the trunk. Try to make the tree look three dimensional, and root it to the ground by painting its cast shadow.

sequence start to finish

1 Draw the tree carefully, noting the tangle of branches. Then mask out (see MASKING) the blossom. Lay a variegated wash (see VARIEGATED WASH) over the lower half of the paper with Raw Umber at the top and a mix of Green Gold and Raw Sienna toward the lower edge. Drop in watery Phthalo Blue wet-in-wet at the lower right corner, and while still wet, lift out the color on the sunny right side of the trunk with a clean, dry tissue. Allow to dry, and then, on the top half of the paper, lay another variegated wash, this time starting with Phthalo Blue softened with a touch of Raw Umber, and adding more Raw Umber as you work down toward the half-way area. Allow to dry again before painting some of the branches with a stronger yellowy mix of Green Gold and Raw Sienna to act as a color link with the foreground (see UNITY).

2 When the first washes have dried, begin to build up the leaves, starting with the palest, and using a large round brush and mixes of Raw Umber, Phthalo Blue, and Green Gold. Take the brushstrokes across the tree, stippling the wettish paint (see BRUSHWORK). Take some of these color mixes into the branches in places, and also add them to areas of the foreground to strengthen it.

3 Now add some mid-toned leaves, using the previous colors as well as Olive Green. Continue to use stippling brushstrokes, and avoid making the foliage too dense. Paint the softly focused area under the tree with a mid-toned mix of Indigo and Dioxazine

special detail perspective of branches

1 *When drawing observe the perspective – some of the branches recede, some come toward you, and are foreshortened, and some are seen sideways on. Lay a wash of Raw Umber and Green Gold over the whole area, snd lift out color (see LIFTING OUT) on the light side of the trunk and some of the branches, with a tissue.*

2 *When dry, brush in a mix of Green Gold and Raw Sienna on parts of the braches and trunk. Pay attention to the fall of light, which creates shading that models the forms and explains the spatial relationships. The branch coming forward on the right, for example, is in deep shadow, so paint this with a cool, mid-toned mix.*

3 *The pattern of cast shadows often has a reddish-mauve tint, giving it a spring-like feel. Glaze on the lightest shadows with mixes of Dioxazine Violet, Phthalo Blue, and Raw Umber, curving around the trunk and branches to build up the forms. For the warmest shadows, use a mix of Dioxazine Violet and Burnt Sienna.*

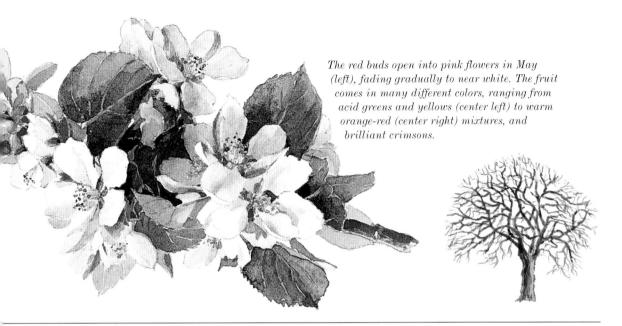

The red buds open into pink flowers in May (left), fading gradually to near white. The fruit comes in many different colors, ranging from acid greens and yellows (center left) to warm orange-red (center right) mixtures, and brilliant crimsons.

Raw Umber

Phthalo Blue

Burnt Sienna

Raw Sienna

Green Gold

Olive Green

Dioxazine Violet

Indigo

Alizarin Crimson

Violet for the shaded grass. reserving some stalks of grass by painting around them. When dry, rub off the masking.

4 Tint the white blossom shapes with pale Alizarin Crimson, leaving some white highlights. When dry go in with a stronger mix of the same color, making small dotty marks to describe the tiny buds. Glaze on the lightest shadows on the trunk and branches with mixes of Dioxazine Violet, Phthalo Blue, and Raw Umber, making sure that they follow the curvature of the branches. Allow to dry.

5 Adjust the tones on the branches and trunk, darkening them in places with mixes of Dioxazine Violet and Burnt Sienna. Allow to dry, then add a stronger, more golden area behind the tree with a mix of Green Gold and Burnt Sienna. When dry, paint in the darkest accents on the trunk and branches with a dark mix of Dioxazine Violet and Burnt Sienna.

6 Now add final touches to the leaves. Stipple in some dark background leaves with a mix of Olive Green and Indigo, but take care not to

overdo it, or the painting will look spotty and confused. Splatter (see TEXTURING METHODS) just a little White Gouache across the central section of the tree, followed by a small amount of dark Alizarin Crimson to add a suggestion of texture. Finally, paint in the distant apple tree with pale mixes of the previous colors, keeping it very understated.

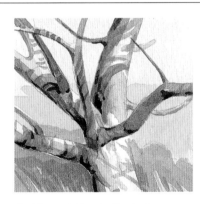

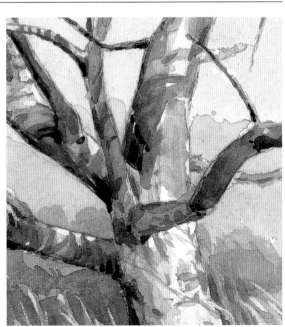

4 After painting in the shadow on the grass. Adjust the tones on the branches and trunk, to suggest some branches thrusting forward and others curving back away from you, note the considerable tonal variations created by the fall of light. Paint the darkest marks with a mix of Dioxazine Violet and Burnt Sienna.

Malus domestica

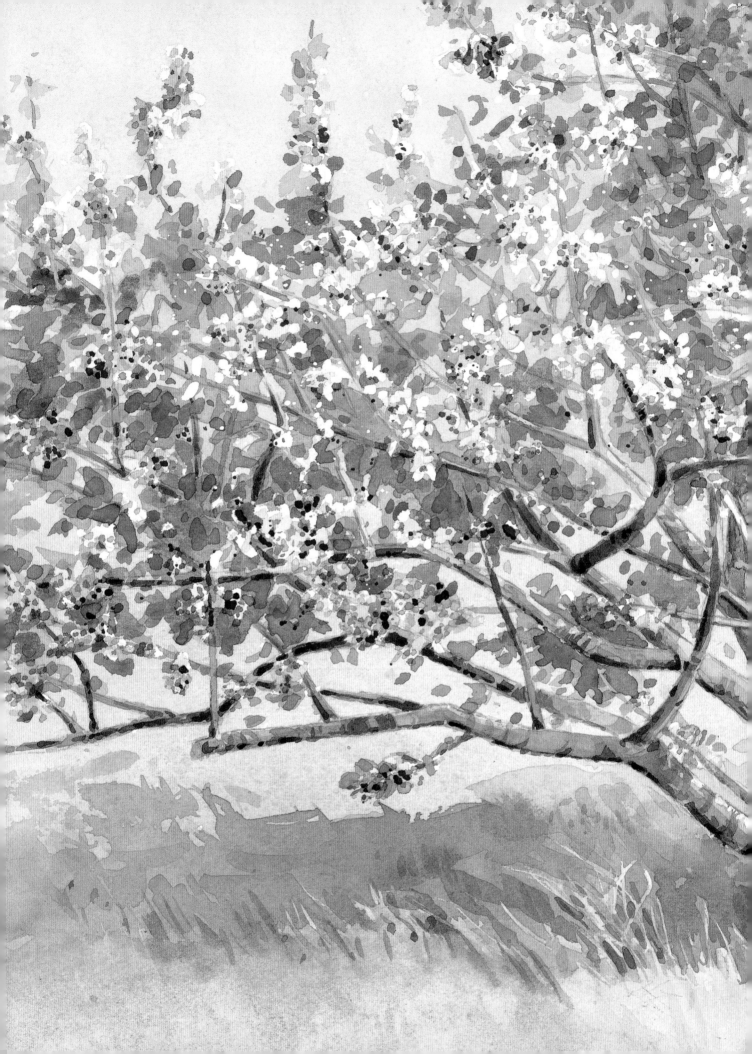

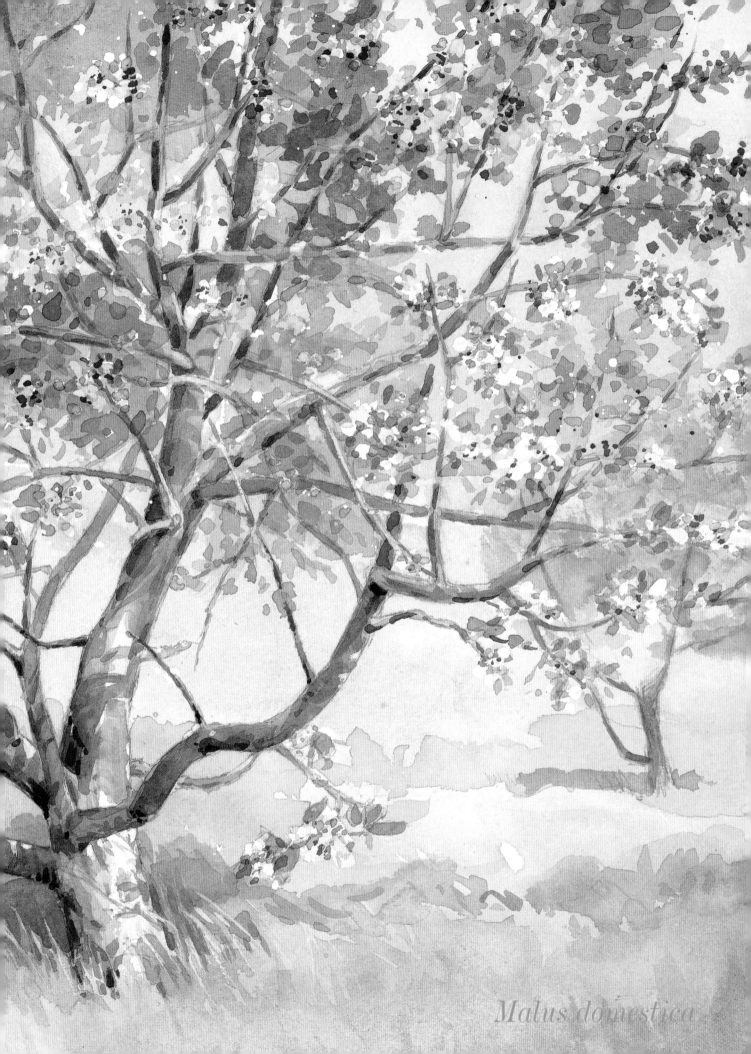

Malus domestica

Nerium Oleander Oleander

This bushy, evergreen shrub – with its lovely pink flowers that can bloom all year round – is native to Asia and the Middle East, but is now a familiar sight throughout the Mediterranean countries, and the USA. It's elegant spiky leaves and brilliant pink flowers combined with its ability to tolerate very inhospitable conditions make it a very popular choice as a decorative ornamental shrub for American cities, where can adorn both sidewalks and freeways.

Most varieties reach a maximum height of 6 to 10 feet (2-3 meters) and are about 5 feet wide. They can be easily grown in pots as shown here. Or alternatively they can be trained into a small trees with one or several trunks. The challenge to the painter is to catch the crispness and delicacy of the leaves and flowers, without losing them in the surroundings.

sequence start to finish

1 Make a careful drawing, paying special attention to the spacing of the glasshouse struts and the perspective of the frontage. It is seen at a slight angle and thus recedes, making the spaces between the struts smaller toward the right side. Mask out (see MASKING OUT) a few of the leaves, letting the brush describe the shapes and angles, then mask the branches, trunks and struts.

2 Brush in the reflected area of sky at the top of the greenhouse glass with a No. 10 brush and a mix of Phthalo Blue, Sap Green, and Neutral Tint, keeping the wash loose and watery. Paint up to the edges of the leaves, but not over them. Allow to dry, then make a stronger mix of the same colors but with less blue, and paint the dark areas, defining some reflected detail on the right side, and leaving small white patches of paper to suggest the glass surface. When dry, gently lift out (see LIFTING OUT) a few light streaks to suggest detail just visible within the interior.

3 For the first color on the leaves, make a mix of Gamboge Hue and a little Sap Green, and apply it loosely, using the tip of the No.10 brush to make crisscrossing strokes that suggest leaf shapes. Leave a few leaf-shaped white patches, but don't overdo these. Allow to dry and paint a second layer in the same way, using a stronger mix of the same colors, and leaving some leaves as the first color. For the third layer, add some French Ultramarine and Neutral Tint to the mix, and brush this back and forth for the underlying leaves in the shadow areas. Finally, add a good quantity of Neutral Tint to the green mix and paint in the intense darks.

special detail using masking fluid

1 *Masking fluid can be both clear and colored, in this case green, making it easy to identify the reserved areas. Begin by sketching in the leaf shapes and painting masking fluid over the areas you wish to highlight.*

2 *When the masking fluid has dried, brush in various mixes of Gamboge Hue and Sap Green. You should brush very loosely over the masking fluid reserving further sections of white. Allow to dry.*

3 *Repeat the process with stronger mixes of the same colors building up subtle shades. Allow to dry, and brush in strokes of Ultramarine Blue with a little Neutral Tint. When dry, brush in a much darker mix of the same colors.*

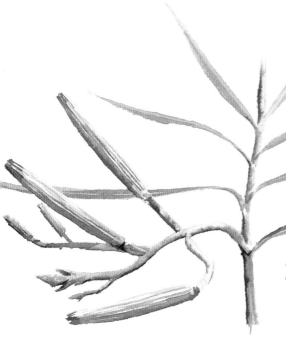

The leaves are long and narrow, and usually dark green in colour (center left), although some varieties have leaves variegated with white or yellow. They are generally between 3 and 7 inches (10-22 cm) long, leathery in texture and usually grow from the stem in groups of three. The fruit (left) consists of a long narrow capsule 3 to 4 inches (10 to 12 cm) long and ⅓ inch (6 to 8 mm) in diameter; that opens to disperse fluffy seeds. Generally cultivated plants do not fruit.

Phthalo Blue

Sap Green

Neutral Tint

Gamboge Hue

French Ultramarine

Light Red

Naples Yellow

4 When everything is dry, remove all the masking fluid, and add detail to the glasshouse struts with a No. 2 brush mix of Neutral Tint and a little Light Red (you could also draw in a few fine pen lines if desired). With the No. 10 brush and a mix of Naples Yellow and a little French Ultramarine, paint the side of the glasshouse below the glass, dropping in French Ultramarine and Light Red wet-in-wet (see WET-IN-WET) to create interest and give the impression of aging.

5 Mix a pale terracotta color of Light Red and Naples Yellow, and a darker one of Light Red and French Ultramarine for the shadows. Use the first mix to paint the ground below the glasshouse, and when dry, add the shadows with a mix of French Ultramarine and a little Light Red. Paint the outside and the inside rim of the clay pot with the light mix, and then drop in the darker mix on the shadow side wet-in-wet. When dry, use the dark mix to brush in the shadow beneath the rim and the soil, leaving a few white patches to reinforce the sunlit effect. Paint the trunks and branches of the bushes with the terracotta colors, again dropping in the shadows wet-in-wet. When dry, use the small brush and the darkest foliage color to define the right-hand edges and add some dark accents to the branches.

6 Wet the outside area of the dark-colored pot. Make a mix of Phthalo Blue and Neutral Tint, and use the No. 10 brush to drop this color onto the shadow side, letting it spread across to become paler on the left. When dry, paint the inside of the pot with the same mix, this time making the color darker on the left and leaving tiny white lines in places around the rim.

4 When dry, remove the masking fluid and touch in the branches with a mix of Light Red and Naples Yellow, varying the shades according to whether the area is in light or shade. Finally touch in the leaves with pale mixes of greens.

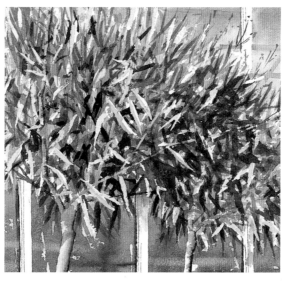

Nerium oleander

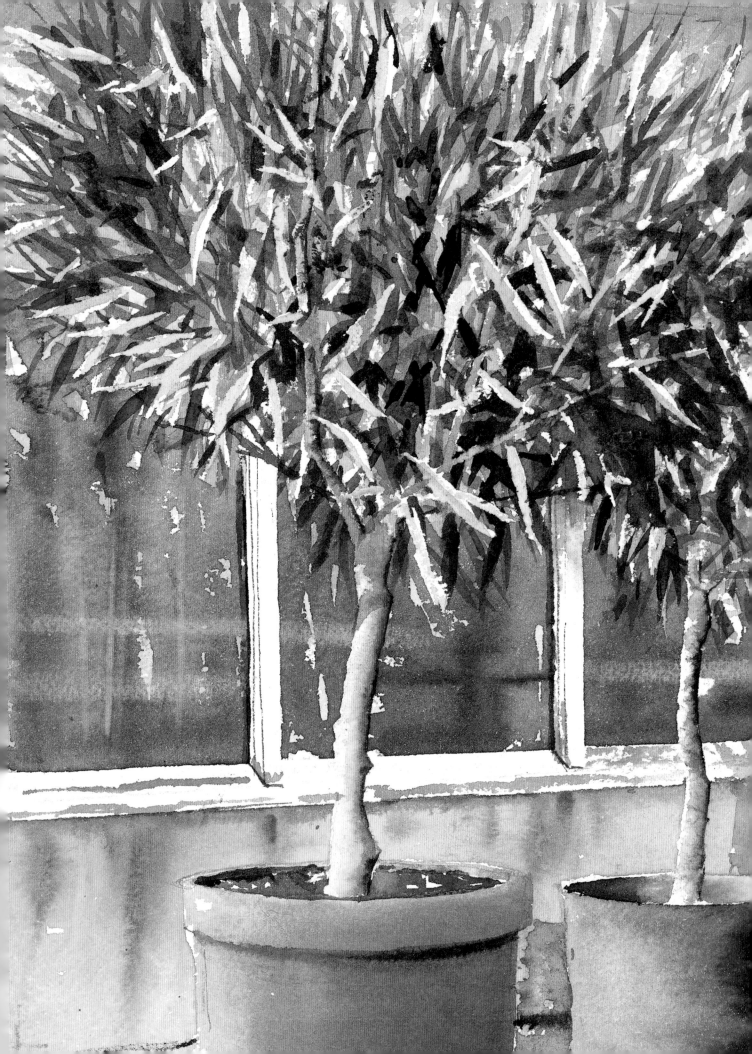

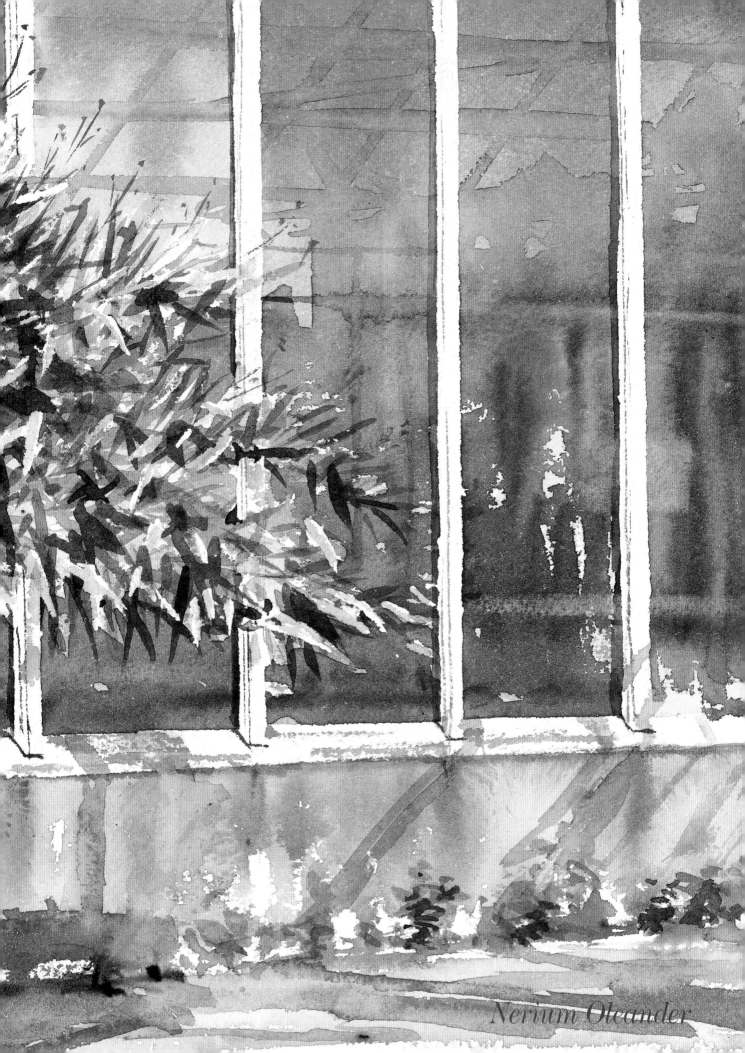

Nerium Oleander

Olea europaea Olive

The olive is native to a narrow strip around the Mediterranean, but it favors poor, thin soils, and can flourish in many hot, dry landscapes. It is one of the longest lived of all fruit trees, and some of the ancient olives growing in the Garden of Gethsemane in Jerusalem are said to be around two thousand years old. The olive harvest takes place in the winter, when the ripe fruits are beaten from the trees with long poles and then gathered from the ground. The olive is a graceful, slow-growing tree, and mature examples make exciting painting subjects, as they become dramatically gnarled in old age, typified by low, wandering branches that contrast wonderfully with the delicate, silvery foliage. The trunks are not just brown, so look for interesting variations in color, as well as patches of textural detail such as knots and fissures.

sequence start to finish

1 Draw in the main masses of the foliage and the trunks, taking care with the latter, which need to be carefully stated. Sketch in the goat, which adds a touch of interest in the right corner. Then begin to paint the foliage shapes, working on dry paper and loading a medium-sized, round brush with watery mixes of Prussian Green, Viridian, and New Gamboge. Take care to feather (see BRUSHWORK) the brushstrokes at the outer edges. Then change both the color and the brush, using a large round brush and Transparent Orange to stroke in the tree trunks and warm-colored ground, grading to New Gamboge toward the distance. Allow to dry.

2 The foliage is tricky, and needs to be simplified into light and darker masses with a suggestion of the small thin leaves but without too much detail. The nearest trees are slightly lighter and are warmer in color than those behind, so paint the next darkest tone – just very slightly darker – on these trees with Prussian Green and a No. 10 round brush. On the lightest clumps, use short, stabbing brushstrokes to suggest the leaves, but make the color more solid for the shaded areas. Continue to build up the forms in the same way on the middle-distance trees, with the same colors and tones, always keeping the direction of the light in mind.

3 Next paint in the second tone on the trunks, branches and ground with a thin glaze of Burnt Sienna, using the same color to indicate some small stones and shading under the trees. Allow to dry, then glaze a thin layer of Prussian Green on the foreground trees and on the shadowed sides of the small stones. This makes a color link (see UNITY) with the foliage to bring the composition together.

special detail mixing colors by glazing

1 *Glazing means mixing colors on the paper surface by laying one over another. Light reflected off the paper shows through, giving a more vibrant effect than premixed colors. It's vital not to build up too many layers, and to make sure that the underlying layer is completely dry.*

2 *You can be selective with glazes, by leaving some parts untouched, and varying the strength of the color. But you must always work quickly and very lightly so that you don't disturb the underlying layers, and you must always use transparent paint colors (see COLOR MIXING).*

3 *Here we used Transparent Orange followed by Burnt Sienna. Lay on a third one of a watery Dioxazine Violet to build up blue-violet shadows, which are ideal for giving an effect of sunshine. Glaze the left side of the trunks, then sweep the color over the ground around the trees. Allow to dry.*

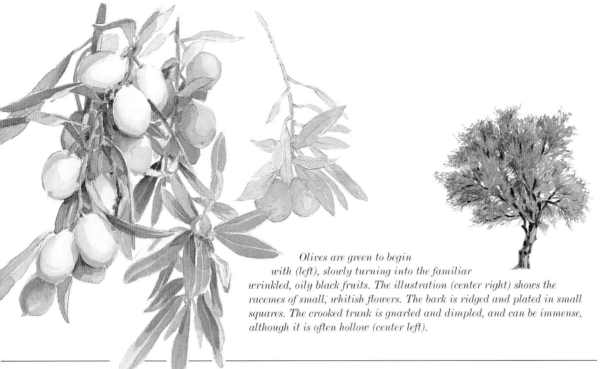

Olive Green

Burnt Sienna

Transparent Orange

Viridian

New Gambodge

Cobalt Blue

Prussian Green

Dioxazine Violet

Olives are green to begin with (left), slowly turning into the familiar wrinkled, oily black fruits. The illustration (center right) shows the racemes of small, whitish flowers. The bark is ridged and plated in small squares. The crooked trunk is gnarled and dimpled, and can be immense, although it is often hollow (center left).

4 Starting with the nearest trees, and using a mix of Viridian and Burnt Sienna, paint in the third tone on the foliage, aiming for a little extra definition on the clumps of foliage, but always bearing in mind the overall shapes and light direction. Concentrate the color mainly in the shaded areas, and avoid fussy detail in the light areas. As you work, keep half-closing your eyes to simplify the forms. For the trees in the middle distance, change the color to a mix of Olive Green with a touch of Burnt Sienna, and for the far right tree, use Prussian Green alone. Soften the edges where needed as you paint by dabbing gently with a soft, clean tissue.

5 Using the same brush, well loaded with watery Dioxazine Violet, paint the third glaze on the ground shadows, tree trunks, and branches,. On sections of the foreground trunks, especially where they disappear into the foliage, use a mix of Dioxazine Violet and Burnt Sienna. Now that the foliage has been painted, you can wash in the sky at the top of the tree with fairly strong Cobalt Blue. Then complete the foliage, using a smaller, round brush to add dark accents in the shadowy areas. For these, use mixes of Olive Green and Burnt Sienna on the nearest trees, and mixes of Viridian and Dioxazine Violet (cooler colors) on the others.

6 Add final dark accents to the nearest trunks and branches with mixes of Dioxazine Violet, Burnt Sienna, and Prussian Green. The far distant tree on the right needs to be cooler in color (see COLOR MIXING), and more in silhouette to balance the composition, so omit the Burnt Sienna, and wash in details with a mix of Prussian Green and Dioxazine Violet. Finally, scratch out white highlights on the nearest trunks using a sharp blade (see SCRATCHING OUT).

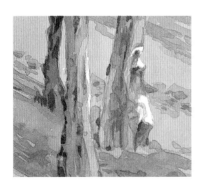

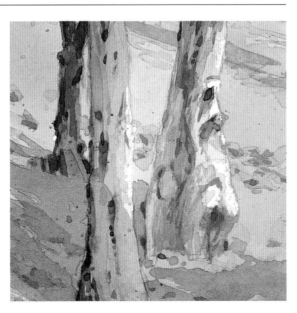

4 Paint in the final dark accents with mixes of the previous colors – Dioxazine Violet, Burnt Sienna, and Prussian Green. Brush in the dimples and fissures so as to give a gnarled appearance. When glazing, always choose the first color with care, as it will influence the end result.

Olea europaea

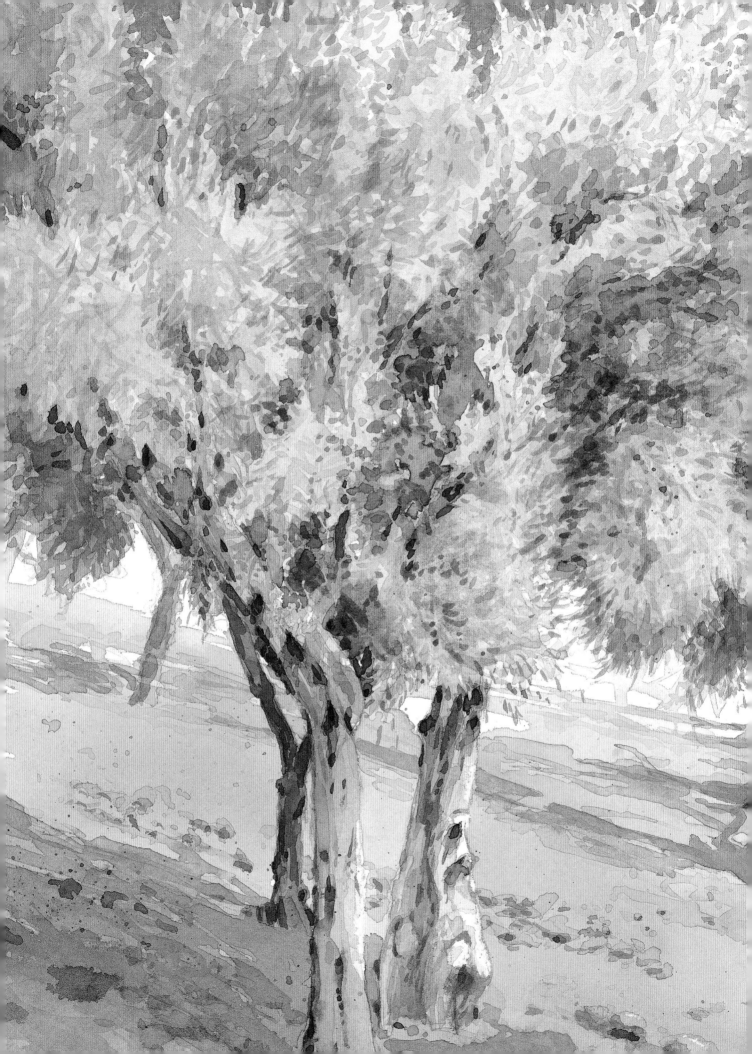

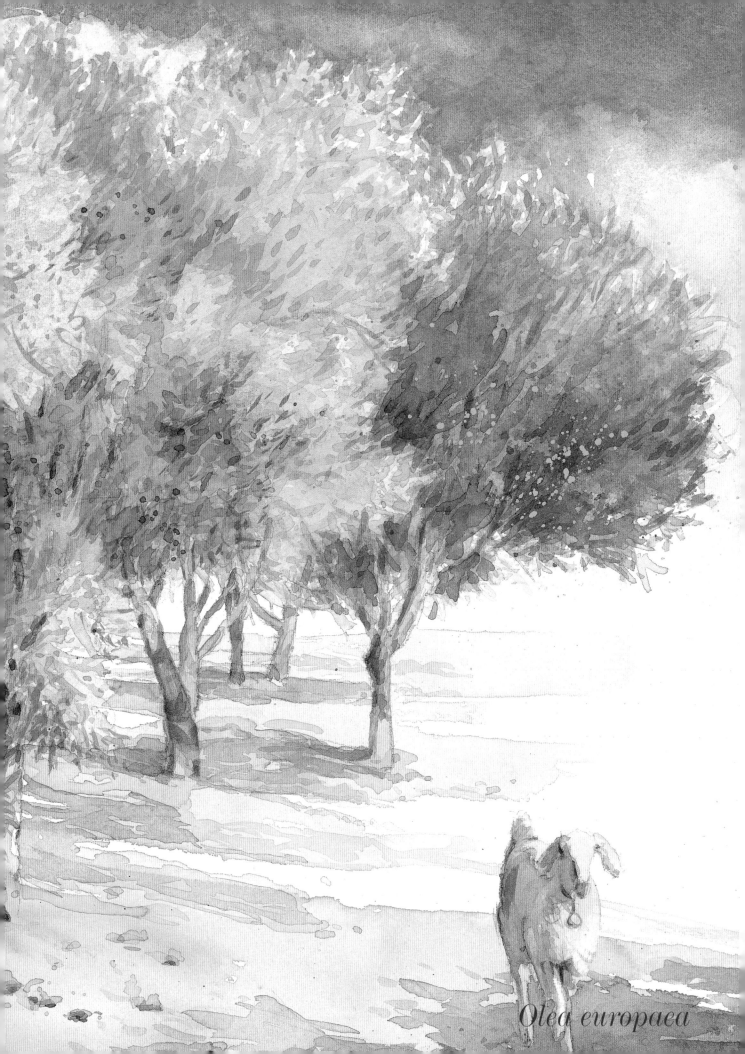

Olea europaea

Pinus pinea Umbrella Pine

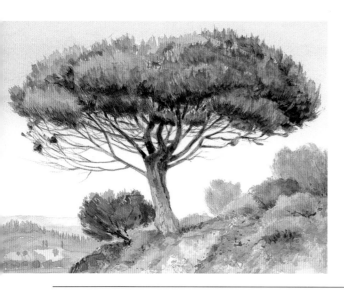

This tree, with its unique crown that flattens out at the top and becomes very dense, is one of the classic Mediterranean landscape trees. It provided Roman gardeners, and later those of the Renaissance, with the perfect foil for the black pillars of their cypresses.

In spring, when growth starts, the tree goes through a distinct period called the "candle" phase, referring to the young shoots that elongate rapidly before the leaves develop. The large, beautiful cones, surrounded by the pine needles that form one of the tree's most characteristic and ornamental features, ripen over a three-year period, and contain the large, edible pine kernels called *pinyons* or *pinocchi*.

Try to capture the unique qualities of the tree and the underlying pattern of its structure, noting the way in which the branches continue to divide after separating from the trunk.

sequence start to finish

1 This is a highly rhythmic picture based on broadly oval repetitions, but ensure that these don't become mechanical or boring by varying the shapes, sizes, and intervals between them. In the preliminary sketch, very lightly draw in the main outlines and give an indication of the foliage clumps. Lay a variegated wash (see VARIEGATED WASH) over the whole picture, wetting the paper and starting at the top with a large wash brush and pale Cobalt Blue. Change color half-way down to pale Raw Sienna and continue with this color down to the bottom. While damp, lift out color (see LIFTING OUT) from the tops of the foliage clumps with a tissue.

2 Paint the cool colors in the far-distant area, working wet-in-wet (see WET-IN-WET) with mixes of Cobalt Blue, Raw Sienna, and touches of Indigo. When dry, start to work on the main tree, looking for the simple patterns formed by the light, middle, and dark tones that emphasize the oval clump shapes. Block in the lightest first, using short, upward strokes that follow the direction of the foliage, especially at the silhouetted edges. Work quickly, using the side of a No. 12 round brush and a mix of Transparent Yellow, Raw Sienna, and Hooker's Green. While damp, go back in it with a relatively dry brush fully loaded with a mix of Hooker's Green and Burnt Umber, and

carefully rough-brush (see BRUSHWORK) the middle tone, painting around the lighter needles on the top of each clump. Again while damp, add a darker tone with a mix of Hooker's Green and Sepia, continuing to make upward strokes. Allow to dry.

3 Using a medium round brush, paint the trunk with a mix of Raw Sienna and a touch of Alizarin Crimson, taking this color into the foreground, but leaving parts of the first wash showing. Create broken textures by sponging in (see SPONGING) slightly darker shades, adding Dioxazine Violet to the mix. Use a sponge also to paint the nearest of the small bushes in the foreground with the

special detail feeding branches into foliage

1 *The way the branches disappear into the very dense foliage clumps is a characteristic of this tree. Begin by drawing the main branches and foliage shapes. Paint the pale sky wash, and allow to dry.*

2 *Using the dry-brush technique and angling the strokes upward paint the foliage clumps with mixes of Hooker's Green, Transparent Yellow, and Raw Sienna. While damp, paint the mid- and darker tones.*

3 *When dry, paint the first washes on the branches. Notice how they feed up into the foliage, and are seen through the gaps. Most are in shade, as is the upper trunk, as the foliage casts shadows on all but the lowest reaches.*

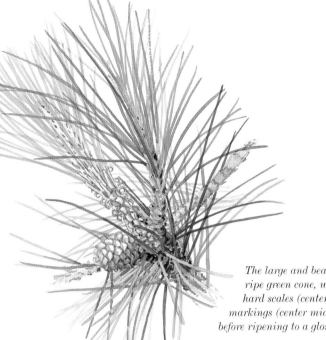

The large and beautiful
ripe green cone, with thick,
hard scales (center left). The bark is dark and fissured, with reddish
markings (center middle). The pale brown cones remain closed for three years
before ripening to a glossy green. The sharp-pointed needles grow in pairs (left).

Burnt Umber

Hooker's Green

Cobalt Blue

Raw Sienna

Dioxazine Violet

Alizarin Crimson

Indigo

Sepia

Transparent Yellow

lightest foliage tone, then paint the farther-off bushes with a mix of Hooker's Green and Cobalt Blue.

4 Paint in the mid-tones on the branches, including the shading on the trunk, with a No. 8 round brush and mixes of Burnt Umber, Cobalt Blue, and Dioxazine Violet. More cool colors are now needed on the foliage clumps, mainly on the right, so glaze on (see GLAZING) some thin Hooker's Green with the side of No. 10 round brush, keeping the strokes lively.

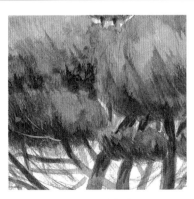

5 The darkest shadows on the undersides of the foliage clumps may need to be intensified. If so, dry-brush with a mix of strong Hooker's Green and Burnt Umber, and then darken the branches with strong mixes of Alizarin Crimson, Dioxazine Violet, Burnt Umber, and Indigo. For the fine twigs on the lower branches, use a rigger (see BRUSHWORK), making feathery dry-brush strokes, working rapidly, and letting the tip of the brush skate lightly over the paper.

6 Add final dark accents to the foreground, and darken the bush on the left, beneath the tree, by first sponging on a Hooker's Green and

Burnt Umber mix and then stating a few branches with a brush. Adjust the tones on the right-hand group, and stroke in dark calligraphic details. Strengthen the edge of the foreground where it meets the blue distance with a dark mix of Dioxazine Violet, Alizarin Crimson, and Raw Sienna. Paint in just a few pinecones and wispy twigs on the tree with White Gouache tinted with Raw Sienna and Burnt Umber, and finally add some small foliage "candles" on the top of the foliage with White Gouache tinted with Transparent Yellow.

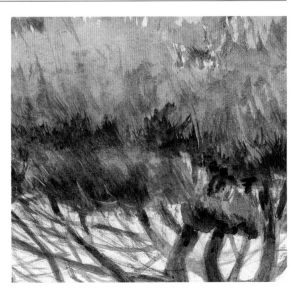

4 *To give the effect of the branches melting into the foliage, the tone used for both must be the same, but the colors can vary. Finally, suggest the small twigs in the sky holes by dry-brushing with a rigger.*

Pinus pinea

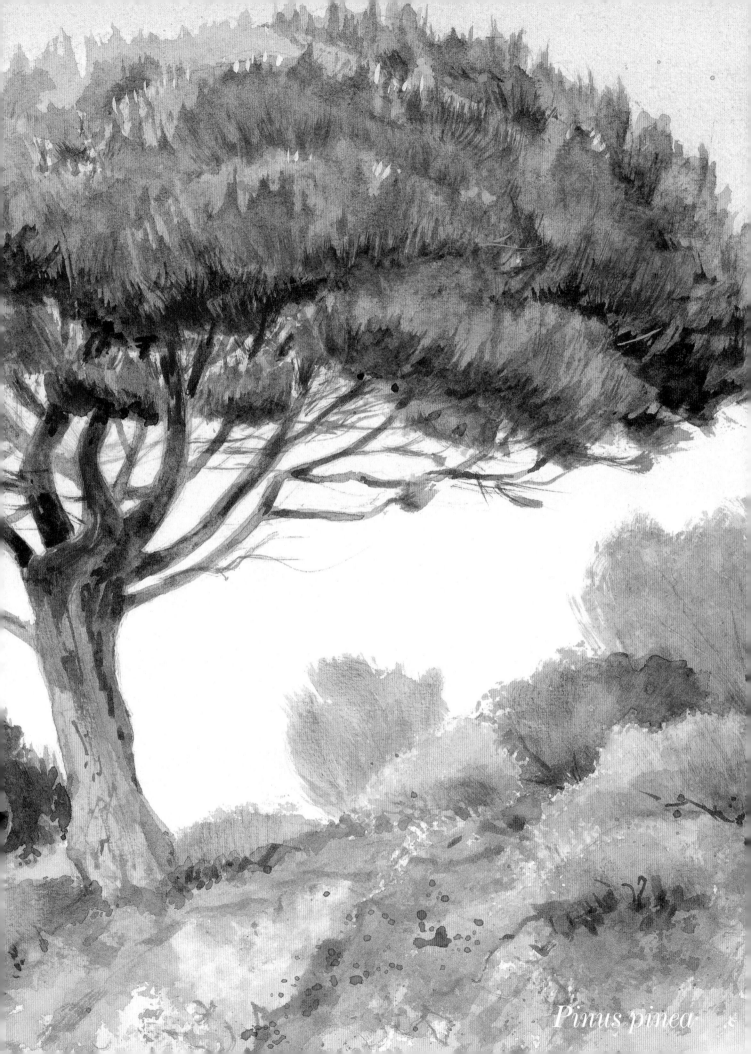

Pinus pinea

Quercus robur Common Oak

The common oak is a broad-spreading deciduous tree with a massive crown, a thick and deeply furrowed trunk ("robur" means "sturdy"), and gnarled, twisting roots. It is a familiar sight in the European countryside, where it is often the focus of rural communities, occupying pride of place in the centers of villages. This species is especially long lived, and specimens have been known to reach ages of 250 to 300 years, during which the trees can exceed 100 feet (33 meters) in height. The wood, which is hard and durable, is much used for furniture and building.

When painting oaks, notice the wide spread, the shapes of the foliage clumps, and the stout branches resembling stags' heads. Try to capture the forms, colors, and textures without engaging in too much detail.

sequence start to finish

1 Working on HP (Not surface) paper (see PAPER) make a careful sketch, paying attention to the characteristic branch structure and the overall shape of the canopy. Make a note of the direction of the light, which in this case is coming from top right, throwing the left side and the bottoms of the clumps into shade. Sketch in the outlines of the deer, then start to paint the foliage, loading a No. 14 round brush with a mix of Green Gold and Hooker's Green. Lay the brush onto the paper at the top right section of the main tree, and gently rotate it to suggest the tree's massed canopy,

leaving some small gaps, or "sky holes." At the outer edges, make horizontal stippling strokes (see BRUSHWORK) to hint at individual leaves. Paint over all the foliage of both trees, darkening the color a little as you proceed to the shaded side by adding more Hooker's Green to the mix, together with a little Cobalt Blue. Allow to dry.

2 Lay a wash of pale Quinacridone Gold over the foreground area of grass and tree trunks, adding touches of Cobalt Blue and Transparent Yellow toward the middle distance. Take these colors over the deer, reserving small areas of white on the one in the foreground. Once the foliage is dry,

start at the top of the paper and paint the sky between the clumps of foliage using mid-toned Cerulean Blue, watering down the color to give a graded wash toward the horizon. Take the color into the sky holes, especially those on the shaded side of the main tree

3 Now start to build up the foliage clumps to give the tree form and three-dimensionality, and enhance the bright yellow-greens of the sunlit leaves. Still using simple, stippled strokes and mixes of Green Gold, Sap Green, and French Ultramarine, lay a darker second tone in the depths of the canopy and on the undersides of the clumps. This tone should blend slightly

special detail hard and soft edges

1 *With foliage, consider the kind of edges that are formed when one wash meets another. Sometimes, you will want soft transitions of tone and color, but don't overdo the blending, or the painting could become dull.*

2 *Start with a wash of Green Gold and Hooker's Green. Allow to dry and add a slightly darker second tone. Vary the size of the strokes, reserving some of the first color. Hard edges will form as the paint dries.*

3 *While still damp add a third tone, and work wet-in-wet (see WET-IN-WET) to strengthen the shadows, dropping in a darker mix of the same colors. The softer blends contrast effectively with the crisp edges on the light areas.*

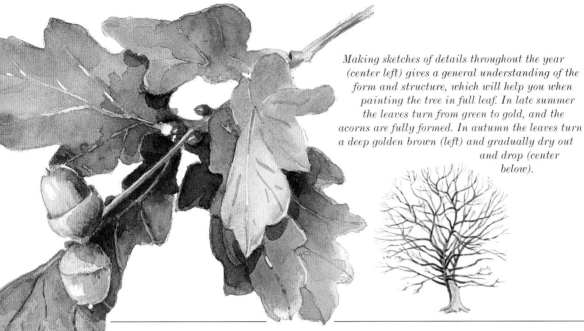

Making sketches of details throughout the year (center left) gives a general understanding of the form and structure, which will help you when painting the tree in full leaf. In late summer the leaves turn from green to gold, and the acorns are fully formed. In autumn the leaves turn a deep golden brown (left) and gradually dry out and drop (center below).

Cobalt Blue

Cerulean Blue

French Ultramarine

Burnt Sienna

Burnt Umber

Transparent Yellow

Green Gold

Quinacridone Gold

Sap Green

Hooker's Green

Olive Green

into the light, bright greens, so soften the edges with a damp brush (see HARD AND SOFT EDGES) as you paint. Use more blue in the mix for the left-hand tree so that it recedes a little, and avoid too much tonal contrast.

4 While still damp, create soft, wet leaf edges by dropping in a very dark mix of the same colors, using a No. 12 round brush. Add a little Olive Green, and employ the dry-brush technique (see DRY BRUSH) to suggest small leaves and a few twigs and small branches, allowing them to blend into the dark undersides of the foliage clumps.

5 Finish the main tree by painting in the branches and twigs, noting how the twigs relate to the branches and the latter to the trunk (it helps to imagine that the foliage is transparent). Use the same colors as before, but with the addition of Burnt Umber. Notice how the dense foliage casts shadows on the branches and all but the lowest areas of the trunk, and how the clumps of foliage overlap and obscure the branches in places – a common mistake is to silhouette the branches against the foliage.

6 Wash in the cast shadow behind the trees with a pale mix of Cobalt Blue and Hooker's Green, painting over the two deer in the shade. In the

foreground, dot in some patches of pale Burnt Sienna, using the same color to add more detail to the foreground deer. Allow to dry, and then paint darker details on all three deer with a smaller round brush and Burnt Umber. Finally, dot in a few small strokes of opaque white tinted with Green Gold and Sap Green on the darkest sections of foliage in the center of the tree, varying the tone to add interest. Don't overdo it!

4 Paint in the branches with a strong mix of Burnt Umber and Olive Green, and dot a little into the shaded areas to suggest darker leaves. Paint in a few lighter leaves also, to give extra interest.

Quercus robur

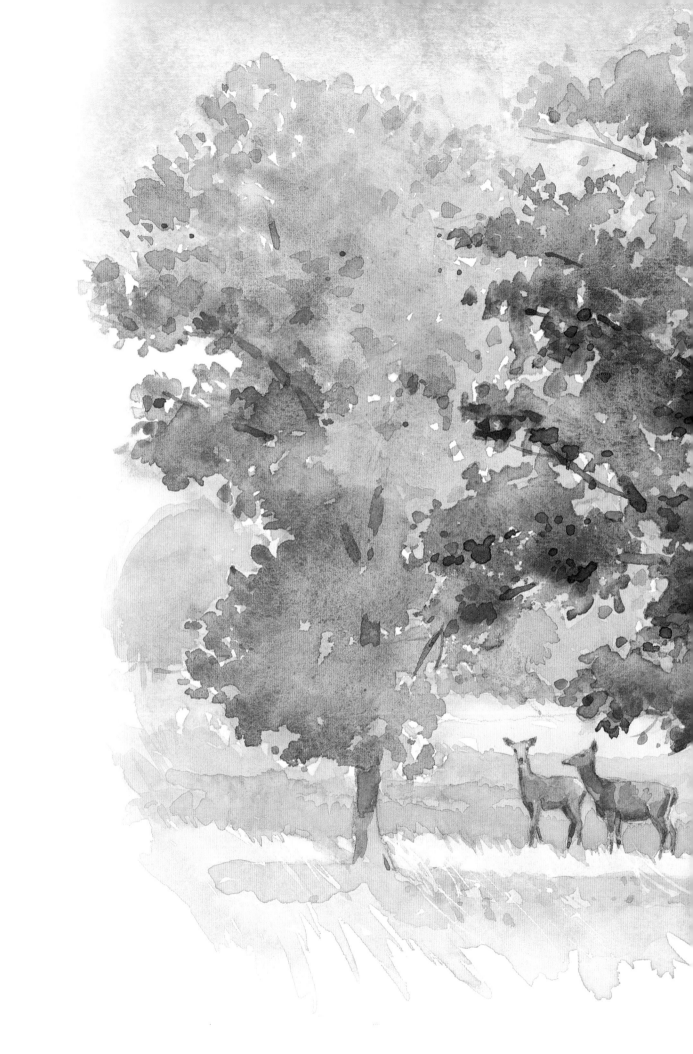

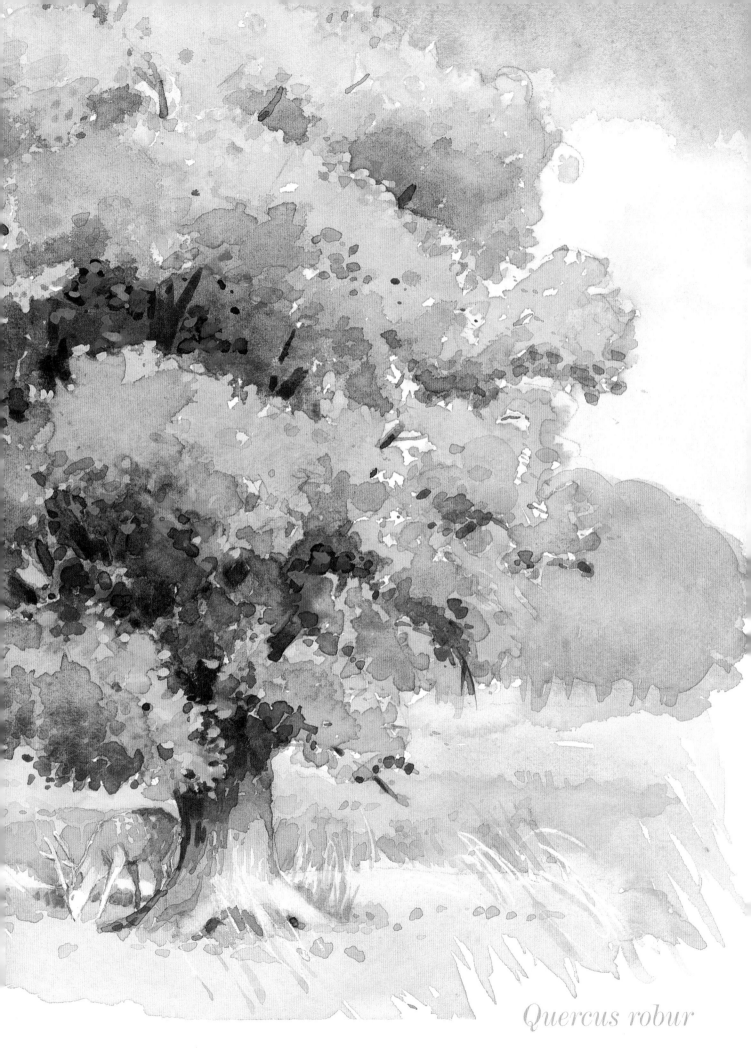

Quercus robur

Rhus typhina Staghorn Sumac

This small, flat-topped tree, a native of the eastern states of North America, is hardy and tenacious, belying its exotic, sub-tropical appearance. Its common name derives from the red-brown, mossy texture of the thick twigs, which closely resemble the velvet-clad horns of a stag in springtime. These sparse twigs are clothed in large compound leaves made up of fifteen or more leaflets, giving a fretted look, and in the autumn they turn glorious rich colors of flaming orange, red, and purple. The fruit clusters, sitting upright on the branches like tapered candles of closely-packed hairy crimson seeds, look positively primeval, especially after the leaves have fallen.

Every species has a particular branch structure, so when drawing and painting, observe this underlying pattern of growth carefully to achieve a convincing portrait.

sequence start to finish

1 Draw in the main tree shapes and lightly indicate the clumps in the middle distance and on the horizon. Mask out (see MASKING OUT and below) some leaf shapes in the body of the main tree, and then turn your attention to the sky. Lay a graded wash (see GRADED WASH) of pale Cerulean Blue, taking the color down to the horizon line. When dry, start at this line and paint a warm foreground wash of pale Quinacridone Gold, working over the large branches and up into the smaller right-hand tree.

2 Paint in the trees on the horizon, starting with a pale mix of Cerulean Blue and a touch of Dioxazine Violet, letting this color fade into the earlier wash on the right. Take the wash around the branches of the main tree to keep the gold color. When dry, paint in the nearer clumps with slightly stronger mixes of the same colors plus Brown Madder, varying the proportions. Continue downward to the lowest edge, strengthening the foreground with a mix of Quinacridone Gold and Transparent Orange, and immediately dropping in a darker mix of Dioxazine Violet, Quinacridone Gold, and Transparent Orange. Before dry, use a rigger brush (see BRUSHWORK) to make downward strokes, teasing the color into the gold wash to suggest grasses. Let dry.

3 Now start developing the tree masses, bearing in mind that the light is coming from the left, so the leaves will be generally lighter on this side. Try to work over the whole surface at the same time and to simplify where possible. Using a round No. 10 brush well loaded with paint – Transparent Orange in some places and Quinacridone Gold in others – work over the foliage with broad strokes for the main areas of color, making finer strokes at the edges to suggest the leaf shapes. Leave "sky holes" between areas of foliage, especially toward the top of the trees. Near the darker right side, use Transparent Orange on its own, but add a little Dioxazine Violet for the

special detail using masking fluid

1 *Masking fluid allows you to work boldly without losing highlights. Decide where the pale shapes are to be, draw them in, and paint the fluid over them. When dry, paint the foliage colors over the whole area.*

2 *Here masking fluid is used just after drawing, but can be used at any stage. Next, add tones using Brown Madder and Alizarin Crimson, varying the brushstrokes from broad masses to leaf-shaped marks.*

3 *Now paint in darker accents on the leaves. When dry, add the branches with mid- and dark tones of Indigo and Brown Madder. Paint the fruits, and when dry, gently rub off the masking fluid with a putty eraser.*

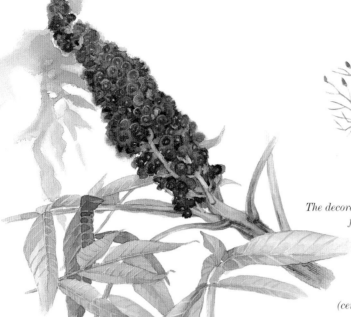

The decorative, pyramid-shaped, dense
fruit clusters, up to 8 inches (20cm) long,
are crimson, and velvety in texture
(left). The flowers open in July, and
remain on the tree long after the leaves
have fallen (center left). The colors of the
leaves in autumn are quite spectacular
(center right). The tree in winter (above).

Cerulean Blue

Quinacridone Gold

Brown Madder

Dioxazine violet

Transparent Orange

Alizarin Crimson

Indigo

background tree silhouette
on the right. Continue to
build up with slightly
darker tones, mixing in Brown Madder
and Alizarin Crimson, and working up to
the darkest tones of all, which are
either strong Alizarin Crimson or a mix
of Brown Madder, and Dioxazine Violet.
Allow to dry, and then dot in the fruit
with the darkest leaf mix.

4 When fully dry, rub off the masking,
and tint the white leaves with pale
shades of the previous foliage colors.
Next, add some shading on the trunk,
using mixes of Dioxazine Violet,
Cerulean Blue, and a touch of
Quinacridone Gold, and reserving areas

of the first wash where it catches
the light. Paint the trunk and branches
of the distant right tree with the same
colors, but avoid leaving highlights, as
this tree must appear to recede.

5 Some darker accents are needed at
the lower edge of the composition,
so paint in some feathery saplings with
the No. 10 brush and a mix of Dioxazine
Violet and Brown Madder. Using this
same color, and varying the tones
slightly, paint some dark leaves on the
left-hand tree, and then add the
branches with a mid-toned mix of Indigo
and Brown Madder. With a stronger mix
of the same colors, paint in the darkest
accents on the trunk and branches of the

main tree, leaving some lighter so that
they recede. There are more twigs
showing at the left of the tree, so paint
these over the orange leaf colors to give
the effect of leaves in the background.

6 Finally, introduce touches of
Cerulean Blue mixed with White
Gouache into the shaded strip of
golden grass. This cool blue is roughly
the complementary of the dominant
orange of the foliage (see COLOR),
providing a telling contrast to the
overall warmth of the color scheme.

4 When the fluid is removed, the
shapes usually look too white, and
will need to be tinted. Use the
previous foliage colors to do this, but
keep them a pale golden color so that
they stand out.

Rhus typhina

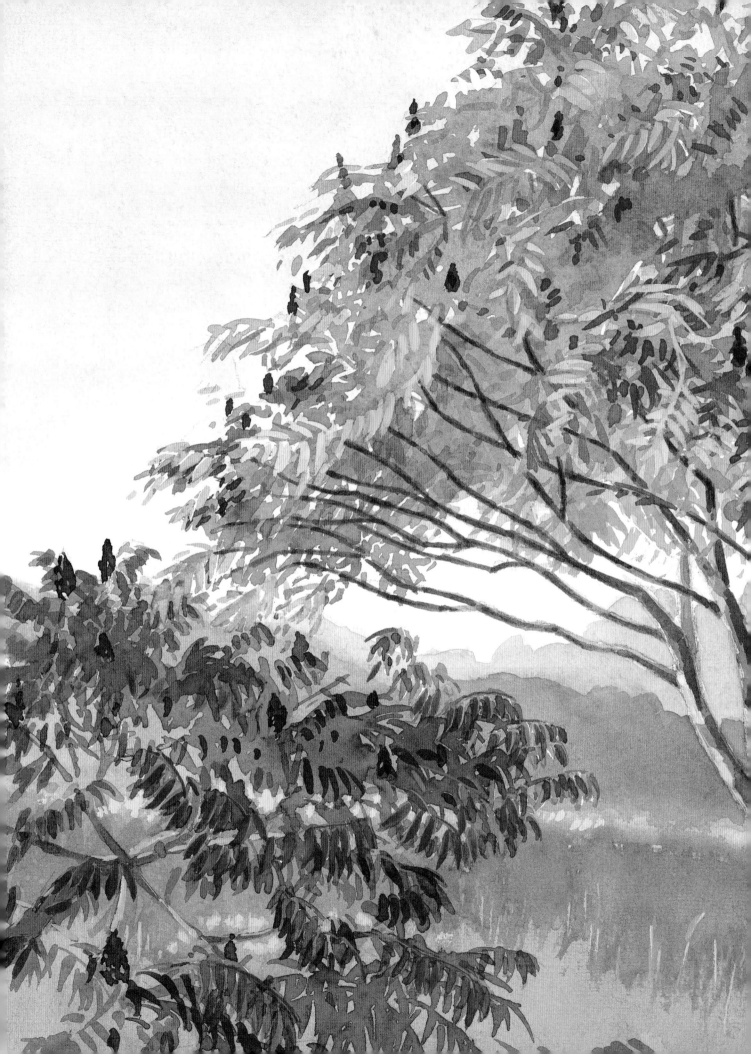

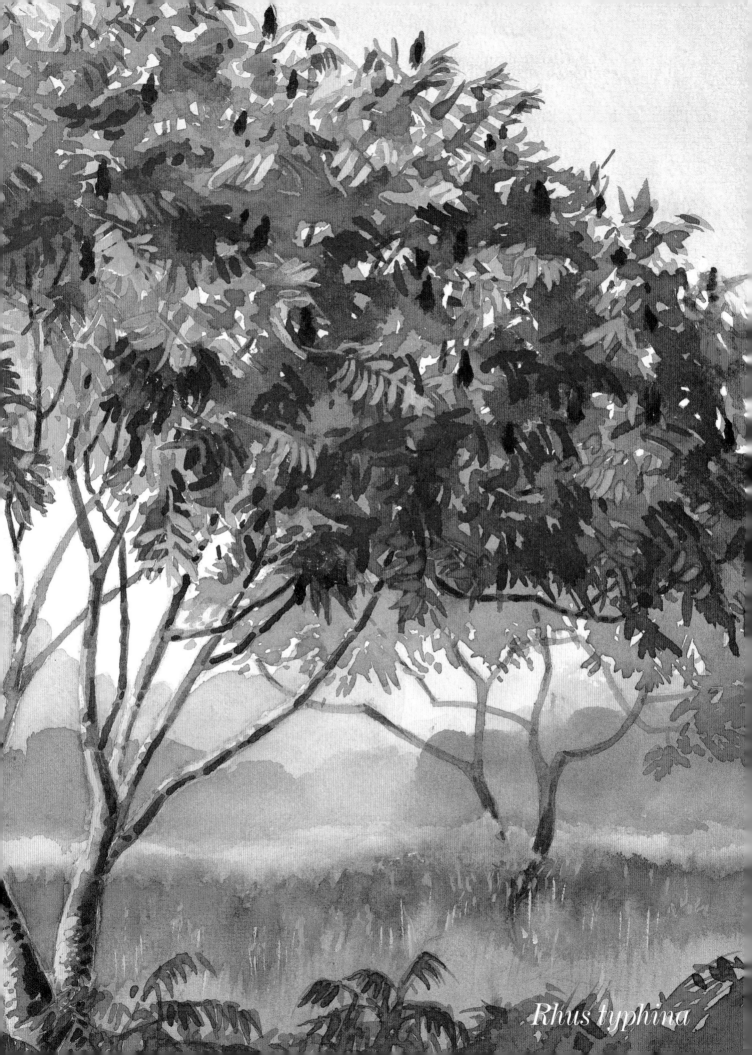

Rhus typhina

Salix chrysocoma Golden Weeping Willow

The weeping willow is a hybrid of the wild willow, which grows only in western China. Nowadays this lovely tree seems almost a necessary adjunct to any ornamental pond or lake, and on still days the golden cascades of hanging foliage, together with their reflections in blue water, can look quite breathtaking. Willow trees will only spread naturally along watersides or on marshy ground because their minute seeds need damp soil for germination. In winter the bright yellow framework of branches and twigs stands exposed, like a sculptor's armature, and one of the first signs of spring is the early fat buds bursting into powder-puff catkins.

Weeping willows are large trees, but the branches and leaves are delicate, and the challenge lies in finding ways of capturing the lacy qualities without losing sight of the overall structure of the tree.

sequence start to finish

1 This willow needs to be drawn rather more precisely than some of the other trees, as the structure is quite complex. Mask out (see MASKING OUT) the three small ducks and a few horizontal lines where the foreground bank meets the water, then use a No. 18 flat brush to lay a wash of Transparent Yellow plus a little French Ultramarine over the sunlit tree and on the foreground grass, leaving a few "sky holes" at the center and right side. At the outer edges, make short, thin, feathered brushstrokes (see BRUSHWORK) to suggest the leaves. This first wash acts as an underpainting, which will give extra warmth to the completed work.

2 When the wash has dried, paint the sky, first wetting the area roughly with clean water. Using a No. 14 round brush and French Ultramarine with a touch of Alizarin Crimson, lay a variegated wash (see VARIEGATED WASH), carefully cutting in around the edges of the tree, and grading to very pale Quinacridone Gold at the horizon. Allow to dry, and then wash in the distant willow with a mid-toned bluish mix of French Ultramarine and Transparent Yellow. While damp, use a clean, damp flat brush to lift just a little of the color to suggest the fall of light. Allow to dry.

3 Now paint the next leaf tone on the large tree, using the flat brush and

a mix of French Ultramarine and Transparent Yellow with a touch of Quinacridone Gold to soften the green. Feather downward-sloping strokes to indicate shading on the foliage clumps, leaving some of the first wash for the lightest leaves. Work across to the right-hand, shadowed side of the tree, changing to a mix of Phthalo Green and Alizarin Crimson, and taking the color right over to the outer edges. Allow to dry.

4 Next concentrate on the skeleton of the tree, but try to simplify where possible, as too much fussy detail will weaken the painting. Using a No. 10 round brush and mixes of French Ultramarine, Alizarin Crimson, and

special detail using body color

1 White Gouache, or body color, allows you to paint light over dark, but should only be added in the later stages. After sketching in the main shapes, lay a wash of Transparent Yellow over the tree.

2 Gouache needs a toned or colored ground to exploit its covering power. Thus the watercolor is applied first as a base. Paint the darker, cooler-colored background trees, using the side of a flat brush.

3 Continue to build up the foliage with darker tones, and paint some more solid areas of color. When dry, paint in the branches with a rigger and mixes of French Ultramarine and Alizarin Crimson.

The bark (left) is a pale grayish-brown color, and characterized by irregular furrows. The narrow, lance-shaped, yellow-green leaves, with their finely serrated margins, (center left) grow 3 to 6 inches (7.5-15cm) in length. The yellow-orange catkins(center right) arrive with, or just before the leaves. The tree in winter is shown on the right.

French Ultramarine

Transparent Yellow

Alizarin Crimson

Quinacridone Gold

Phthalo Green

Indigo

Phthalo Green, paint the dark trunk and the major branches, taking the color over the leaf masses. Later on, you will be painting more light and dark leaves, which will soften the dark branches. Paint in some finer twigs with a rigger (see BRUSHWORK), and then add some shading to the foreground grass with Phthalo Green plus a little French Ultramarine, letting the color merge into the bottom of the trunk.

5 The light is coming from the left and behind the tree, so the darkest leaf clumps are in the foreground. Paint these foliage masses with a mix of Phthalo Green, Alizarin Crimson, and a little Transparent

Yellow. To create a little texture, use the side of a No. 8 round brush – which gives a more ragged stroke than the tip – and stroke the color downward, following the direction of the cascading foliage. Take the color over parts of the trunk and branches to soften them, and then paint the water behind with a mix of Phthalo Green and Alizarin Crimson, dry-brushing (see BRUSHWORK) in the center to leave a strip of broken white. When dry, rub off the masking on the water and ducks.

6 To paint the lightest foliage and emphasize the lacy leaves, use a No. 6 round brush and White Gouache (see BODY COLOR and below) tinted with Phthalo Green and French Ultramarine. Lightly

dry-brush the color downward, starting at the shaded side, and taking strokes over parts of the trunk and branches to give depth. Change the tint as you work toward the left side of the tree by adding Transparent Yellow to the mix, and when dry add the very lightest accents with just white and a touch of Transparent Yellow.

7 To link the foreground grass to the trunk, paint horizontal strips with a mix of Indigo and a touch of Alizarin Crimson. Finally, accent parts of the trunk and branches with a dark mix of the same colors, and paint the ducks with shades of Indigo and a little Alizarin Crimson.

4 Make a fairly dry mix of White Gouache and watercolor, and apply it to the paper. The paint will adhere only to the raised grain of the paper, giving an effect that effectively describes the foliage.

Salix chrysocoma

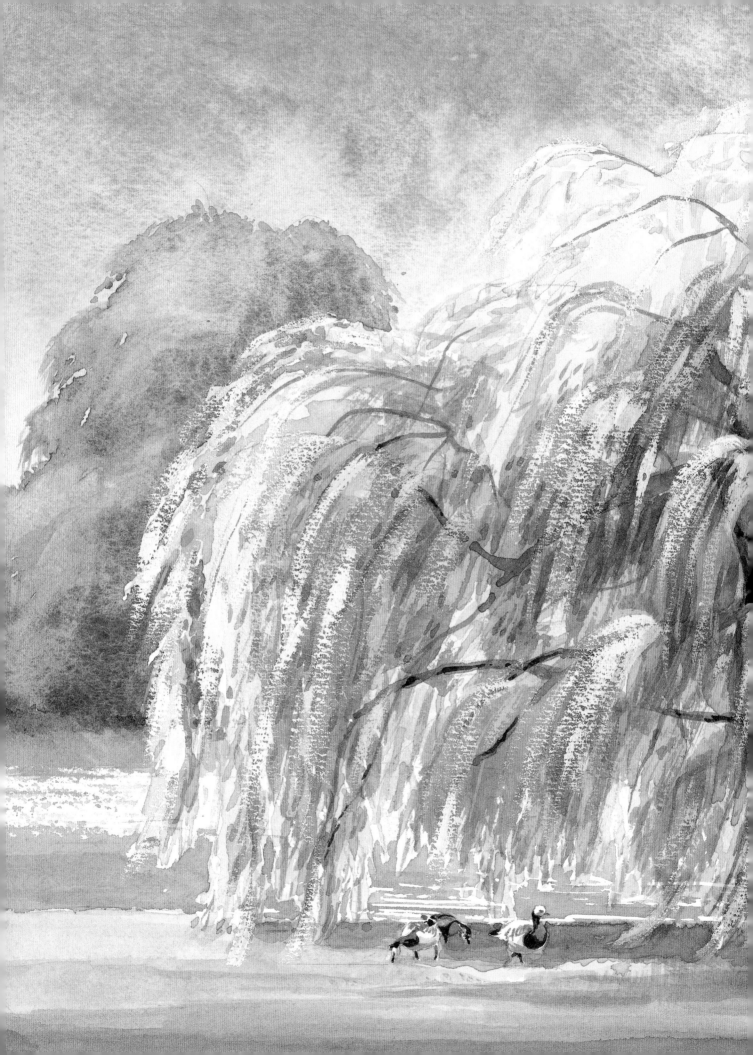

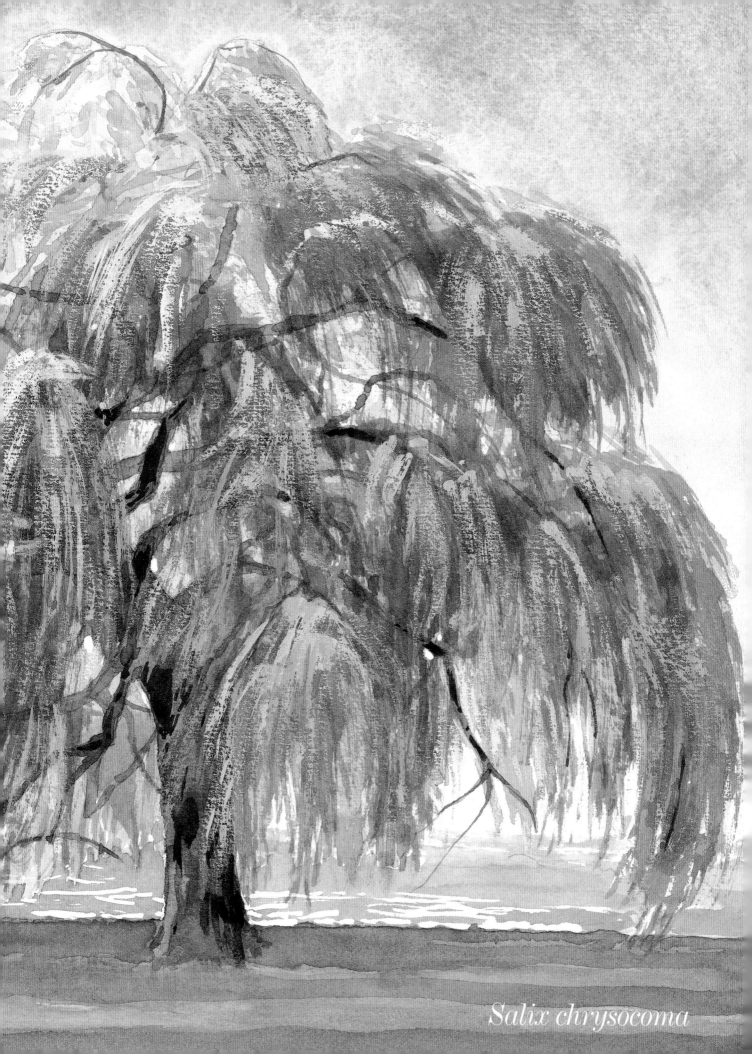

Salix chrysocoma

Trachycarpus fortunei Windmill palm

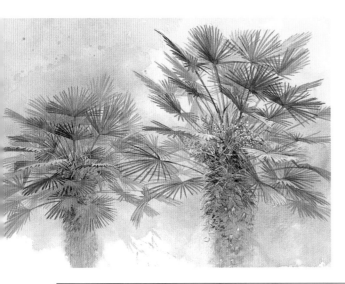

This tree, also known as Chusan palm, is a native of the temperate Far East, and is the hardiest of all the palms. The leaves are fan-shaped (palmate), which is one of the three basic leaf shapes in palms, the others being feather-shaped (pinnate) and double-feather. Each year the windmill palm grows two or three of the huge fan leaves, measuring 39 inches (1 meter) or more across. It sheds its old yellowed leaves at the same time, but the old leaf bases remain, covering the trunk with a mat of brown furry fiber. The trunk can reach a height of 15-30 feet (5-10 meters), with the tufts of leaves sprouting out close to each other at the top, giving an exotic appearance.

The challenge for the artist is how to interpret the play of light on the pleated leaf forms, while giving solidity to the tree by making some leaves recede and others come forward.

sequence start to finish

1 Carefully draw in the palm fronds, noting how the shapes vary according to the angle of viewing. The right-hand tree is in front of the other and is thus larger. Mask out (see MASKING OUT) the areas where the leaves catch most light as well as a few of the tufts on the trunks and the fruiting stalks on the large tree. Dampen the paper all over with clean water and then lay in a variegated wash (see VARIEGATED WASH) with Cobalt Blue and Transparent Yellow, dropping a little Burnt Sienna at the top, above the left-hand tree. Leave a few white areas. Let the colors merge a little, then leave to dry.

2 Paint the first washes over the trunks, working wet-in-wet (see WET-IN-WET). Start with a watery wash of Prussian Green on both trunks and then drop in both Dioxazine Violet and Burnt Sienna at the top of the right trunk. Soften the outer edges with a clean, damp brush to avoid a hard line where they meet the background, then allow to dry.

3 Now start to paint the leaves, working from the lighter ones in the background toward the dark ones in the foreground. Use a medium-sized round brush with a good point to make linear brushstrokes radiating outward from the center of each leaf, always keeping the

overall shape in mind. On the right-hand tree, use fairly pale Cobalt Blue, changing to Prussian Green for the background leaves on the left tree. Allow to dry.

4 The next layer of leaves – those in the middle distance, and some of the lower fronds cutting across the trunks – are painted a tone darker. Continue working with the same brush, painting with combinations of Hooker's Green, Transparent Yellow, and Prussian Green for the right-hand tree. The palm on the left must be cooler in color to allow it to recede a little.

5 The tops of the trunks can now be given more definition. For the right-

special detail analyzing leaf structure

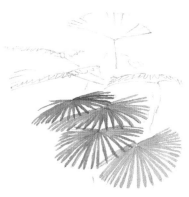

1 *Each leaf is a fan-shape, with the leaf spikes radiating out from a center point. But the appearance changes depending on whether the leaf is foreshortened, turning to the side, pointing upward, or hanging down.*

2 *The three upper leaves are foreshortened, appearing as flattened ellipses. Relate the stalks to the centers of the fronds, and note how the direction of the foreshortened spikes changes from one side to the other.*

3 *The four lower leaves progress from a quite shallow elliptical shape at the top, to the open fan-shape of the bottom leaf. Here you can clearly see how the spaces between the leaf spikes are larger at the front of the leaf.*

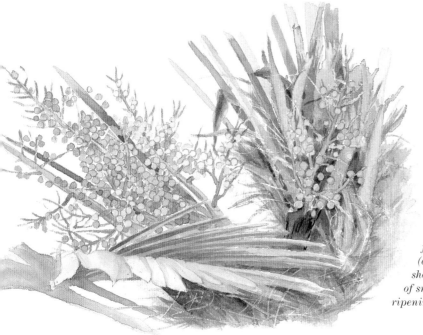

Broad, fan-shaped, pleated leaves radiating outward from the stem (center). Detail showing long panicles of small spherical fruits, ripening to blue (left).

Transparent Yellow

Cobalt Blue

Prussian Green

Burnt Sienna

Dioxazine Violet

Hooker's Green

hand one, use the round brush and a Burnt Sienna and Dioxazine Violet mix, teasing the paint into some of the darker crevices. While still wet, use a rigger to drag out the color at the edges to suggest the fine hairs. Paint the left-hand trunk with a cooler mix of the same colors. When everything is dry, rub off all the masking, and then complete the left-hand tree. Tint the wispy dried bark hairs with mixes of Dioxazine Violet and Burnt Sienna, and the white areas of the leaves with mixes of Transparent Yellow and Prussian Green. Paint the darkest leaves with strong mixes of Hooker's Green and Prussian Green, taking the stalks right into the heart of the crown.

6 Finish the main tree, first tinting the white leaf sections with pale shades of Transparent Yellow and Prussian Green. Paint the darkest leaves with strong Hooker's Green at the top, lightening it with Transparent Yellow for the leaves on the left, which overlap those of the smaller tree. Make sure to take all the leaf stalks well into the trunk and crown. Tint the small round fruits with pale Prussian Green and a mix of Prussian Green and Transparent Yellow, leaving a few of the forward-thrusting ones white. Tint the fruit stalks with a warmer mix of Transparent Yellow and Burnt Sienna.

7 Finally, add the darkest accents in and around the stalks and leaves at the crown with dark mix of Dioxazine Violet and Burnt Sienna. If some of the small white negative shapes at the top of the left-hand tree have become lost in the painting process, restate them with thin White Gouache, then spatter a little Transparent Yellow into the background area here and there to break up the wash and to carry the yellow over from the right side.

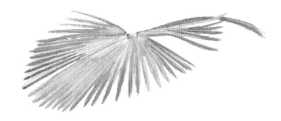

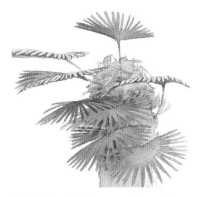

4 Note how the leaves overlap each other and how they vary in tone, with the flattened upper ones that face the sky catching more light. Paint the leaves from light to dark, weaving the stalks into the top of the trunk.

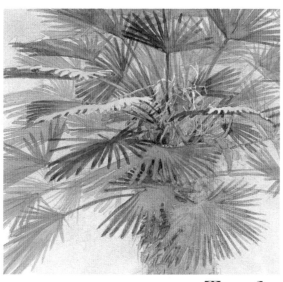

Trachycarpus fortunei

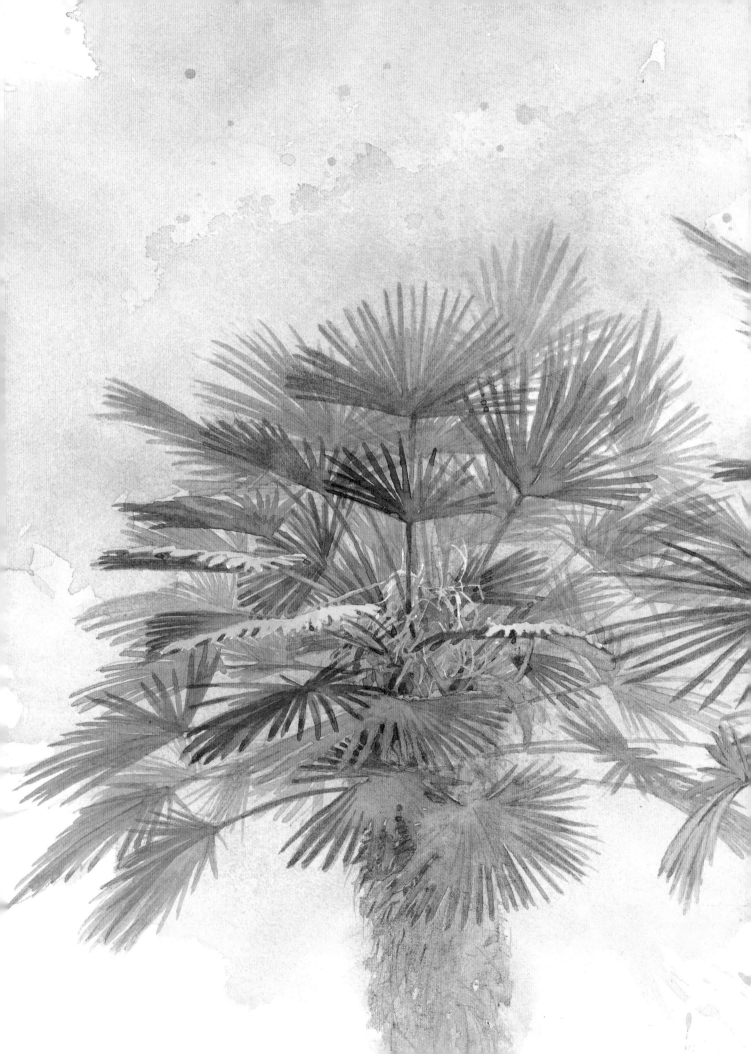

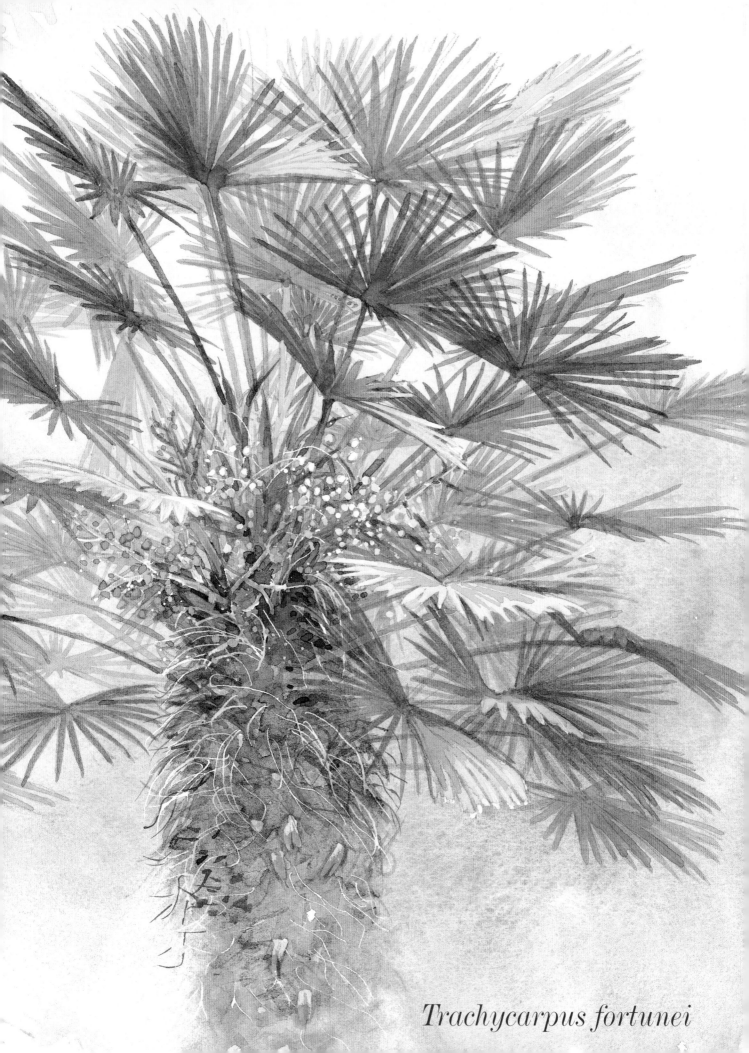

Trachycarpus fortunei

American Elm

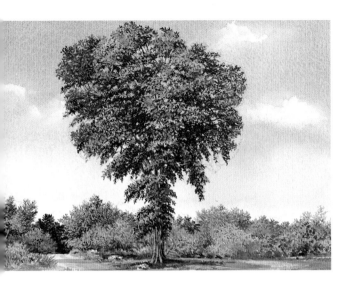

This tree, native to North America, and found from Florida to Newfoundland, was a major feature of the landscape until Dutch elm disease began to threaten the entire elm family. It is now making a return in the USA, as resistant species are being grown, though the British elm has been almost entirely destroyed. It is a large, broad, and wide-spreading deciduous tree, sometimes reaching a height of 100 feet (30meters). It is immediately recognizable by its distinctive vase shape, and is much valued as a lawn tree, and as a shade tree in urban areas. It has simple leaves with doubly serrated margins with an oblique leaf base, dark green in color, and turning yellow-brown in the autumn.

The challenge is to do justice to the height and shape, and in this painting the tall tree has been contrasted with low-growing trees and shrubs to give a sense of scale.

sequence start to finish

1 Lightly draw the composition with a 2B pencil, paying careful attention to the main shape and the relationship of the trunk to the branches. Wet the paper in the sky area, turn the board upside down, and apply a wash of pale Indian Yellow, working up from the horizon line and fading out the color toward the top. Allow to dry, turn the board the right way up, and then apply another wash of Cerulean Blue, this time working from the top downward, and quickly lifting out (see LIFTING OUT) cloud shapes with a tissue. This method of laying two washes in opposite directions gives the effect of a graded wash.

2 Now begin to paint the leaves of the main tree, working from the top down and using a small round brush and various mixes of French Ultramarine and Cadmium Yellow, Yellow Ocher, and Indian Yellow. Make small separate brushmarks, varying their size and shape, and keeping the paint relatively dry, so the marks do not run together too much. Leave small patches of the sky color for highlights, and take care to preserve the light, negative shapes (see NEGATIVE PAINTING) where the sky shows between the clumps of foliage and the lower branches.

3 Before completing the foliage, paint the trunk and lower branches, starting with a light wash of Cerulean

Blue, Raw Sienna, and Payne's Gray. The trunk is central to the picture so be careful not to make it too wide and to keep the branches in proportion. When dry, use the dry-brush technique (see BRUSHWORK) to work over the first color with mixes of Vandyke Brown and Neutral Tint, and Neutral Tint on its own. Use the same colors to paint the smaller branches at the top, using a very fine brush or a rigger (see BRUSHWORK), and paying special attention to the relationship of these branches to the foliage clumps at the top and edges.

4 Finish the foliage on the main tree next, starting by adding dark

special detail texture with watercolor, acrylic, and sgraffito

1 *The texture of the elm's bark, with deep ridges that show different layers of color, is interesting. Draw in the outline, indicate the patterns of the bark with downward pencil strokes then lay the first light wash.*

2 *Using the side of the brush and very dry watercolor, define the bark texture, using yellow-brown mixes of Vandyke Brown and Neutral Tint. The paint will catch on the grain of the paper, giving a bark-like texture.*

3 *Make small dark brushstrokes to describe the cracks on the shadowed side of the trunk, closer together as the form turns around at the edge. Then dry-brush over the light areas with White Acrylic.*

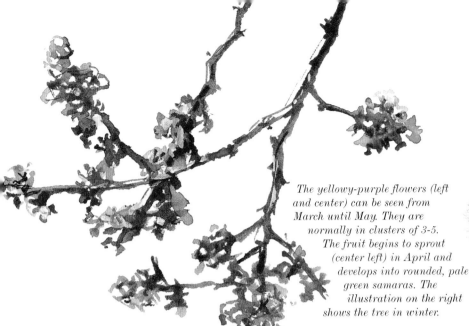

The yellowy-purple flowers (left and center) can be seen from March until May. They are normally in clusters of 3-5. The fruit begins to sprout (center left) in April and develops into rounded, pale green samaras. The illustration on the right shows the tree in winter.

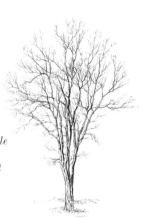

Winsor Violet

Vandyke Brown

Neutral Tint

Payne's Gray

French Ultramarine

Cerulean Blue

Burnt Sienna

Raw Sienna

Yellow Ocher

Indian Yellow

Lemon Yellow

Cadmium Yellow

shadows at the bottoms and edges of the leaf clusters with various mixes of Payne's Gray, Vandyke Brown, and French Ultramarine. Work in some warmer color to enliven the greens, using mixes of Burnt Sienna, Yellow Ocher, and Indian Yellow. Now add the highlights, mixing a little White Acrylic with the first foliage colors, and adding a little Lemon Yellow. Don't overdo it as the tree needs to stand as a dark shape. The foliage clumps at the top of the tree come forward in space, giving form to the tree, so here use White Acrylic again, this time mixed with Burnt Sienna and Yellow Ocher.

5 With the elm now complete, you can paint the background trees and bushes. Begin by laying a wash over the whole area, using a large brush and a mix of Cerulean Blue and Lemon Yellow with a touch of Raw Sienna. When dry, build up the foliage with the color mixes used for the elm, reserving some of the first wash for the light-colored bush on the right of the elm. For the dark bush at the end of the road, use a strong mix of Vandyke Brown and Ultramarine, and bring touches of this dark tone into the foliage at right and left to balance the composition.

6 Finally, lay a wash over the whole foreground area except the road,

using a large brush and a mix of Raw Sienna, Yellow Ocher, and a touch of Winsor Violet, lifting out (see lifting out) highlights on the stones while still damp. When dry, paint the road with a mid-toned wash of Neutral Tint, again lifting out the curving near-white highlights at the end of the road. Paint the pattern of shadows with a medium-sized round brush and mixes of Payne's Gray and Vandyke Brown, using a small brush and the same color to build up the forms of the stones. Add the very dark shadow spreading out from the foot of the tree with a darker mix of the same colors, making small leaf-shaped marks at the edges to link with the foliage above.

4 Using the tip of a sharp knife, scratch back to the white of the paper in places, making downward strokes, and then lay on more dark washes over the scuffed paper. This is a useful method for texturing.

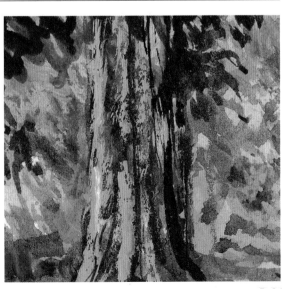

Ulmus americana

American Elm

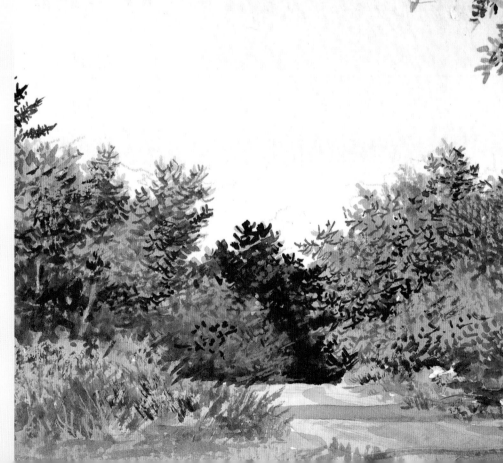

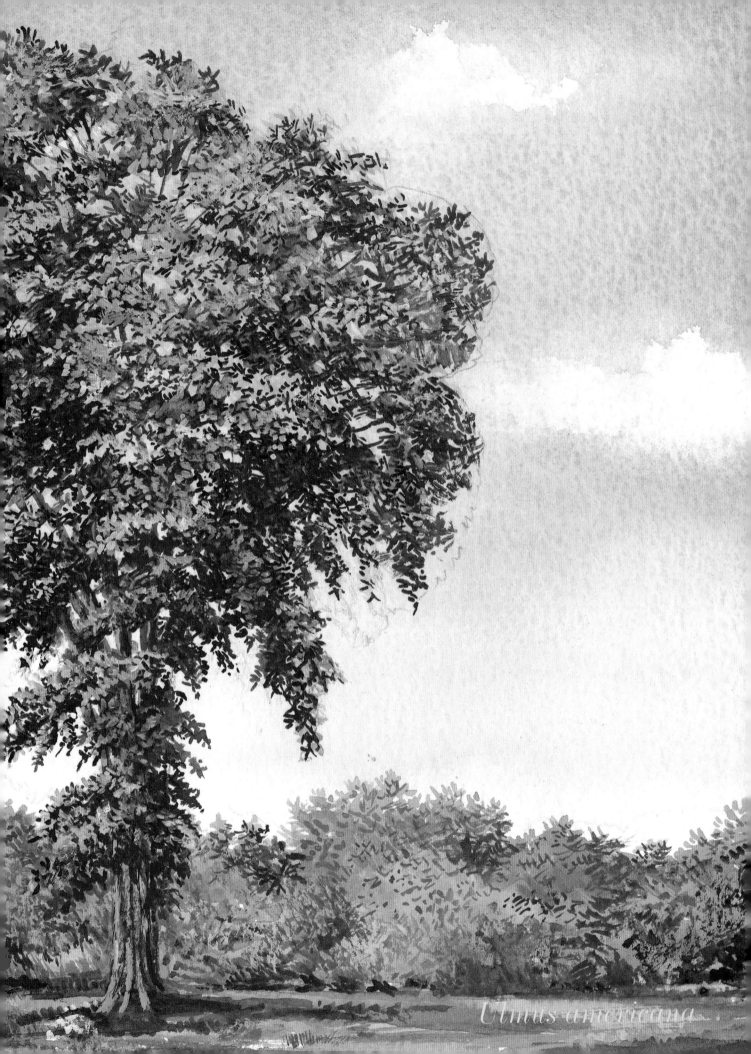

Ulmus americana

Guelder Rose

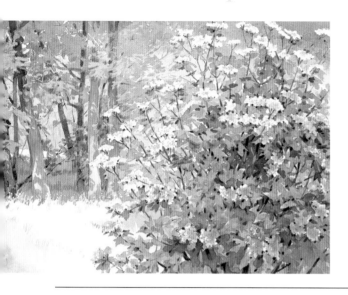

Viburnum opulus, a native of Europe, North Africa, and North Asia, is a shrubby deciduous tree, rarely exceeding 16 feet (5m) in height. The name "guelder" refers to an unusual form of the wild tree that grew in the Dutch province of Guelderland about 400 years ago.

The attractive, showy flower heads open in June and are noticeable from some distance. They have large, white, conspicuous outer flowers, and a mass of small creamy-white, bell-shaped flowers in the center, which produce red berries in autumn. The leaves are 1 to 3 inches (3-8cm) long, with irregularly-toothed lobes.

Note how the branches show a gradual diminution, and take care not to overstate or understate this. In the autumn, when the tree has lost most of its foliage, you can see the skeletal structure more clearly.

sequence start to finish

1 Carefully sketch in the large mass of the tree, indicating the flower shapes and the contrasting woodland area on the left. Mask out the blossoms (see MASKING OUT), picking out the pattern they form, and also mask a thin horizon strip at the back of the left-hand group of trees. Then, with a pale wash of Green Gold, and a No. 14 round brush, paint in the distant sunlit tree mass, When dry, paint the sky with watery French Ultramarine, darkening the color toward the right corner by adding Dioxazine Violet to the blue. Now paint a haphazard wash of very pale Green Gold over the foreground, leaving an area white. Allow to dry.

2 Begin to paint the leaves by laying a mix of Green Gold and Hooker's Green over most of the tree, massing the brushstrokes together more in the center and toward the lower edge. While still damp, add a stronger, mid-toned mix of the same colors with Indigo, still concentrating on leaf shapes and masses, but leaving areas of foliage as the first color. Before dry, tip in pale Dioxazine Violet in places and tilt the board to encourage the colors to flow downward. Allow to dry.

3 Paint in some cooler foliage colors on the more distant trees on the left with mixes of Hooker's Green and Indigo, stippling the brushmarks (see

STIPPLING) at the edges of the masses. When dry, paint the tree trunks with pale Quinacridone Gold, using a stronger tone for those at left and center. Allow to dry again before painting the grass with a mix of Hooker's Green and touch of Green Gold. Take this color over the trunks, varying the tones, and following the shadow contours on the lighter ones. Also bring some color into the left foreground to suggest grasses. Add the shadows to the tree trunks with two tones of Dioxazine Violet. Allow to dry.

4 Continue to build up the leaves with a stronger blue-green mix of Phthalo Green and Green Gold. Paint

special detail defining flower and leaf shapes

1 Trees are often painted much too solidly, so leaving gaps between branches, through which the sky or background can be seen, makes them look more realistic. Sketch in the blossoms and indicate the slender branches, and mask out the flowers.

2 On a fully-clad tree, you will only see small gaps between the foliage, but they are very important in giving a feeling of light and air. Take care not to make the shapes too repetitious. Paint in the lightest leaves with a mix of Green Gold and Hooker's Green.

3 Paint the mid-toned leaves, adding Indigo to the previous mix. Pick out more individual leaves at the upper outside edges. Leave some of the first leaves showing and also tiny gaps of background. When dry, add a third tone to the leaves with a mix of Phthalo Green and Green Gold.

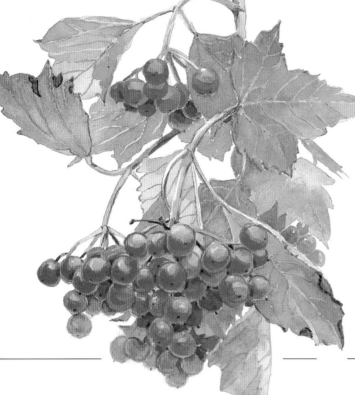

Slender branches bend down under the weight of the bunches of scarlet berries (left), which ripen in autumn just as the leaves are fading into orange and russet hues.
The fragrant, flat, flower head has showy, white, (sterile) outer florets with small, creamy ones in the center (center right). The deeply-toothed, lobed leaf is similar to a maple leaf (center left).

some leaves negatively (see NEGATIVE PAINTING), especially toward the lower right corner, and some positively – mostly at the outer edges. When fully dry, rub off the masking fluid on the blossoms, and begin to paint them wet-on-dry (see WET-ON-DRY). For the centers, use a mix of Quinacridone Gold and Dioxazine Violet. Leave more white on the blossoms that catch most light, leaving only the centers tinted.

5 Don't be afraid of dramatic contrasts between the lights and darks. To make the blossoms show up well, strengthen the leaves that are most in shadow with strong mixes of Indigo, Quinacridone Gold, and Hooker's Green. Let dry. To pull the leaves and blossoms together in the lower section, glaze pale Phthalo Green over some areas, then allow to dry.

6 Now paint in the stout branches at the center and lower edges with a No. 6 brush and a mix of Quinacridone Gold and Dioxazine Violet. Paint the new growth, carrying the flowers, with previous foliage colors, varying the tones. Weave these branches in and out of the leaves, taking some in front of the white flowers to give depth. When dry, tint White Gouache with Dioxazine Violet and Quinacridone Gold, and add just a few slightly lighter strokes to

some of the branches in deepest shadows to suggest patches of light.

7 Finally, adjust the tones on the left-hand group of trees, using Dioxazine Violet and Phthalo Green to accent different areas, but keeping the three nearest trees lighter. Stroke in thin branches and twigs with a rigger, and then darken the grass beneath the trees with pale washes of French Ultramarine and a little Dioxazine Violet. When dry, rub off masking fluid on the thin horizon strip.

4 When painting the flowers remember the pattern they form, like the sky holes, has to be designed over the tree to avoid the trap of equal spacing. Careful handling of the colors and tones is needed to avoid a jumpy, spotty look.

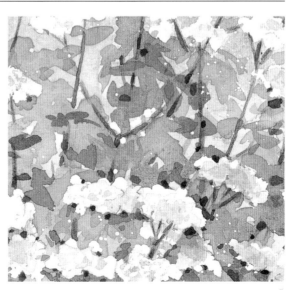

Hooker's Green

Dioxazine Violet

French Ultramarine

Quinacridone Gold

Indigo

Phthalo Green

Paynes grey

Raw Sienna

Burnt Umber

Cerulean blue

Gamboge hue

Naples yellow

Light red

Viburnum opulus

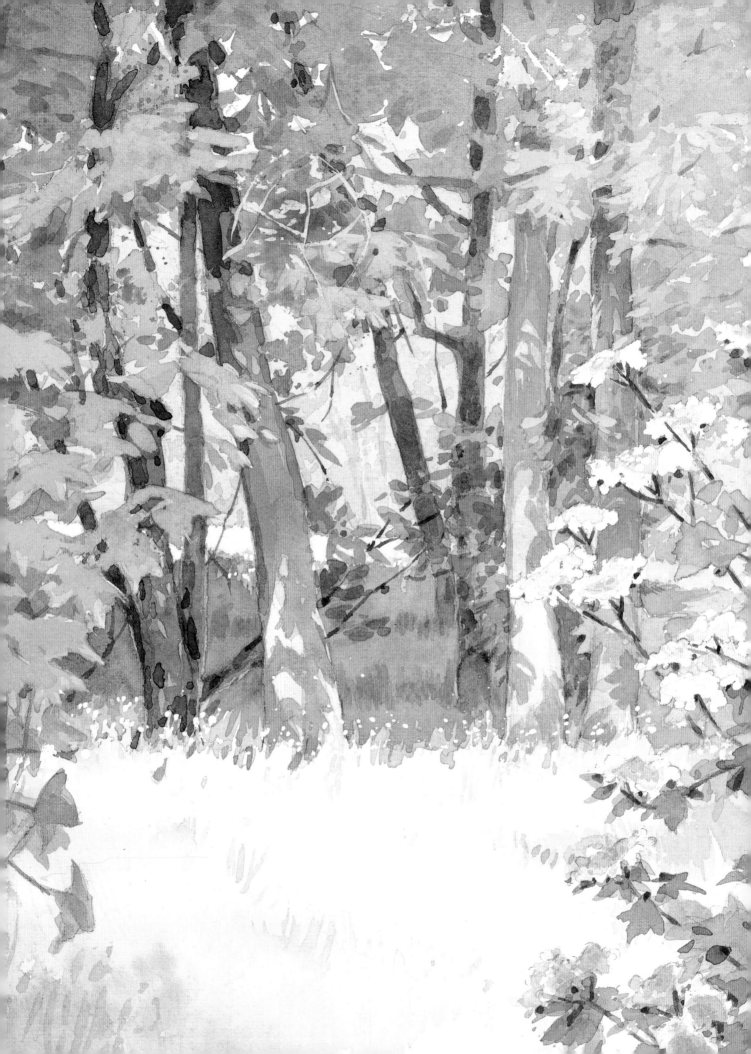

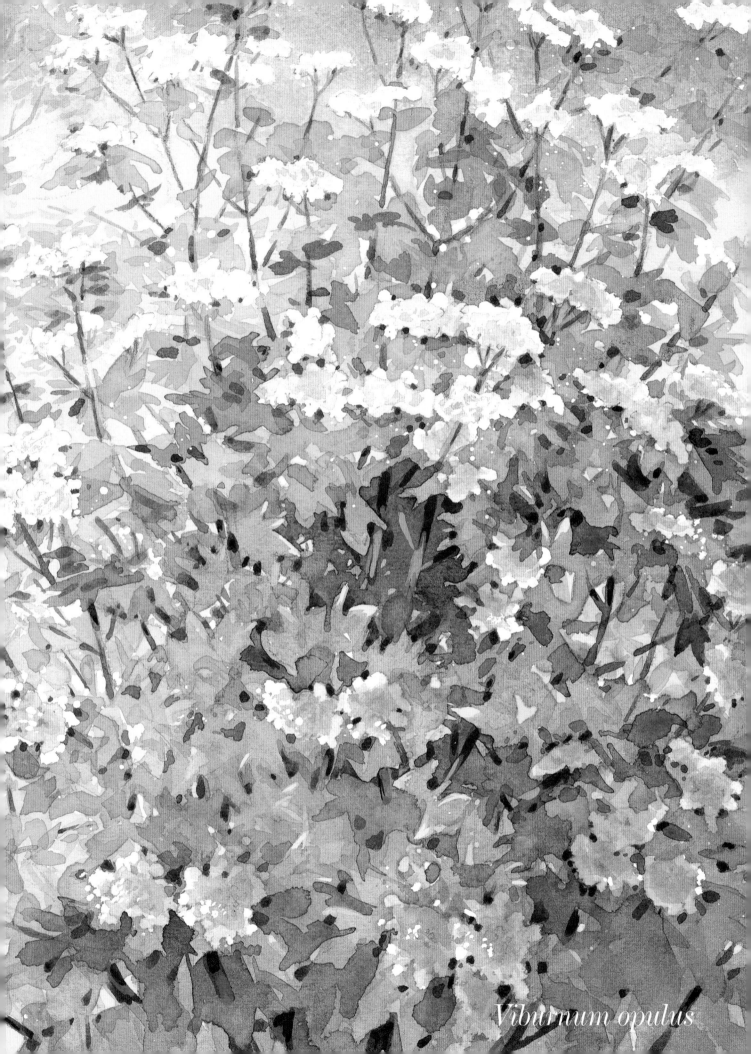

Viburnum opulus

Yucca aloifolia Spanish bayonet

This versatile, evergreen plant or small tree, which can reach 7-10 feet (2-3 meters), in height, has a strong architectural presence, and creates a dramatic focal point in any style of garden. It looks especially fine when in flower – the sword-shaped, dark green leaves are crowned with large panicles of purple-tinged, bell-shaped white flowers clustered on an erect stem. The erect, robust trunk can be simple or branched, and in maturity it has an attractive, cork-like bark.

When painting these complex structures, notice how the light affects the foliage, with lighter, warmer greens on the light side and cool, darker tones on the shadow side. The challenge is to differentiate between these two areas so that the completed painting is not confused.

sequence start to finish

1 Make a carefully structured drawing, emphasizing the clumps of leaves that are catching the light – mainly on the right – then mask out (see MASKING OUT) the slender trunks. Before starting to paint, take time to consider the different stages of the painting and the effect of the light. Here the sun is at a three-quarter degree angle to the plants, helping to model the forms.

2 Wet the paper all over with a sponge or brush, then lay on the first washes, using a No. 14 round brush and mixes of Green Gold and Prussian Green on the right foreground leaves, and Prussian Green alone toward the shadowed side. Let the colors blend in the middle, and while the paper is still damp, brush in the lower background clumps with the same colors. On the lower right group, which needs to be kept soft and slightly out of focus, lift out (see LIFTING OUT) the flower shapes before dry with a clean dry brush, then paint in fairly dry Naples Yellow to blend softly. Allow to dry.

3 To give interest to the painting, aim at a strong pattern of tonal interchange, with some leaves lighter than those behind and others darker. This composition requires a good deal of negative painting (see NEGATIVE PAINTING and below). Using the same brush and pale, watery Prussian Green, start at the top right and paint around the first wash to reserve the light, yellow-green leaves. Continue working toward the shaded left side, using Cobalt Blue instead of Prussian Green in places, especially at the top edge, and leaving some light leaves in the middle section. Brush in more leaves at the lower edge, using Prussian Green and Green Gold, letting them merge into the larger clumps behind the trunks. Keep the right side very understated, adding just a little more detail. Allow to dry.

4 Now put on the next tone with watery Prussian Green. Switch to a smaller round brush (No. 8), and again

special detail negative painting

1 *With negative shapes, the drawing must be carefully done, showing the leaves and the placing of the small negative shapes known as "sky holes" between them. Mask these off and then lay a wash of Green Gold.*

2 *Remember that warm colors advance and cool colors recede (see COLOR), and use these to model the forms. So start with a warm yellow-green on the light-catching right side and cooler blue-green on the left.*

3 *Use pale Prussian Green and Cobalt Blue to build up the layers of leaves. Think about this method as painting backward – it is a difficult technique, but essential for painting light against dark.*

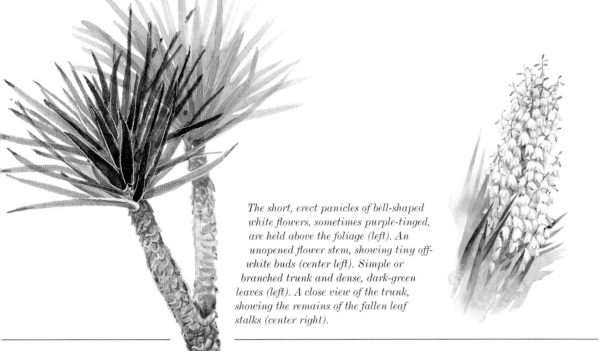

Prussian Green

Green Gold

Naples Yellow

Cobalt Blue

Hooker's Green

Dioxazine Violet

The short, erect panicles of bell-shaped white flowers, sometimes purple-tinged, are held above the foliage (left). An unopened flower stem, showing tiny off-white buds (center left). Simple or branched trunk and dense, dark-green leaves (left). A close view of the trunk, showing the remains of the fallen leaf stalks (center right).

concentrate on painting around leaves to reserve some as the second tone. Strengthen the Prussian Green progressively as you work toward the shaded side, and also paint between the lighter leaves at the lower edge to create interesting spiky shapes. All the colors used so far have been transparent pigments, producing a glowing effect.

5 Continue to build up the leaf masses with mid-toned mixes of Prussian Green and Hooker's Green, and paint some of the darker upper leaves as positive shapes. Strengthen the background yuccas behind the main trunks with a mid-toned mix of Prussian Green and a touch of Dioxazine Violet.

This color helps to pull the main plants forward to the front of the picture plane. When dry, rub off the masking.

6 Tint the trunks with pale mixes of Naples Yellow and Dioxazine Violet, varying the shades a little. When dry, paint in the details to suggest the scaly bark, and model the forms by adding shadows to the left side of the trunks, using various mixes of Dioxazine Violet, Prussian Green, and Green Gold. Lastly, brush in the darkest marks with stronger mixes of same colors for the shadows.

7 Finish the foliage by adding the darkest accents with strong Prussian Green, taking care to reserve the darkest tones for the shaded areas. Paint in the three faded flower stalks at the top of the main group with Naples Yellow and Dioxazine Violet, and add a suggestion of a flower on the left lower corner, together with distant flowers on the right-hand group. If the small "sky holes" have become lost and need restating here and there, for example where the leaves are a little too dense, paint in negative shapes with White Gouache.

4 *Using Prussian Green and Hooker's Green, add the darkest tones of background leaves and the small negative shapes between them, and then adjust the negative shapes of the sky holes if needed.*

Yucca aloifolia

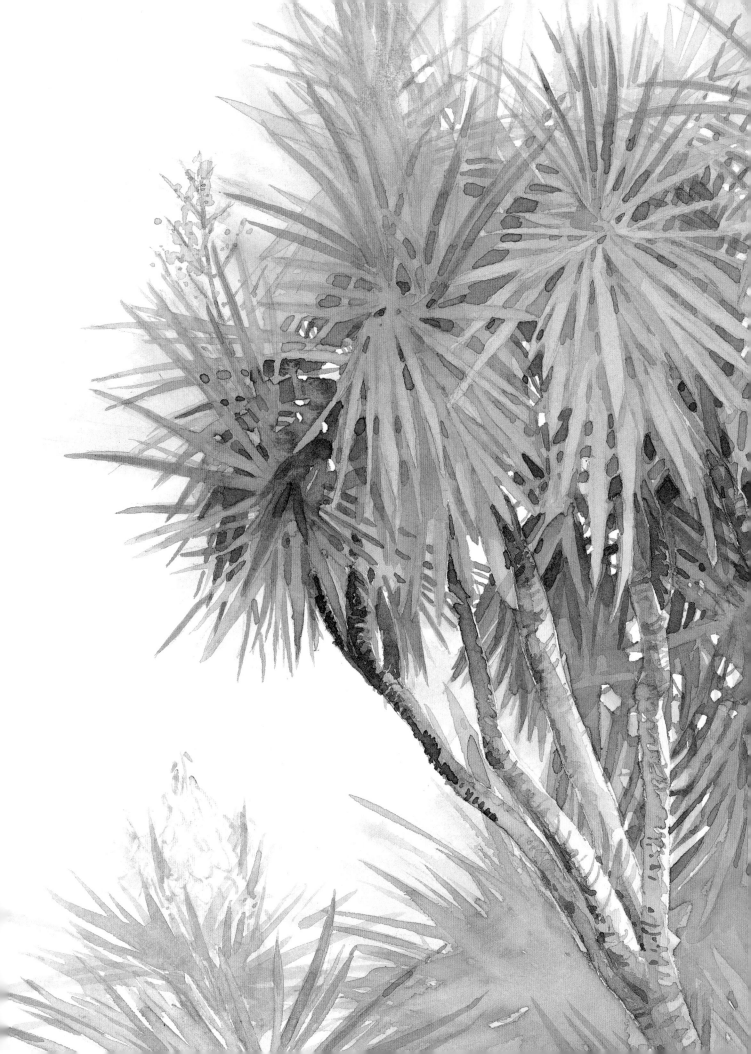

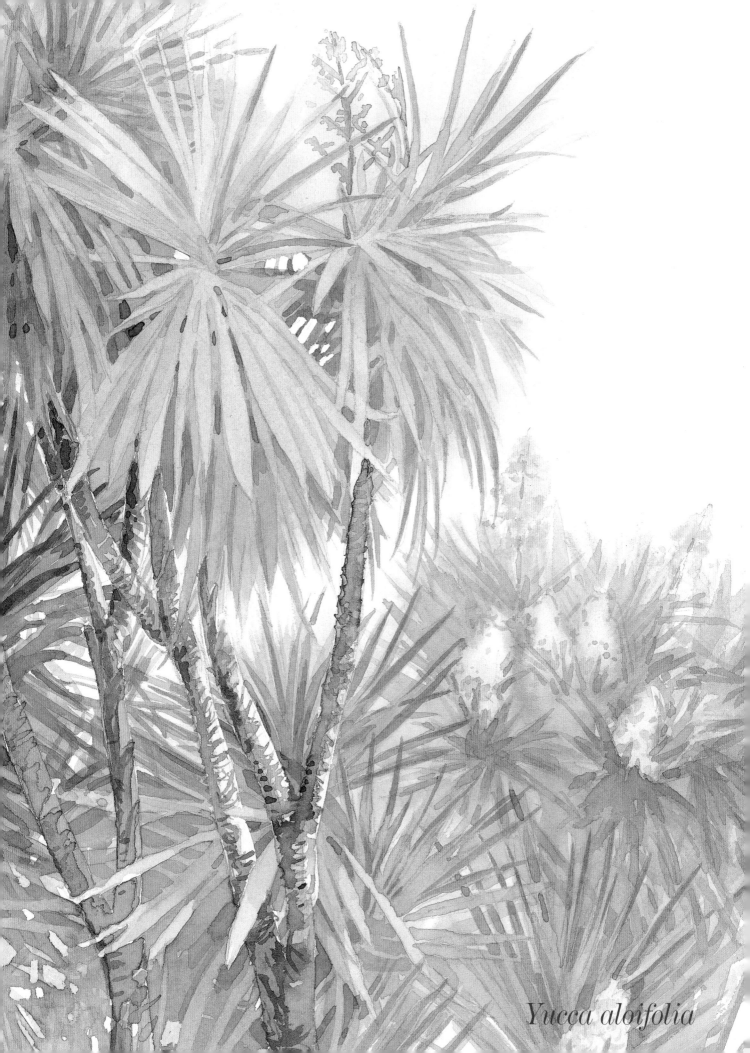

Yucca aloifolia

Zelkova carpinifolia Caucasian Zelkova

This tree was discovered in 1760 in the Caucasus mountains, yet remains little known. It is closely related to the elm, but its characteristic short, buttressed, beech-like trunk and extraordinary system of crowded upright branches are unique to this tree. The long, steeply ascending branches divide from the trunk a short distance above the ground to create a broad domed shape, growing up to around 115 feet (35 meters). The tree is soberly colored, with toothed, elliptical, dark green leaves that turn yellow or bronze in the autumn. The thin, pale gray bark, similar to that of the beech, flakes off to reveal little patches of quite startling orange. When painting, concentrate on the main shape of the tree and the upward diagonal thrust of the branches.

sequence start to finish

1 Working on a Rough paper, and using a 2B pencil, make an outline drawing of the tree and other landscape details. Keep the drawing to a minimum, avoiding any shading, as this could compromise the transparency of the paint. Brush in a pale, wet wash over the sky area, using watery Cobalt Blue with a touch of Alizarin Crimson, keeping the edges of the tree canopy ragged by holding the brush near the end of the handle and letting the tip "jump around" to produce an indistinct shape. If the edge seems too hard when it has dried, lay on a little water and lift out some of the color with a damp brush. Allow to dry.

2 The background trees can be laid down fairly simply with a wash of Aureolin Yellow, Cobalt Blue, and a touch of Alizarin Crimson. Avoid detail and tonal contrasts, as these trees are some distance away and must appear to recede. Next, put a simple but fairly strong yellow wash over all the foreground fields, dropping in a little Cerulean Blue and Cobalt Blue while still wet. To lay on these colors, use a large, round No. 12 brush, which will hold a good quantity of paint and produce fluid passages of color. Allow to dry.

3 Now start on the main trees. Still using the same brush, again well loaded, flick pure Aureolin Yellow onto

the main area of the leaves, aiming at spattering and flicking the paint rather than splashing it on. Immediately, before any of the yellow has begun to dry, add pure Cobalt Blue, still using a flicking motion of the brush, and making the color densest at the bottom left, where the foliage is in shadow. On the right side of the tree, where the sunlight strikes, flick in Cerulean Blue to blend with the yellow, adding Cobalt Blue half-way down.

4 The trees on the left can be painted in a more conventional manner. Push the brush onto the paper so that the color is released from the bottom, near the ferrule, and move it firmly upward in

special detail lifting out the bark detail

1 *Lightly draw in the tree outline and lay down some Indian Yellow over the main area of the bark using the side of the brush. This method, combined with the grain of the Rough paper, will provide surface texture.*

2 *When dry, drop Cobalt Blue and Aureolin Yellow onto the paper so that they mix to produce green, and while still damp, drop a little Cerulean Blue to blend gently into the underlying colors. Allow to dry.*

3 *Strengthen the tone with a touch more Cobalt Blue and some Brown Madder. Cerulean Blue and Brown Madder both granulate on the paper surface, producing an attractive texture suggestive of the rough bark.*

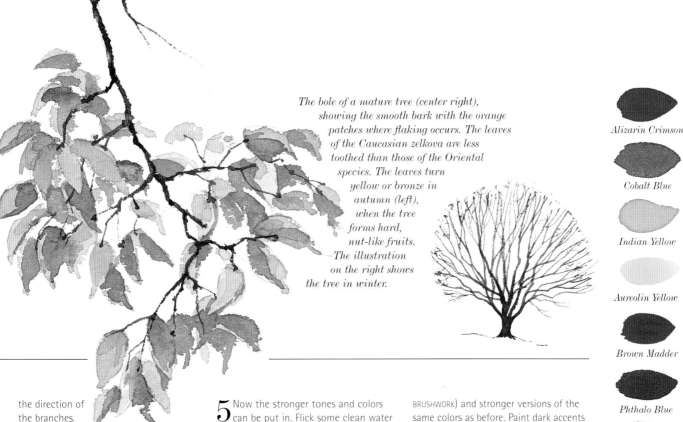

The bole of a mature tree (center right), showing the smooth bark with the orange patches where flaking occurs. The leaves of the Caucasian zelkova are less toothed than those of the Oriental species. The leaves turn yellow or bronze in autumn (left), when the tree forms hard, nut-like fruits. The illustration on the right shows the tree in winter.

Alizarin Crimson

Cobalt Blue

Indian Yellow

Aureolin Yellow

Brown Madder

Phthalo Blue

Cerulean Blue

the direction of the branches. Take care not to score the paper – you need only enough pressure to move the paint. Allow all the foliage colors to dry before working on the trunks and branches, using combinations of Indian Yellow, Brown Madder, and Cobalt Blue. Start with the yellow, pushing the color up into the leaves, and while still wet, drop in some Brown Madder in different places. Leave some of the yellow as highlights on the main trunk, and add some Cobalt Blue on the shadow side to darken it a little. Allow to dry.

5 Now the stronger tones and colors can be put in. Flick some clean water onto the shadow area of the foliage, then work in some Phthalo Blue and Alizarin Crimson, holding the brush lightly at the end of the handle to achieve random marks. If the colors begin to look too heavy, add a little Aureolin Yellow, keeping the colors moving and mingling all the time to produce an assortment of tones and textures. When dry, put in the background hills and hedge lines, using various mixtures of the foliage and bark colors.

6 Taking care to preserve the yellow highlights, add some detail to the main trunk, using a No. 3 rigger (see

BRUSHWORK) and stronger versions of the same colors as before. Paint dark accents on the shaded side of the trunk and on some of the shadowed branches in the center of the tree, lifting out the color in places (see LIFTING OUT) to give the impression that the branches are behind the leaves. Then switch to the No. 12 brush and paint the cows with a dilute wash of Brown Madder. When dry, add a darker mix of Brown Madder and Cobalt Blue to build up the forms. Finally, lay in the shadow areas under the trees with the large brush and mixes of Aureolin Yellow, Cobalt Blue, and Alizarin Crimson, pulling out some of the wet color with the tip of the brush to suggest the grasses.

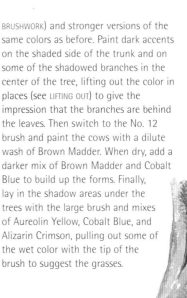

4 When dry, flick some clean water over the dark area, and use a clean tissue to lift out a little color. Paint in the hollow in the trunk with Cobalt Blue and Brown Madder, and soften one or two edges to provide contrast.

Zelkova carpinifolia

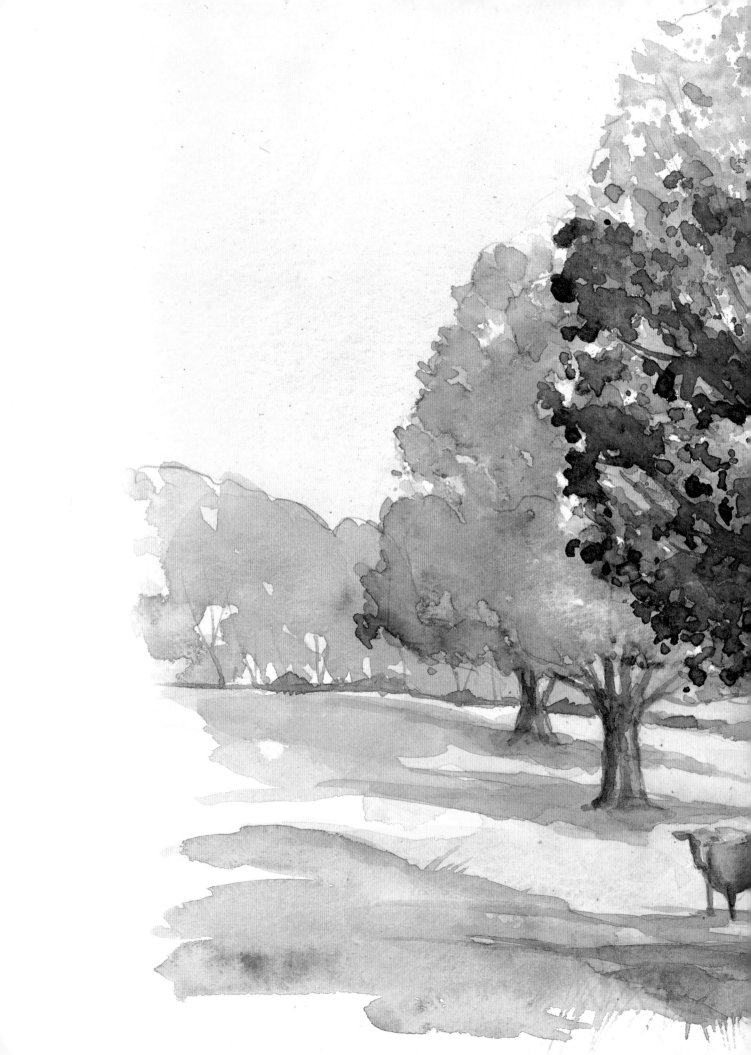

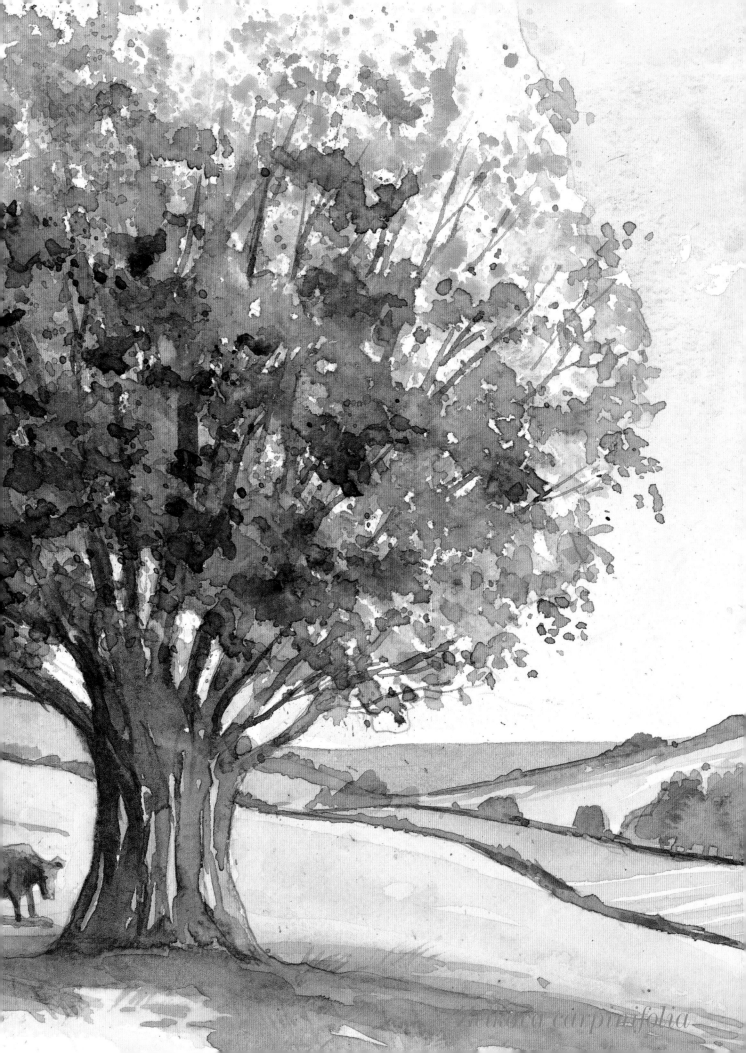

zanata carpinifolia

composing
tree paintings

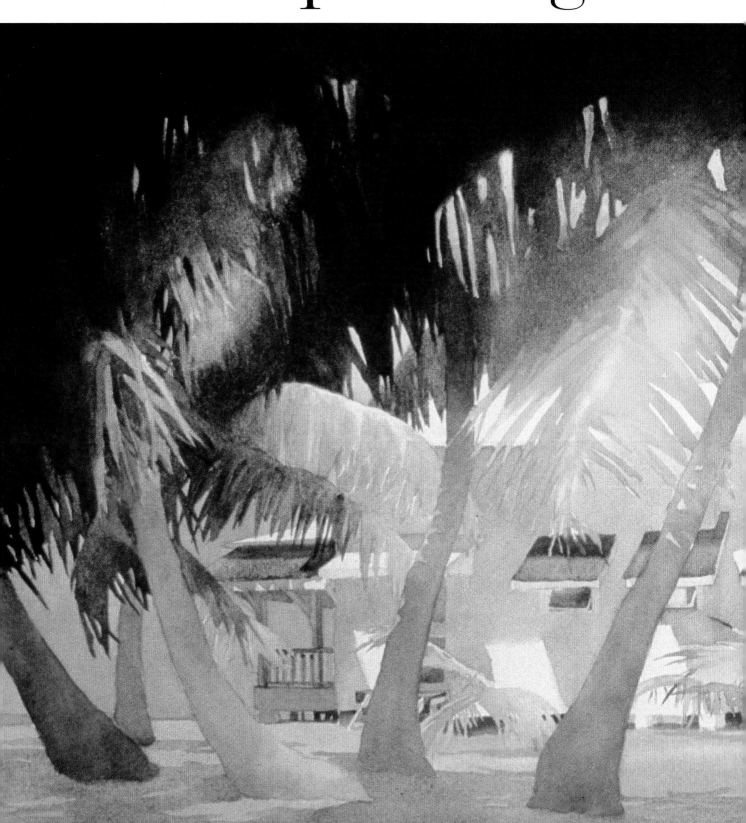

Now that you have mastered a range of watercolor techniques and learned how to paint "portraits" of individual trees, it is time to take a step farther into the realm of picturemaking. Technique is a vitally important tool and should never be under-rated, but it is the pictorial values – how the painting is designed, the balance of colors and tones and so on – that allow you to express your ideas and give your paintings the stamp of individuality.

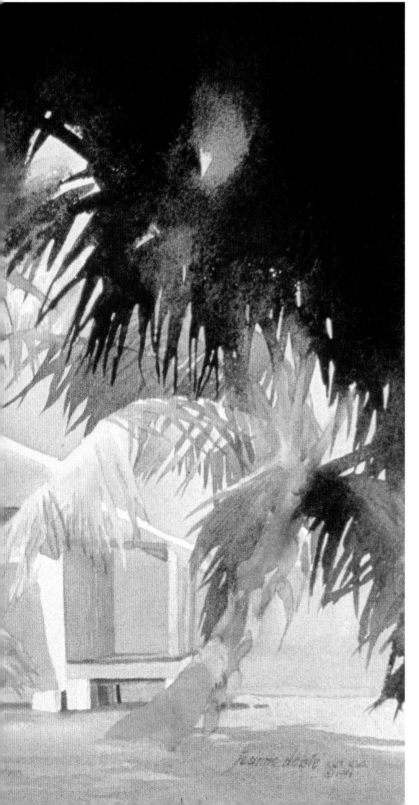

In any branch of landscape painting it is important to remember that you don't have to paint exactly what you see. You can move elements around, perhaps bringing a group of background trees forward into the middle distance to balance a dominant foreground tree, or shifting a centrally-placed tree over to one side. It is always best to avoid too much symmetry, as this gives a dull and static feel that prevents the viewer's eye from traveling into and around the composition.

CHOOSING THE VIEWPOINT

The major compositional decisions can be made before you put pencil or brush to paper, because they stem from the choice of viewpoint. If you are working outdoors, always include a viewfinder in your kit. These can be bought, but it is easy to make your own simply by cutting a rectangular aperture in a piece of card (the aperture should have the same proportions as your painting surface.) Hold this up to frame the view in different ways, moving it away from you to bring the subject toward you and closer to push it back in space. The viewfinder will help you to decide the format of your painting (a vertical or horizontal rectangle.) the placing of the main elements, and how much foreground or sky to include.

LEADING THE EYE

There are no hard and fast rules about composition, but in general, a painting should have a good balance of shapes, colors, and tones, and sufficient contrast to create interest. But the most important aspect to consider is what is known as compositional movement, or compositional rhythm. The viewer must be led into the painting, and encouraged to travel around it via strategically-placed visual "signposts." Think of the picture

◄ SUNDANCE
In this painting by Jeanne Dobie, the distribution of tones and subtle, complementary contrasts all play vital roles. The pale leaf shapes are repeated from one area of the painting to another; the diagonals of the windows echo those of the two central tree trunks and contrast with the angles of those on the left. The dark tones at the top of the picture are echoed by smaller dark areas on the building behind. The shadow at the top of the central leaf is echoed in the color of the grass, and the yellows of the leaves are set against mauve-gray shadows on the building.

as three separate planes: Foreground, middleground, and background, and try to devise ways of creating links between them. Often a touch of foreground interest, such as grasses or small foliage, can lead in to the main center of interest, while elements in the middleground will lead toward the background. Don't clutter your paintings with too much detail, especially in the immediate foreground, as this can form a visual block, but don't leave empty areas where nothing is happening.

PERSPECTIVE IN LANDSCAPE

One of the major challenges in landscape painting is to create a sense of space and recession so that the trees and other elements don't look flat and two-dimensional. There are two main ways of giving the impression of space: one is by using linear perspective and the other is by controlling the tones and colors, as explained below.

The main effect of linear perspective is to make objects appear smaller and closer together as they recede, so that a clump of trees in the middleground may be only half the size of one in the foreground. Receding parallel or semi-parallel lines, such as walls or hedges at the edges of fields, also become progressively closer until they meet at a point on the horizon line (your eye level). You won't always see obvious parallel perspective effects in landscape subjects, but sometimes there are paths, rivers, or lines of plowing running in from the foreground or middleground toward the background – any of these will help to explain the spatial relationships of the various landscape elements.

AERIAL PERSPECTIVE

The most effective way of creating space is by careful observation of a different kind of perspective, known as aerial or atmospheric perspective. Tiny particles of dust in the atmosphere draw a kind of veil over more distant objects, so that the tones become paler, with less obvious light/dark contrasts.

▼ **RED CHESTNUT CANDLES**
This delightful painting by Juliette Palmer has been very cleverly composed. The flowering tree is the primary subject, as the title implies, but the eye is led from this to the group of trees behind the wall, where strong tonal contrasts create a center of interest in the middleground. The lively brushwork describing the grasses provides just the right amount of foreground interest, and the darker green shape on the extreme left has a dual function: it balances the tree shapes and prevents the eye from going out of the picture at the side.

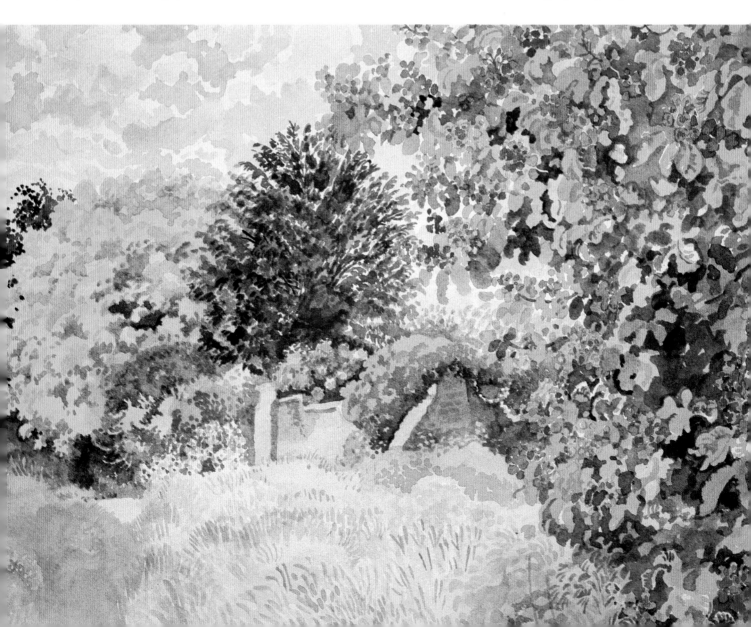

Walter Garver has used both linear and aerial perspective in his painting, to create space and to lead the viewer into the picture. The curving sides of the road and bank almost meet at the end, and the effect is heightened by the small, indistinct figure. The group of trees to the left of the figure is much lighter in tone than the nearer ones, and cooler in color than the grassy bank on the right. Notice also how the foreground is brought forward by the use of the strong, near-white shape of the puddle, surrounded by dark browns.

▼ PERSPECTIVE AND VIEWPOINT

When making use of linear perspective it is important to choose the viewpoint with care. The horizon line at which receding lines meet is your eye level, and that the vanishing point is opposite you on this line. Here the eye level is just below the center of the picture, and the near-horizontal formed by the side of the road leads the eye to the vanishing point opposite the artist's own position.

VP - Vanishing point

This effect is obvious in the case of very far-off landscape features, but aerial perspective to some extent affects any elements that are not in the immediate foreground.

The colors are also altered by recession, becoming progressively cooler, or bluer – you will probably have noticed that far-away hills or mountains appear as a uniform pale blue, although you know that the real colors are probably greens and browns. Compare a foreground tree with a similar one in the middle distance and you will see this alteration of colors and tones. There may be vivid yellows and greens on the nearer tree, with strong tonal contrasts, but the greens will be bluer and paler on the more distant tree. These effects require careful observation, as we tend to paint what we know rather than what we see, but once you understand the principle of aerial perspective you can use contrasts of warm and cool colors and tonal values to pull foreground elements to the front of the picture and push others back in space. Form can be suggested in the same way, by using warm colors for forward-thrusting clumps of foliage and cooler ones for those at the back or behind a tree.

◀ **WOODLAND SHALLOWS**
By contrasting curves, diagonals, and verticals, Joe Dowden has achieved a beautifully balanced composition that perfectly expresses the tranquility of the subject.

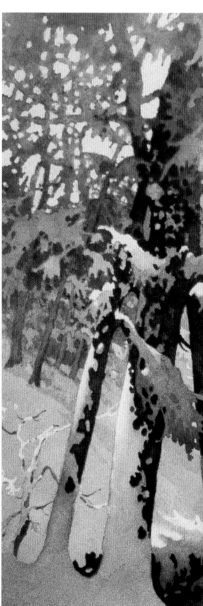

▶ **WINTER'S BRIGHTER MOMENTS**
Roland Roycraft has achieved a wonderfully rhythmic feel in this composition by exploiting the shapes made by the patches of light and shadow on the snow. He has used the minimum of detail in the foreground in order not to detract from the strong, pale shape that leads the eye up to the dark red-brown area and thence to the tree trunks. The red-golds of the foliage tie this area to the dark central shape by making a color echo, and the elegant shapes of the leaves and the snow patches on the tree trunks provide a wealth of pictorial interest.

▶ **NEGATIVE SHAPES**
In this area at top left of the painting, the artist has exploited the interplay of positive and negative shapes where the sky shows through the trunks and branches. Negative shapes play an important role in composition, and need to be planned with care so that they do not become dull and repetitive.

▶ **HIGHLIGHT SHAPES**
To enable you to see the shapes of the highlights on the snow more clearly, this drawing reverses the tones of the painting, showing the light areas as dark and vice versa.

COLOR: HARMONY AND CONTRAST

Colors can be described as belonging to different groups, or "families," the main division being between the warm and cool colors. The warm group consists of the reds, oranges, and yellows, while the blues, blue-greens, and mauves belong to the cool color family. The neutrals will belong to one or the other depending on the main component (neutrals are never truly neutral), so that a red-brown will be part of the warm group, and a gray-brown part of the cool one.

You can create a quiet, harmonious effect in your painting by using colors that belong to the same family, but unless you bring in a little contrast the result can be rather too bland.

This is always a danger in landscape painting, as the colors are naturally harmonious, so you may need to think of ways of introducing contrast. A well-known artistic device is to bring in a touch of red – a few flowers, a figure, or a hint of red on trunks and branches – to enliven a predominantly green color scheme.

Green and red are complementary colors, opposite one another on the color wheel. The other two groups of complementaries are yellow and mauve, and blue and orange, so you could introduce contrast into a painting of a tree in autumn by heightening the blue of the sky, or bringing blue into shadows.

▼ VALDEMOSA, MAJORCA
Kaye Teale has used a very limited palette of harmonizing colors, but has introduced a subtle touch of red-brown beside the church to lift the dominant greens. What gives her painting a sense of excitement is not the color scheme but the use of shapes, with the spiky verticals of the trees and tower contrasting with the gentle curves of the hills.

▶ CHANGE OF SEASONS
To capture this peaceful scene, Robert Reynolds has used a wide range of bold but harmonious colors and a series of color echoes – notice how he has brought in muted reds on the foliage and branches. The strong negative painting of the yellow leaves in the foreground creates a lively pattern that leads the eye up to the richly colored reflections and thence to the delicate stippled foliage above.

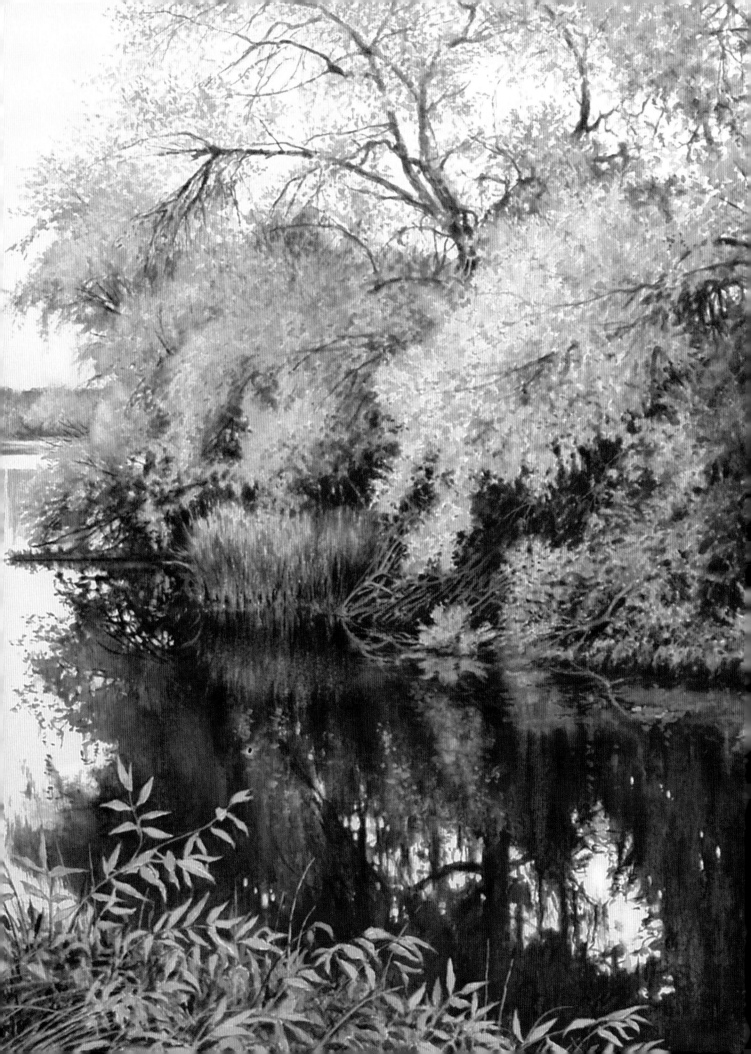

This wheel shows how the warmer colors are grouped on one side, with the cooler ones on the other. The colors opposite one another are called complementary colors. These create strong contrasts, and can be used to draw the eye to a focal point in a painting. They have another useful property: As they can be mixed together to produce a range of neutral colors, and a too-bright color can be muted by adding a little of its complementary color.

ECHOING SHAPES AND COLORS

Making links between different areas of the picture helps the viewer's eye to roam around it and it also gives unity to the composition. Even when there is one dominant feature in a painting, the other elements, although playing secondary roles, must be seen as equally important. To produce a well-balanced and satisfying painting, the various components need to be linked by color, shape, or tone.

One way of producing this unity is to echo colors from one area to another. For example, bringing in a little of the blue of the sky into the foreground or foliage shadows will "tie" the different planes of the picture together and avoid the disjointed look that can be seen in works by inexperienced artists. Don't overdo this, or it will look too obvious – often all you need is just a touch of blue added to a mix for foliage or tree trunks.

You can set up shape echoes in the same way. A group of middleground or distant trees can be given a similar shape to those in the foreground – but again, be subtle, and don't use exactly the same shapes, or the painting will become dull and repetitive. Sometimes the rounded shapes of clouds can echo those of trees; if you look back at Juliette Palmer's painting, you will see that she has used small, rounded shapes for the clouds, echoing those of the foliage clumps.

▶ MOLOKAI BANYAN TREE
In this unusual painting, Dyanne Locati has focused on the roots of the tree, which often make a fascinating subject in themselves, and treated them in a semi-abstract way as a series of sinuous, inter-connected shapes. To remove the subject farther from reality, she has avoided a traditional landscape painter's palette and heightened all the colors, making use of an exciting range of complementary contrasts as well as deep, rich tones.

◀ TONE AND COLOR CONTROL
The imaginative use of color is the first thing that strikes the eye in this painting, but the artist has also controlled the tones with care to create the pattern of intertwining branches.

Glossary

Cross-references to entries in the glossary are in *italics*

backruns the result of applying paint against an area before it is completely dry. The new color seeps into the old, creating a range of interesting effects. Many water-color painters use backruns deliberately, both in large areas and small, as the effects they create are unlike those achieved by conventional brushwork.

blossoms the flowers that appear on the tree in the spring and that are shed by summer.

blending the achieving of a smooth, gradual transition from one color to another so that there is no discernable boundary between them. This is a slightly trickier process with watercolor paints than it is with oil or pastel because water-based paints dry more quickly than other media.

body color opaque paint, usually the result of using *gouache* colors or mixing watercolor with white gouache to lessen its transparency. White Acrylic is a useful alternative to gouache.

bract a modified and often brightly colored leaf.

catkins a long spike shaped bloom covered either in scaly *bracts* or asexual flowers. The name derives from their resemblance to cats' tails.

complementary colors colors that are immediately opposite each other on the color wheel (see page 124). For example, orange is complementary to blue, as green is to red. These colors enhance each other and appear more intense when used in close proximity to each other.

cones pollen or egg bearing scales that come from trees of the pine family. depending on the type of pine the masses can vary in shape from compact spiky globes to elongated ovals, and long thin spikes.

composition the arrangement or design of the different elements—lines, objects, shapes, colors, and textures—to be expressed within a painting or work of art.

cool colors the colors associated with the sensation of cold, usually in the range of blue, violet, and green. However there are so many varying tones of each color that a red-based blue can appear warm while a green-based blue can seem cold.

deciduous trees or plants that shed their leaves seasonally, or at a specific stage in their development, this shedding usually occurs in the autumn.

dry brush the method of painting with just the bare minimum of paint on the brush so that the color only partially covers the paper, creating a broken-color effect.

evergreen trees and plants that keep their foliage and remain green and functional throughout the year. Often used for decorative purposes such as topiary.

focal point the object or area in a painting that attracts the most attention and to which the eye is naturally drawn.

fruit the reproductive body of a seed plant. Often, although not always, covered in a sweet edible pulp.

glazing applying a wash of color over a dried color to amend it or give it more depth. The number of glazes used at any one time should be limited.

gouache opaque watercolor. Unlike pure watercolor, it does not dry as a transparent color with the underlying background influencing it, but as a solid, flat color. Artists like to use white gouache for highlights, or mix it with a watercolor to add details or emphasis to certain areas in a painting.

hedgerows a boundry, often between fields, made of densly planted trees or shrubs.

lifting out the method of creating light shapes and highlights in a watercolor painting by lifting out parts of a wash while it is still wet. Small sponges or paper towels are usually used for this method.

masking the method of laying masking fluid over white paper or dry paint to reserve fine lines or small details before the area is treated with a general wash. When the painting is finished the masking fluid is rubbed off or peeled away.

negative painting the method of reserving light shapes and highlights in a painting by painting darker colors around them.

stippling a technique of applying paint where the painting is built up entirely with tiny strokes of a fine, pointed brush. Alternatively, some artists use a broad, flat brush, charging it with just a little paint and allowing it to follow the direction of a form.

stamen one of the male, pollen-bearing organs of the flower.

warm colors the colors associated with the sensation of heat or warmth, usually in the range of red, orange, and yellow. However, a blue-based orange may appear cool, while a red-based orange may appear warm.

wet-in-wet a standard watercolor technique in which colors are laid into or over one another while still wet.

wet-on-dry a standard watercolor technique in which successive washes are worked over color which has already dried.

Index

Credits

Quarto would like to thank the following individuals who took part in the projects: Joe Francis Dowden, Adelene Fletcher, Barry Herniman, Martin Taylor.

And the following for supplying additional images Jeanne Dobie, page 116; Juliette Palmer, page 118; Walter Garver, page 119; Roland Boycroft, page 120–121; Kaye Teale, page 122; Robert Reynolds, pages 2, 123; Dyanne Locati, page 124–125.